A TREASURY
OF BIBLE
PICTURES

Published by
Lion Publishing plc
Sandy Lane West, Oxford, England
ISBN 0 7459 1944 8
Lion Publishing Corporation
1705 Hubbard Avenue, Batavia, Illinois 60510, USA
ISBN 0 7459 1944 8
Albatross Books Pty Ltd
PO Box 320, Sutherland, NSW 2232, Australia
ISBN 0 7324 0226 3

First edition 1987
This edition 1990

Acknowledgments

Design
Nigel Poulton

Picture Editor
Caroline Masom

Captions and introductions
Pat Alexander

Archaeological notes
Alan Millard MA MPhil FSA

Index
Ruth Connell

Photographs
J.C. Allen 4.8, 4.17, 5.2; Ashmolean Museum 1.18, 5.45, 8.19; Austrian Archaeological
Institute/M. Bietak 2.5, 2.18; Britain/Israel Public Affairs Committee 9.18, 9.19, 10.22;
British Museum, by courtesy of the Trustees 1.12, 2.10, 2.21, 2.26, 3.10, 3.18, 3.39, 4.14, 4.15,
5.16, 5.20, 5.21, 5.24, 5.26, 5.42, 6.2, 6.3, 7.1, 7.3, 7.15, 10.8, 12.26, 12.28; Bodleian Library,
Oxford 7.18 Ms Pell Aram bag (recto), 7.19 Ms Pell Aram IV int.; Cairo Museum 3.32; Maurice
Chuzeville/Musée du Louvre 2.25, 5.14; Peter Clayton 2.7, 2.16; C. M. Dixon/Photoresources
3.13; Alistair Duncan/Middle East Archive 1.1, 1.26, 3.26, 12.3; E.T. Archive 10.10/Dagli
Orti 3.12, 5.12; Georg Gerster/John Hillelson Agency 1.3, 1.7, 5.18, 6.1; Haifa Maritime
Museum 12.35; Sonia Halliday Photographs/F.H.C. Birch 8.5, 10.4, 12.14, 12.20, 12.37,
12.43/Sonia Halliday 1.21, 2.2, 2.3, 2.17, 2.22, 3.3, 3.6, 3.9, 3.16, 3.21, 3.23, 3.24, 3.25, 3.29,
3.30, 3.31, 3.34, 4.1, 4.5, 4.6, 4.20, 4.21, 5.3, 5.8, 5.30, 5.31, 5.33, 8.17, 8.18, 9.4, 9.12, 9.13,
10.3, 10.7, 10.9, 10.11, 10.16, 11.1, 11.3, 11.4, 11.7, 11.9, 11.11, 11.12, 11.13, 11.14, 12.9, 12.11,
12.16, 12.21, 12.24, 12.33, 12.41, 12.45 and cover/Anne Holt 1.5/Laura Lushington 2.4,
11.18/T. Rising 7.10, 7.11/Barrie Searle 2.20, 9.1, 9.2, 11.10/Jane Taylor 1.19, 1.20, 3.1, 3.2,
3.27, 3.28, 3.33, 5.4, 5.5, 5.10, 5.13, 8.12, 8.14, 8.15, 8.16, 10.15, 10.17, 10.18, 10.19, 10.23,
10.25, 12.1, 12.2, 12.22, 12.40, 12.42; Robert Harding Associates 2.23, 2.29, 5.15, 7.2, 7.4, 7.6,
7.7, 7.8, 7.9, 7.12, 8.4, 8.10, 10.12, 10.24/Rainbird 2.13, 2.14; Michael Holford 1.11, 2.6, 2.8,
2.9, 2.11, 2.12, 2.15, 5.11, 5.17, 5.22, 5.23, 5.25, 5.36, 5.37, 6.8, 7.14, 8.2, 8.3, 8.6, 8.7, 8.8, 8.9,
8.11, 10.1, 10.13, 10.14, 12.25, 12.27; Illustrated London News Picture Library 1.8; Israel
Museum, Jerusalem 2.30, 3.8, 3.11, 3.15, 3.17, 4.16, 5.6, 5.7, 5.38, 9.14; Jericho Exploration
Fund 3.7; Dr K. A. Kitchen 3.32 (detail); Lepsius Denkmaler III 1.15/16, 1.25; Erich
Lessing/John Hillelson Agency 11.17; Lion Publishing/David Alexander 1.2, 1.9, 1.10, 1.13,
1.14, 1.22, 1.27, 2.19, 2.27, 3.5, 3.14, 3.22, 3.37, 4.2, 4.3, 4.4, 4.7, 4.10, 4.11, 4.12, 4.18, 4.19,
5.1, 5.27, 5.29, 5.32, 5.34, 5.39, 5.40, 5.41, 5.43, 6.9, 6.10, 7.5, 7.16, 7.17, 9.8, 9.10, 9.11, 9.15,
9.16, 10.5, 10.6, 11.6, 11.8, 11.15, 11.16, 11.19, 12.4, 12.5, 12.6, 12.7, 12.8, 12.10, 12.12,
12.13, 12.15, 12.17, 12.18, 12.19, 12.23, 12.30, 12.31, 12.32, 12.36, 12.38, 12.39, 12.44; Alan
Millard 1.4, 2.24, 3.20, 4.22, 9.6, 9.7; Nigel Press Associates 2.1; John Rylands Library,
University of Manchester 12.46; Staatliche Museen zu Berlin 6.6; Werner Forman Archive
12.29; ZEFA (UK) Ltd 1.23, 1.24, 3.4, 4.9, 5.19, 5.44, 6.5, 7.13, 8.1, 8.13, 9.3, 10.2, 10.20,
10.21, 11.2, 11.5, 12.34.

British Library Cataloguing in Publication Data

A Treasury of Bible Pictures.
1. Bible — Antiquities
I. Masom, Caroline II. Alexander, Pat III. Millard, A. R.
220.9'3 BS620
ISBN 0-7459-1944-8

Library of Congress Cataloging-in-Publication Data

A Treasury of Bible Pictures.
1. Bible — Antiquities. 2. Bible — Illustrations.
I. Masom, Caroline. II. Alexander, Pat. III. Millard, A. R. (Alan Ralph)
BS621.P53 1987 220.9'1'0222 86-27853
ISBN 0-7459-1944-8

Printed in Yugoslavia

A TREASURY OF BIBLE PICTURES

Edited by Caroline Masom and Pat Alexander
Archaeological notes by Alan Millard

A LION BOOK
Oxford · Batavia · Sydney

CONTENTS

Introduction 5

Map: The Ancient Near East 6
Map: Israel 8

Captions marked with an asterisk have
additional information in the archaeological
notes at the back of the book, under the
same number as the caption.

INTRODUCTION

A Treasury of Bible Pictures brings together a unique collection of photographs covering the main biblical places, important artefacts and significant archaeological discoveries which have a direct bearing on our understanding of the Bible.

The arrangement is basically chronological, covering, the 2,000 years of Bible history in twelve galleries of pictures. Captions provide basic information. Further information is given in the archaeological notes.

The pictures in the book have been gathered from a wide range of sources. The brief was to find the best photographs available, and we have plundered the treasures of famous museums and famous photographers. There are objects from the 'royal' graves at Ur, treasures from the Oxus and from Tutankhamun's tomb, reliefs from the palaces of Assyria and Babylonia, glories of Greek and Roman art and architecture. Inscriptions which may not look exciting are

nonetheless among the most significant of all the discoveries relating to Bible times.

The pictures of places cover not only ancient Israel/Palestine but also sites in all the major Bible lands, including Egypt, Iran, Iraq, Syria, Jordan, Turkey, Greece and Italy.

As far as possible all the pictures relating to a particular place appear together. But in order to maintain the chronological framework in some cases a place may appear in more than one gallery. The index makes it easy to find all the information on a particular location.

A Treasury of Bible Pictures has been an exciting assignment. We hope that it will prove to be not only a visual feast but a unique resource which illuminates the Bible for many people.

Caroline Masom
Pat Alexander
Alan Millard

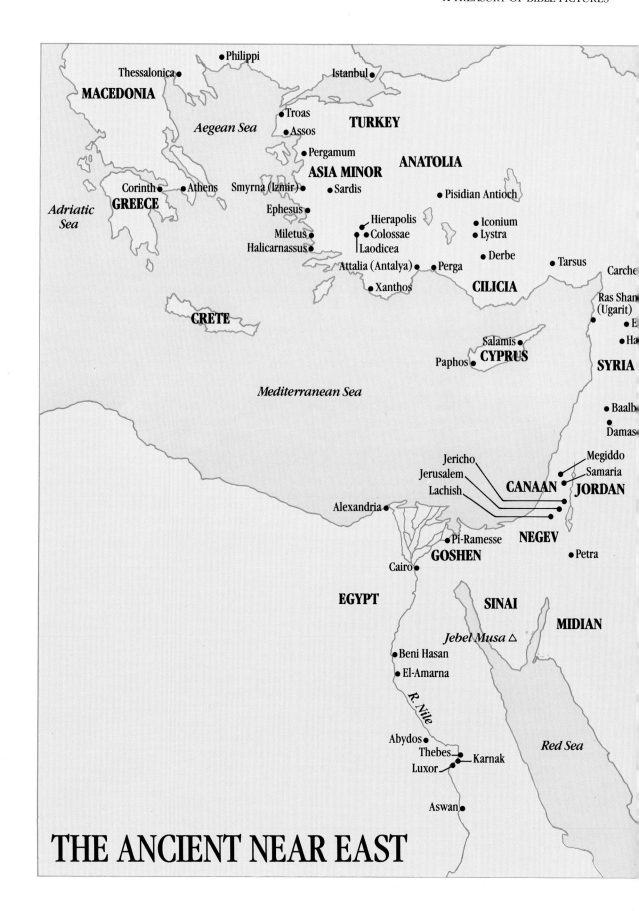

THE ANCIENT NEAR EAST

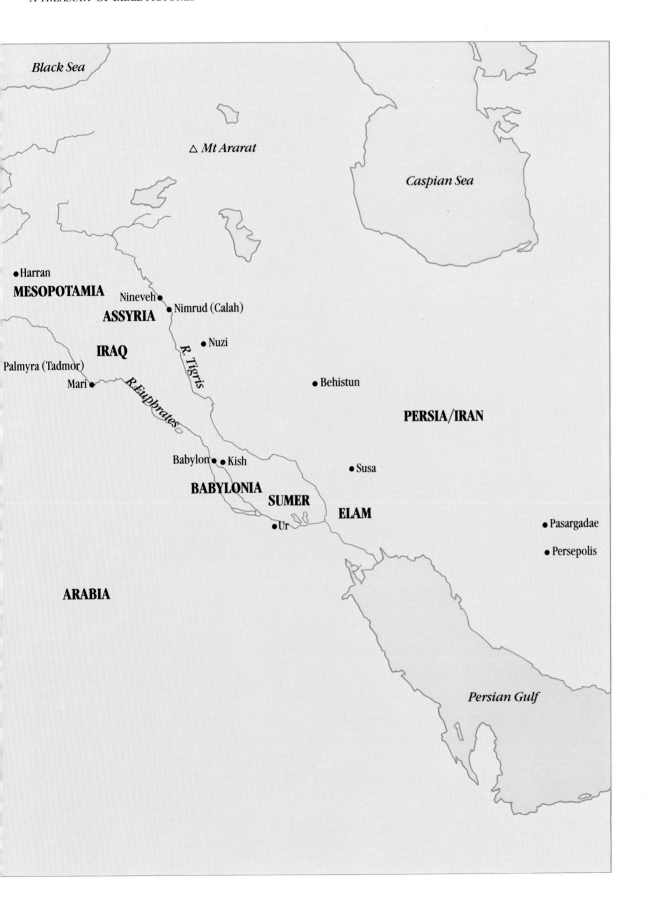

Black Sea

△ Mt Ararat

Caspian Sea

●Harran

MESOPOTAMIA

Nineveh●

●Nimrud (Calah)

ASSYRIA

●Nuzi

IRAQ

R. Tigris

Palmyra (Tadmor)

Mari ●

R. Euphrates

●Behistun

PERSIA/IRAN

Babylon● ●Kish

●Susa

BABYLONIA

SUMER

ELAM

●Pasargadae

●Ur

●Persepolis

ARABIA

Persian Gulf

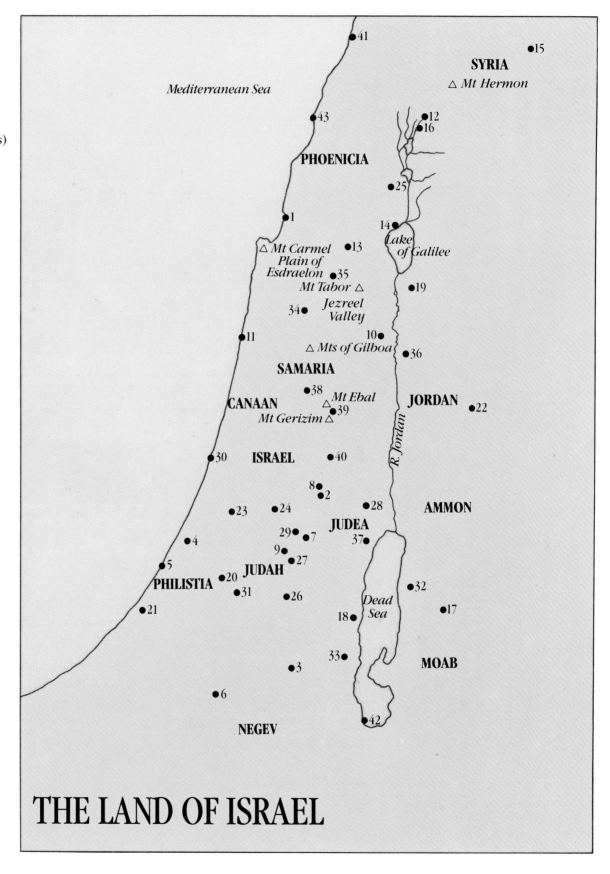

THE LAND OF ISRAEL

BEGINNINGS

— to Abraham and the Patriarchs

The pictures in this gallery cover a period from about 2,500 BC to about 1800 BC, and form a background to Genesis, the first book of the Bible.

Genesis begins with God's creation of the universe and of the human race. The setting is the great Near Eastern cradle of civilization in the basin of the Tigris and Euphrates rivers in ancient Mesopotamia (present-day Iraq).

A world that was wholly good is quickly spoiled by human disobedience and rebellion. The Flood is seen as God's judgement and the opportunity for a new beginning.

The Genesis accounts of the creation and the Flood find parallels in several stories which have come down to us from the ancient world, especially from Mesopotamia. The similarities and the differences are significant.

The Noah story ends among the mountains of Ararat. In Genesis chapter 11 the scene shifts south again to Babylonia and the great tower of Babel (Babylon). From the city of Ur in southern Babylonia (modern Iraq) God called the family of Abraham, who would be the founder of a new nation. Excavation at Ur has revealed a sophisticated civilization, rich in art and the craftsmen's skills. The contrast between Abraham's old life and the new was extreme. City life was exchanged for a semi-nomadic existence, determined by the constant need for fresh pasture for the flocks. Obedient to God's call, Abraham moved first to Harran, then across mountain and desert to Canaan (modern Israel), the land God had promised to give to him and his descendants. It is here that the gallery closes, with pictures of Beersheba and Hebron and the rock of sacrifice, where Abraham's faith and obedience to God survived the ultimate test.

1.1
The early chapters of Genesis, the first book of the Bible, unfold the drama of the creation of the world, the disobedience of mankind and God's judgement in the Flood, followed by a new beginning. The setting is the cradle of civilization in the region of the Tigris and Euphrates rivers.

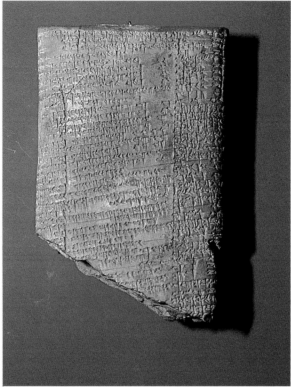

1.2*
Remarkably, the biblical account has parallels not only from the Near East but in legends all over the world. The Genesis account has much in common with other Near Eastern stories, but also equally strong differences. This clay tablet, dating from the seventh-sixth centuries BC, records a story of creation by a god and goddess in the Sumerian and Babylonian languages.

1.3
In southern Iraq the Marsh Arabs continue an ancient way of life. Their houses, woven from reeds, stand on low islands in water rich with fish and wild birds. The danger of flooding is ever-present.

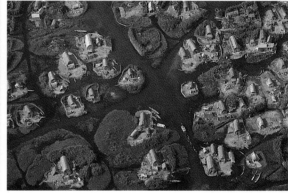

1.5
Cattle graze in the shadow of snow-capped Mount Ararat and Little Ararat, on the eastern border of Turkey. It was among the mountains of Ararat, the Bible says (Genesis chapter 8), that Noah, his family and all the creatures aboard the ark came to ground when the waters receded after the great Flood.

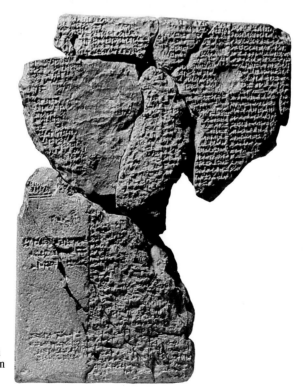

1.4
The Babylonians knew a story about the flood and copied it on clay tablets. This one was written by a pupil-scribe about 1635 BC.

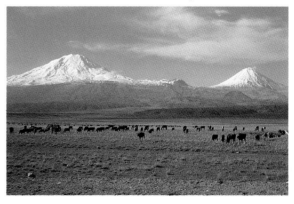

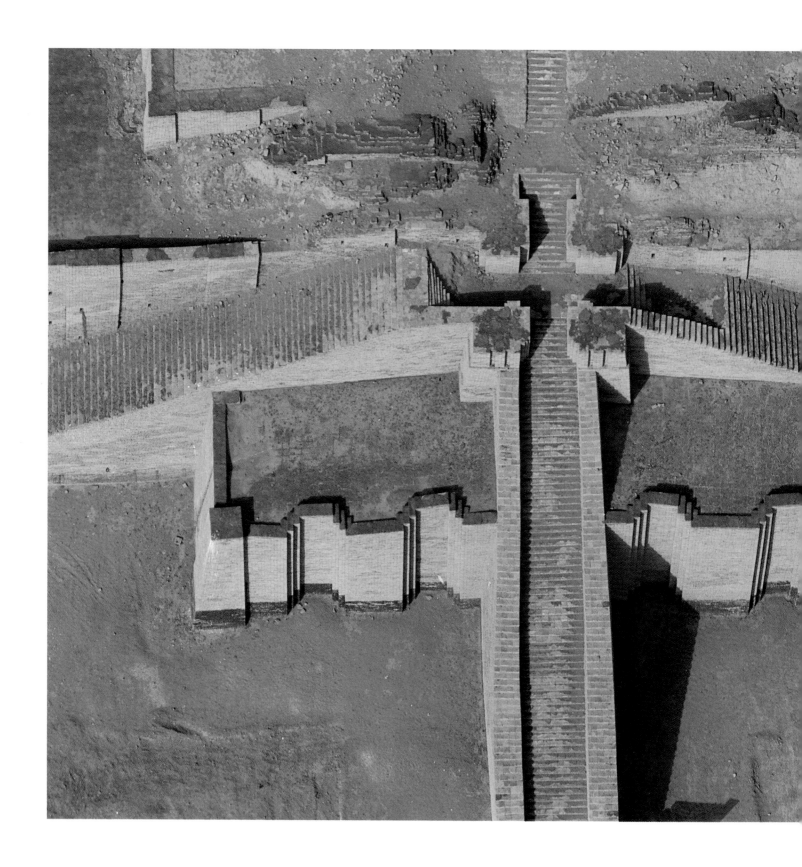

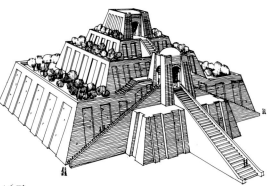

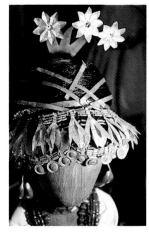

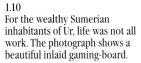

1.9
This golden headdress from the royal graves once belonged to a lady in waiting of a queen of Ur.

1.6,7*
The Tower of Babel (Genesis chapter 11) may have been constructed in a similar way to the temple tower at Ur, shown in a reconstruction (above). Built of brick, it was a huge, terraced structure 60 meters/200 feet long, 45 meters/150 feet wide and about 21 meters/70 feet high. The aerial photograph (left) shows the central stairway leading up to the temple of the moon-god Nannar, which stood on top.

1.10
For the wealthy Sumerian inhabitants of Ur, life was not all work. The photograph shows a beautiful inlaid gaming-board.

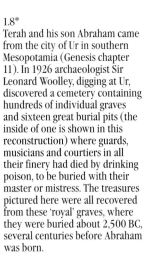

1.8*
Terah and his son Abraham came from the city of Ur in southern Mesopotamia (Genesis chapter 11). In 1926 archaeologist Sir Leonard Woolley, digging at Ur, discovered a cemetery containing hundreds of individual graves and sixteen great burial pits (the inside of one is shown in this reconstruction) where guards, musicians and courtiers in all their finery had died by drinking poison, to be buried with their master or mistress. The treasures pictured here were all recovered from these 'royal' graves, where they were buried about 2,500 BC, several centuries before Abraham was born.

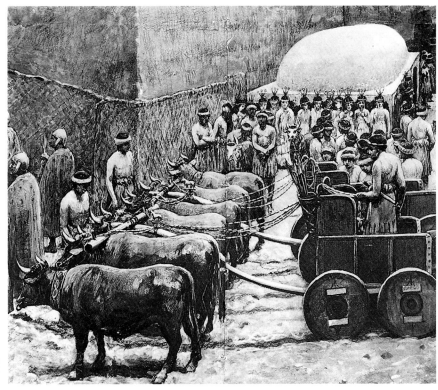

1.11*
The gold bull's head once
decorated a lyre. Before the time
of Abraham, Ur was a great city
in which the arts flourished.

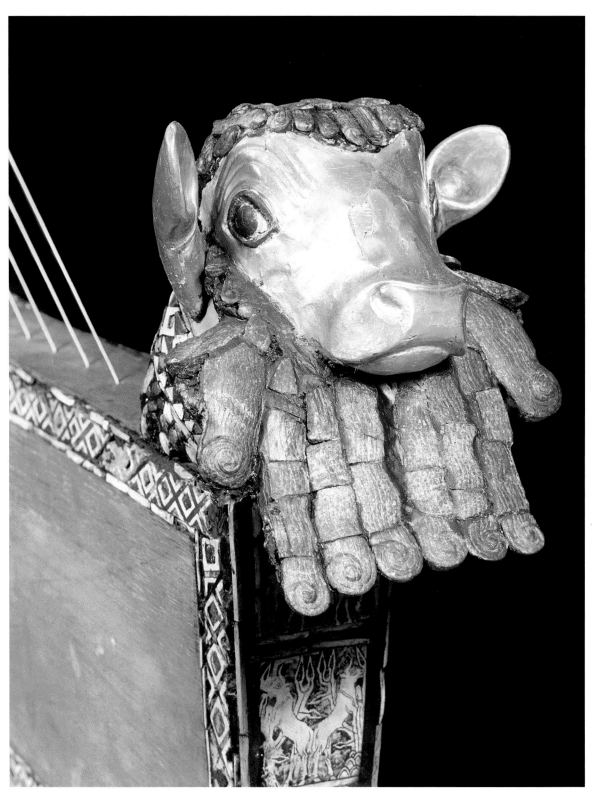

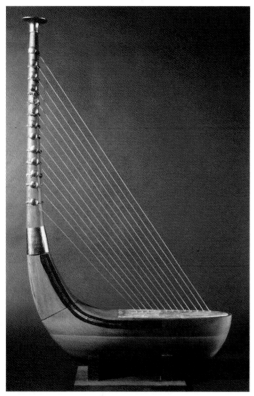

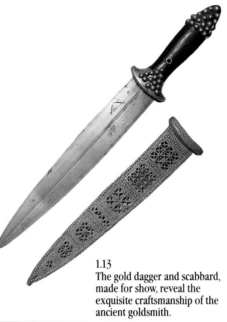

1.12
A second, smaller lyre from Ur is shown here in reconstruction.

1.13
The gold dagger and scabbard, made for show, reveal the exquisite craftsmanship of the ancient goldsmith.

1.14*
This mosaic of shell, red limestone and blue lapis lazuli from the royal graves shows, on one side, scenes of war and on the other (pictured below) a parade of booty and the victory feast which followed.

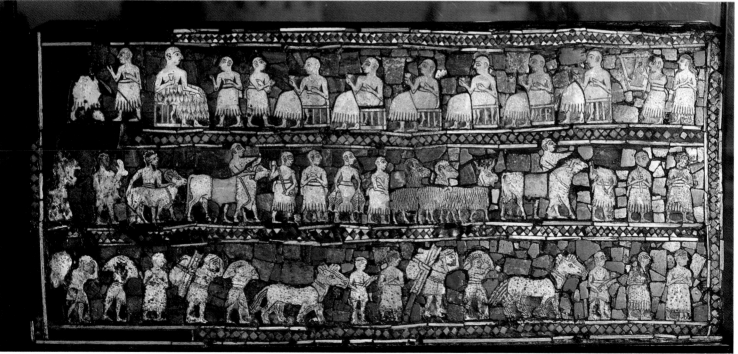

1.15,16*
How would Abraham and his
family have dressed? Close to
Abraham's time is the brilliant
wall-painting of a group of
Asiatics which decorates the
tomb of Khnumhotep at Beni
Hasan in Egypt (about 1900 BC).

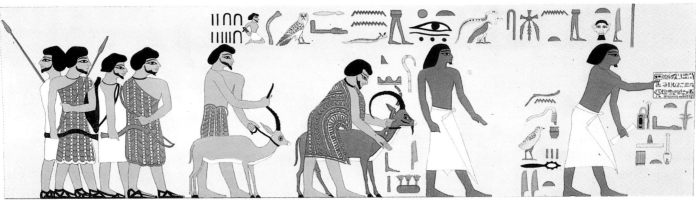

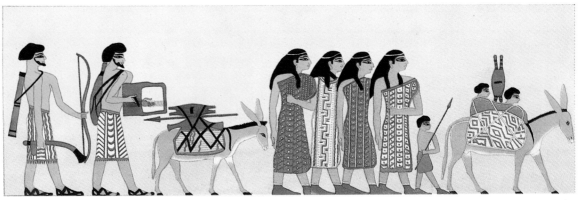

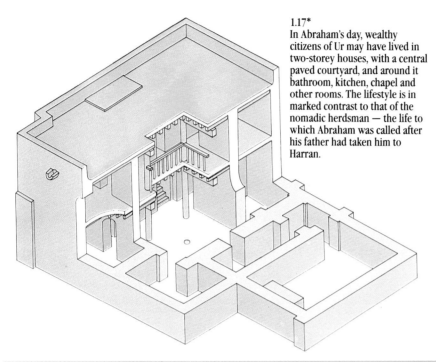

1.17*
In Abraham's day, wealthy citizens of Ur may have lived in two-storey houses, with a central paved courtyard, and around it bathroom, kitchen, chapel and other rooms. The lifestyle is in marked contrast to that of the nomadic herdsman — the life to which Abraham was called after his father had taken him to Harran.

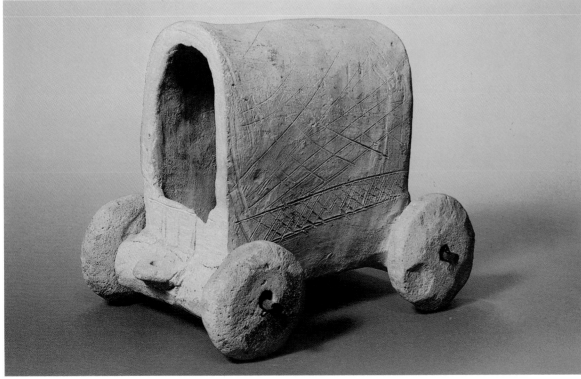

1.18
Most travel overland in early times was on foot or by camel or donkey. But there were also covered wagons made of wood, which do not survive. This pottery model from Hammam in Syria (about 2,200 BC) shows what they looked like. The Patriarchs may have used similar wagons.

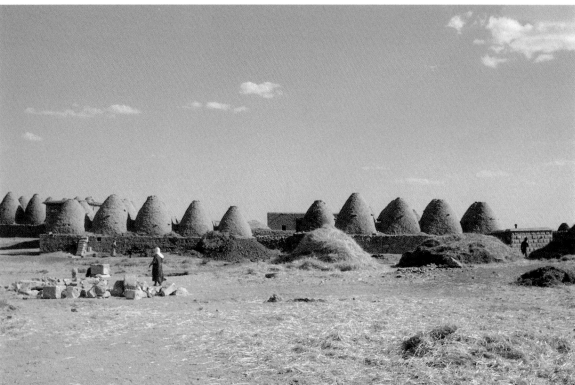

1.19
Abraham's father, Terah, took his family to Harran, on the way to Canaan. There he died, and Abraham received God's call: 'Leave your country, your people and your father's household and go to the land I will show you. I will make you into a great nation.' Today villagers of southern Turkey live near Harran in these traditional 'bee-hive' houses.

1.20*
The encampment of Abraham and his family as they travelled to Canaan must have been much like that of the modern nomadic Bedouin, seen here from the air.

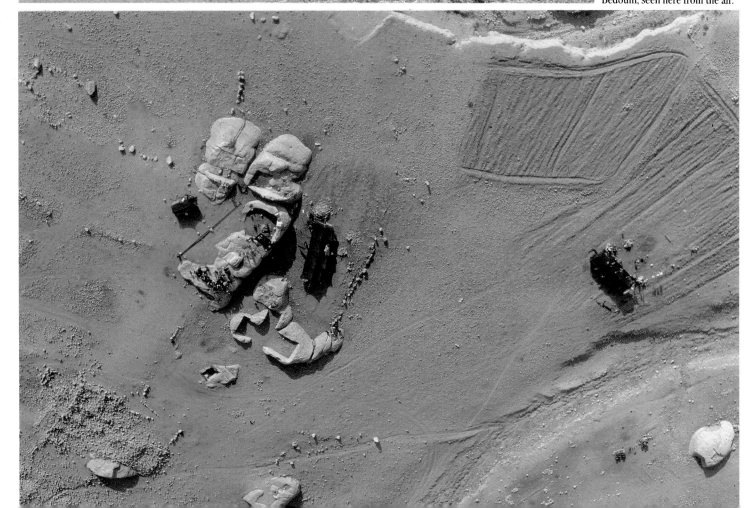

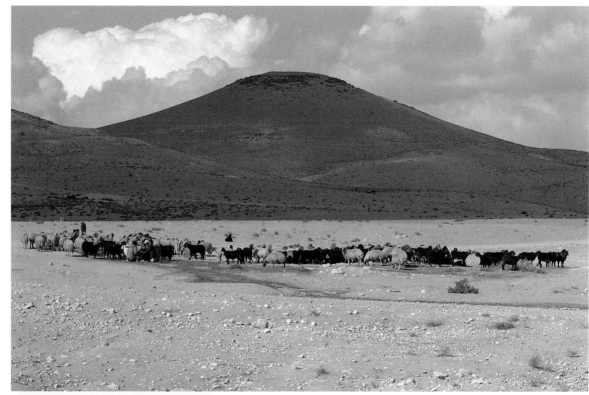

1.21*
Like all such nomads, Abraham was dependent on his flocks of sheep and goats, frequently moving on in search of fresh pasture.

1.22*
Abraham found the land of Canaan already populated. He journeyed south to Beersheba, on the edge of the Negev wilderness/desert, where there was water in an arid region.

1.23,24*
Abraham and his nephew, Lot, split company when their flocks grew too numerous for the available supplies of water (Genesis chapter 13). Lot chose the green and tempting Jordan Valley, but the settlement at Sodom where he stayed was rife with evil and ripe for judgement. When the cataclysm took place (Genesis chapter 19), God enabled Lot's family to escape —

all except Lot's wife who lingered and was engulfed by the rain of burning sulphur. This column of salt at the southern end of the Dead Sea, whose shallow waters now cover the cities, is named after her.

1.25*
The time of the Patriarchs was no peaceful pastoral idyll. The kings of small city-states were often at war with one another. On one occasion Abraham had to rescue Lot, who was taken prisoner when an alliance of five kings raided the territory of Sodom and nearby kingdoms. A tomb-painting at Beni Hasan in Egypt, about 1950 BC, shows Semites during the Patriarchal Age, armed with axe, spears and clubs.

1.27*
These houses are in Hebron, the place where Abraham settled in the land of Canaan. Here Sarah died and Abraham bought a plot of land for family burial. It was the only part of the land he ever possessed. 'By faith he made his home in the promised land like a stranger in a foreign country; he lived in tents, as did Isaac and Jacob, who were heirs with him of the same promise' (Hebrews chapter 11).

1.26*
After long years of waiting, God's promise of a son for Abraham and Sarah was realized. They could look forward now to the 'great nation' God had promised would spring from Abraham's descendants. Then came the test (Genesis chapter 22): the order to go to the mountains of Moriah and to offer Isaac as a sacrifice to God. Abraham's faith did not waver. He obeyed God and Isaac was spared. The place of testing is said to be this rocky outcrop, which became the site of the Temple, now covered by the 'Dome of the Rock', in the city of Jerusalem.

SLAVERY AND FREEDOM

Egypt and the Exodus

In ancient times drought and famine were all too common a feature of life in Near Eastern lands. But while others starved Egypt survived, preserved by the River Nile. Famine had driven Abraham south to Egypt, but only briefly. It was to have a much more drastic effect on the family of his grandson Jacob. It is at this point, when the focus of biblical events shifts to Egypt, that Gallery Two opens. The date is about 1700 BC.

Jacob's youngest-but-one son Joseph was sold into slavery by his jealous brothers and taken to Egypt. His story is recorded in Genesis chapters 37-50. After rising to high position in the household of one of the Pharaoh's officials, he was falsely accused and thrown into prison. It was his God-given ability to interpret dreams, something on which the Egyptians set great store, which eventually set him free and brought him into Pharaoh's favour. Joseph had predicted seven years of plenty followed by seven years of drought, so he was put in charge of the nation's grainstores.

The ancient Egyptians had a highly-developed philosophy of the after-life. Those who survived the judgement could look forward to a pleasant life in the next world and were therefore provided at the time of burial with many of the things they might need. The tomb-walls of the rich were also often painted with scenes from daily life. In the dark, they have kept their clarity and colour through 3,000 years. It is these objects and paintings which survive to show us what life was like, how people lived and dressed, in the time of Joseph and his descendants.

Joseph's family came to Egypt during the great famine he had predicted. They settled in the region of Goshen in the Nile Delta. And they stayed. Joseph died, his descendants multiplied, and a new king came to the throne of Egypt. This is where the Bible book of Exodus begins. Fearing the power of this foreign tribe close to the border, Pharaoh enslaved the Israelites, putting them to work in the brickfields which supplied his new building enterprises. Moses was born in this setting, around 1300 BC. The young Pharaoh Tutankhamun had died about 1350 BC. The pyramids had already stood for 1,000 years.

Partly because of the new cities and temples he built, many people think that Pharaoh Ramesses II was most likely the pharaoh of the exodus — Israel's deliverance from Egypt under the leadership of Moses.

Gallery Two closes with the people of Israel in the 'wilderness' of the Sinai peninsula. It was a formative experience which went deep into their consciousness as the 'people of God'. Here they received God's law, the Torah, and God's presence in their midst was given visible form in the tent-shrine known as the tabernacle.

2.1*
Egypt has been linked with the story of God's people from earliest times. Famine drove Abraham south across the Negev and Sinai peninsula to the granary of fertile Egypt, made prosperous by the River Nile. The satellite picture shows the eastern Mediterranean coast, the Negev, Sinai and the Nile Valley and Delta, with a series of lakes and marshes running south to the Red Sea.

Key to the colours: water shows blue-black or light blue; luxuriant vegetation — bright red; heathlands — red-brown; sand-dunes — yellow; towns and ploughed fields — blue-grey.

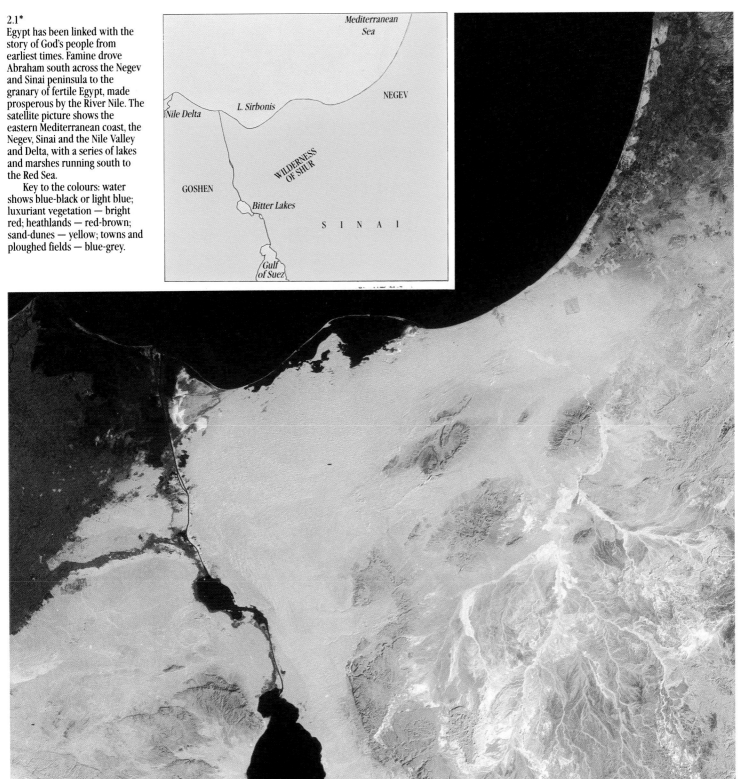

2.2
The Nile has always been the
great highway of Egypt,
providing an easy means of
transport. From ancient times
until the recent construction of
the High Dam at Aswan, the
annual spring flood, which
spread fertile silt to make a wide
strip of cultivable land on either
bank, has been crucial to the
survival and prosperity of Egypt.
The balance was a delicate one:
too high or too low a flood could
spell disaster.

2.4*
The great columns in the pillared
hall of the Temple of Amun at
Karnak (thirteenth century BC)
stand witness to the might of
ancient Egypt, the greatness of its
civilization and the important
status accorded to religion.

2.3
Life in this Egyptian village
follows a pattern as old as time.
The tall palms are evidence of
that vital commodity for any
settlement: water. (They also
provide dates to eat; stones
which can be ground for cattle
food; leaves to make thatch or
mats, and bark which can be
made into rope.) There is clay,
too, for a flourishing pottery.

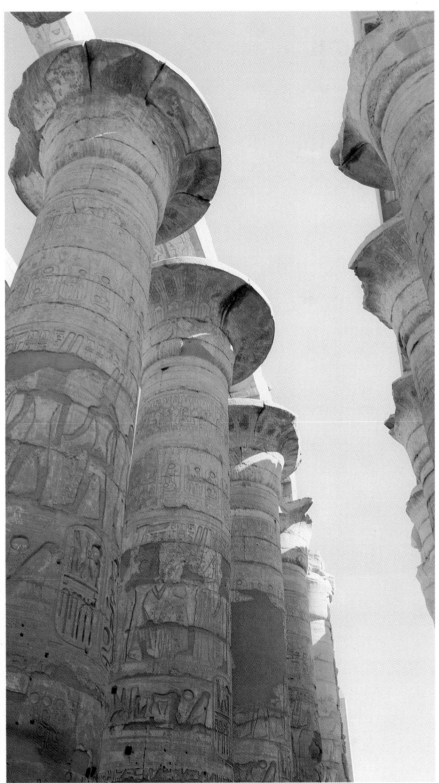

2.5*
As famine had driven Abraham to Egypt so famine drove many, in the years that followed, to make the same journey in search of food. The excavation of a Canaanite mortuary temple at Tell el Dab'a in Goshen has produced evidence of Semitic occupation in the Nile Delta during the time of the Patriarchs, about 1650 BC.

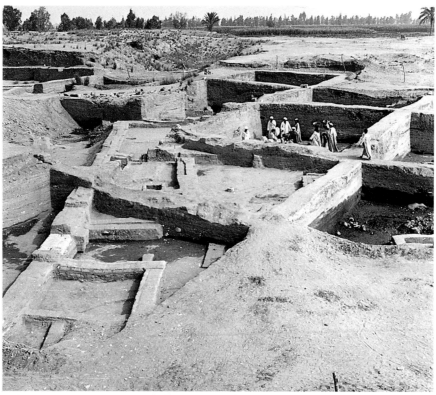

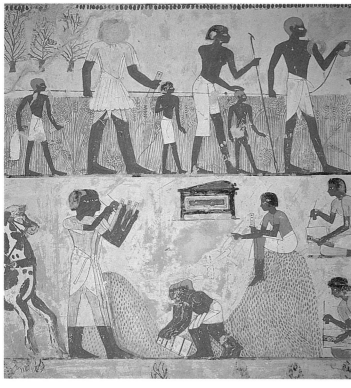

2.6,7*
Sold into slavery by his brothers, Joseph rose to high position as the Pharaoh's second-in-command, after his successful interpretation of the king's dream. (The ancient Egyptians set great store by dreams and wrote whole manuals on how to interpret them.) A seven-year glut would be followed by seven years of famine. Who better than Joseph, then, to supervise the storage of grain and ensure that when the lean years came there would be no shortage? The painting (left) from the tomb of Menna at Thebes shows clerks and overseers measuring and recording the grain harvest (1567-1320 BC). The relief shows a starving man.

2.9*
Ancient Egyptian religion developed a very clear concept of life after death. The body was seen as a home for the soul. At death it was preserved by mummification. The soul needed its personal belongings in a life after death rather like the previous earthly one. So belongings were buried with the body. And, in the case of kings and wealthy people, tombs were often painted with vivid scenes from daily life. This wall-painting from the tomb of Ramose at Thebes shows women wailing at his burial.

2.8
The wooden statuette of an Egyptian high official wearing wig and linen kilt (about 1400 BC) gives an idea of how Joseph may have dressed as Pharaoh's appointed governor.

2.10*
A painting from the tomb of Sebekhotep at Thebes, about 1420 BC, shows tribute being brought by Semitic envoys. This is well into the period when Joseph's family had settled in Egypt.

2.11,12
The ancient Egyptians hoped for a pleasant after-life in the kingdom of Osiris. But first came the weighing up of the person's earthly life. These two photographs show extracts from a copy of the *Book of the Dead*, written on papyrus about 1300 BC. A guide to help equip the dead for life in the next world, it contains a collection of magical spells to help them pass the judgement. The scenes show an agricultural sequence — harvesting flax, harvesting wheat and ploughing. Hunefer, for whom the papyrus was written, stands before the god Ra. His picture (below) provides an example of the dress of wealthy Egyptians at that time.

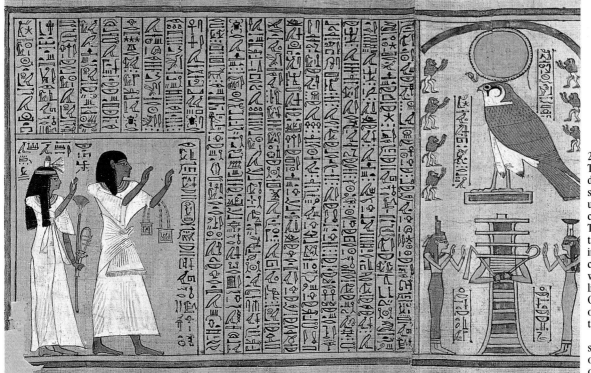

2.13
The most exciting archaeological discovery of this century must surely be Howard Carter's uncovering in 1922 of the burial chamber of Pharaoh Tutankhamun, with its fabulous treasures. The young king ruled in Egypt in the mid-fourteenth century BC, the period during which Joseph's descendants were living in the Delta area of Goshen. Four gold-plated shrines, one inside the other, protected the body of the king.

The photograph (right) shows the guardian figure carved on the inside of the door of one of them.

2.14*
This marvellous necklace and
pendant of scarabs belonged to
King Tutankhamun. It is one of
the rich treasures of ancient
Egypt, where artists and
craftsmen flourished.

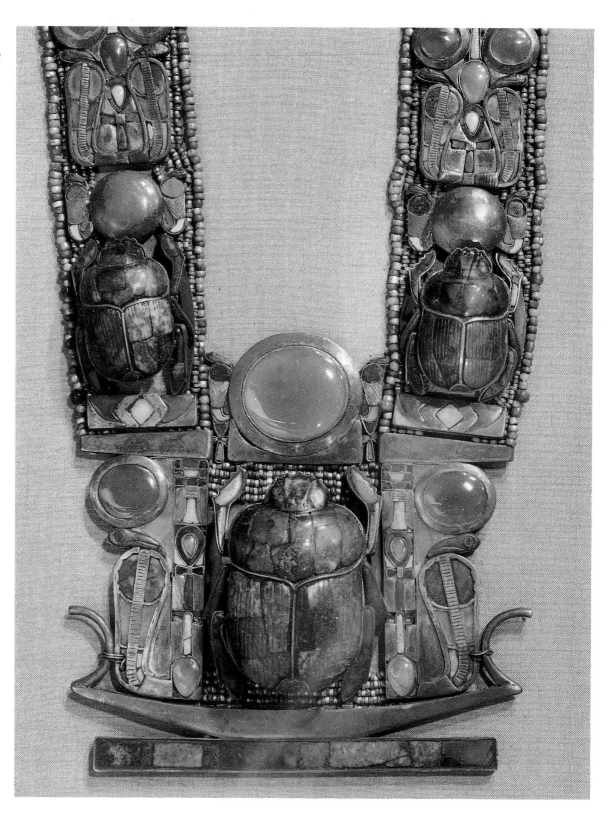

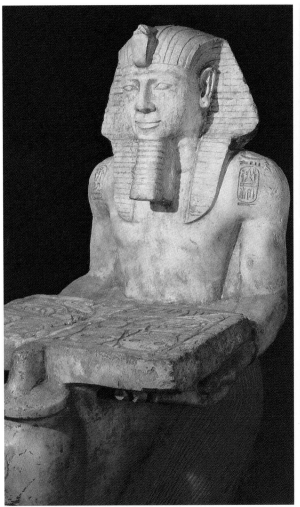

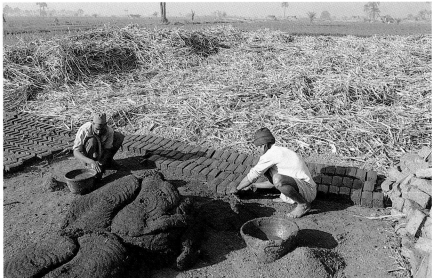

2.15
Joseph and all his generation
died. The Israelites multiplied.
'Then a new king, who did not
know about Joseph, came to
power in Egypt.' The Israelites
were now sufficiently numerous
to pose a threat. They lived close
to Egypt's border and might side
with an enemy. So harsh
restraints were imposed: Israel's
period of slavery had begun.
Because of his great building
works, among other things, many
believe that the 'new king' was
Pharaoh Ramesses II (about
1279-1213 BC) — shown here
holding an offering table — or his
father Seti I.

2.16,17
Slave-masters forced the
Israelites to make bricks for
Ramesses' new cities (Exodus
chapter 1). The bricks were
moulded from clay and straw,
and baked by the hot sun. The
two pictures show the age-old
process — as depicted on a tomb-
wall in ancient Egypt, and as it
can be seen near Cairo today.

2.19
The king stamped his image on all his great building works: he even had his name stamped on the bricks that were used.

2.18
From the site of Pi-Ramesse (Rameses), one of the Pharaoh's new Delta region store-cities (Exodus chapter 1), comes the base of a colossal statue of Ramesses II.

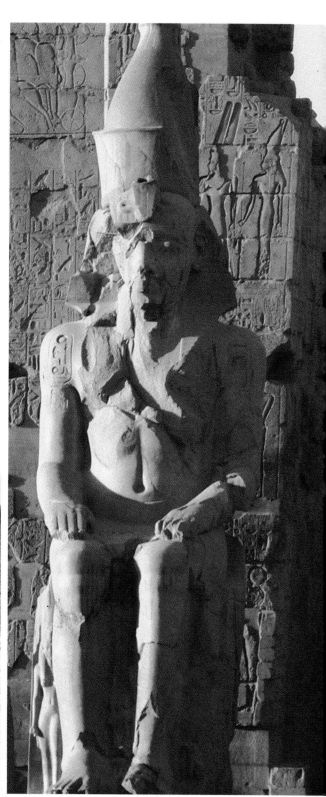

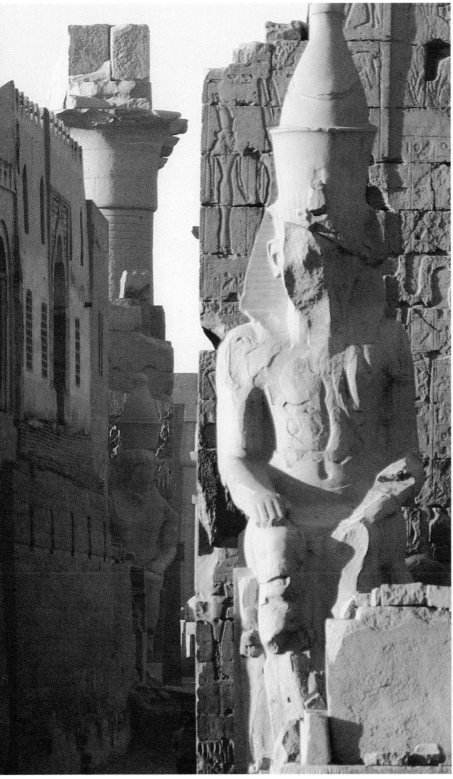

2.20
Two immense statues of
Ramesses II stand at the entrance
to the temple in Luxor. Was this
the man Moses and Aaron had to
confront in their bid for the
nation's freedom?

2.21
After the terrible devastation of
the ten plagues, the Egyptians
were only too glad to be rid of
the Israelites. Moses instructed
the people to ask for articles of
silver and gold, and for clothing.
The Egyptians gave them what
they asked for (Exodus chapter
12). Jewellery like this may have
provided the gold for furnishing
God's tent (the tabernacle) — or
been melted down to make the
golden bull-calf.

2.22
No sooner had Pharaoh let the
people go than he regretted it. He
had his chariot made ready and
set out in pursuit with his army.
But by God's intervention the
Israelites safely crossed the area
of lakes and marshes to the Sinai
peninsula. Despite superior speed
and power, the Egyptian army
was lost. A typical Egyptian war-
chariot is carved on this
limestone block from the Temple
of Seth at Abydos.

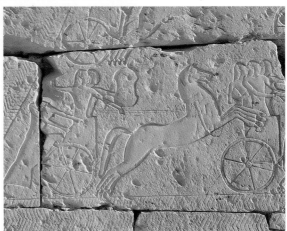

2.23
From the lush and fruitful Delta
of Egypt the Israelites made their
way towards the Promised Land
via the mountains of Sinai. They
did not take the shorter coast
road through Philistine country,
where they would have faced
Egyptian garrisons. 'God led the
people around by the desert
road' (Exodus chapter 13).
 Mount Sinai itself is most
usually identified as Jebel Musa.
Here God made the great
covenant-agreement with his
people, giving them the laws he
required them to live by (Exodus
chapters 19, 20).

2.25*
This black stone pillar, 2.5 meters/7 feet 5ins high, records the laws of King Hammurabi of Babylon, about 1792-1750 BC — the time of the Patriarchs. This famous law-code is often compared with the laws of Moses. There are notable similarities, but equally notable differences.

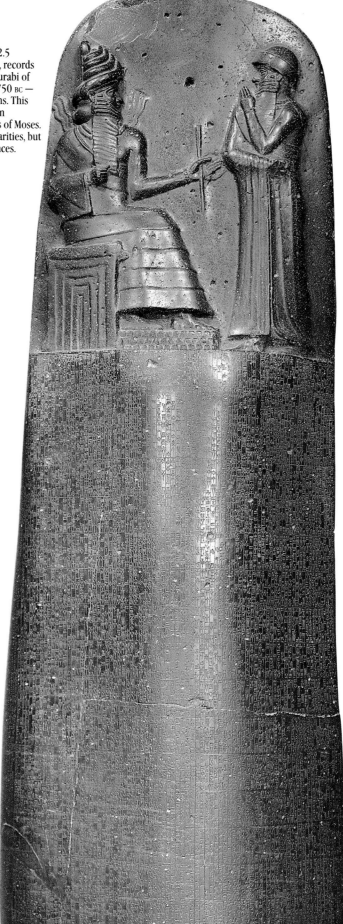

2.24*
God's covenant with Israel at Sinai, recorded in Exodus and Deuteronomy, is strikingly similar in pattern to the international treaties of the time: historical prologue, stipulations, document clause, blessings and curses. The picture shows one such covenant treaty, written in north Syria in cuneiform on a clay tablet, about 1480 BC.

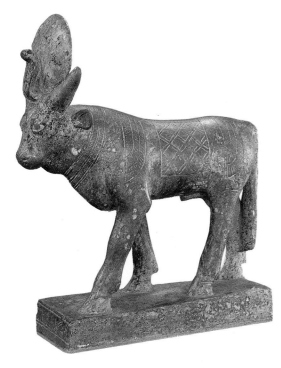

2.26*
Tired of waiting for Moses to
bring them God's instructions,
the Israelites cast their minds
back to Egypt. They persuaded
Aaron to make them a bull-calf to
worship, giving him their gold
ear-rings to melt down. In Egypt
the bull-calf was a symbol of
fertility in nature and of physical
strength. This bronze bull-calf of
Memphis, representing the god
Apis, dates from the fourth
century BC.

2.27
God's people learned hard
lessons during their desert
wanderings, where the harsh
physical conditions underlined
their dependence on God for
even the basic necessities of life.

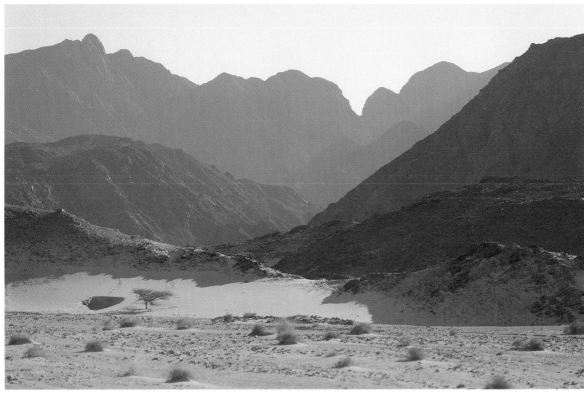

2.28*

The artist's drawing represents Israel's portable tent-shrine, the tabernacle, and its furnishings as described in Exodus chapter 26. This was God's tent, set up in the middle of the Israelite encampment. The basic wooden frame had embroidered inner, and weatherproof outer, coverings.

Inside were two rooms. The inner one held the sacred box, the 'ark of the covenant', which contained the tablets on which God's laws were inscribed. In the outer room was an altar for burning incense, a seven-branched candlestick to give light, and a table on which twelve loaves were placed each Sabbath.

In the open enclosure surrounding the tent was a great basin of water for washing and the altar for burnt offerings.

2.30

The tabernacle had two altars: one for sacrifice, one for incense. Hewn limestone altars from about the time of the conquest have been found at Megiddo. This one, with a horn at each corner, was probably an incense altar (the largest is about 70 cms/27 ins high). Altars for sacrifice are also known, both from the Promised Land and more widely in the ancient Near East.

2.29*

The covenant laws were written down and kept in a sacred box (the ark of the covenant) made of wood and covered with gold. It was placed in the innermost part of the tent of God. A wooden box with rings and carrying poles, found in the tomb of King Tutankhamun of Egypt, illustrates the Bible's description of the ark in Exodus chapter 25.

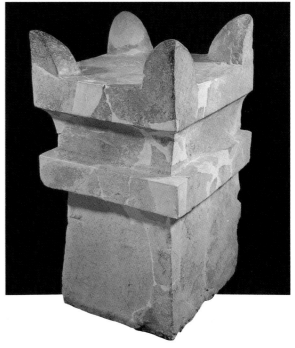

THE PROMISED LAND

Joshua and the Judges

Because of their disobedience and lack of trust in God the people of Israel were condemned to spend forty years in the Sinai peninsula and Transjordan, moving camp from place to place. Even Moses forfeited his right to enter the promised land. He could only view it from the nearby hills. The task of conquest fell to Joshua, Moses' successor.

Gallery Three opens with the people on the far side of the River Jordan, opposite Jericho — the first stronghold they must take, if they are to make the land of Canaan their own and realize God's promise. The date is about 1230 BC. The biblical account of events is recorded in the Old Testament books of Joshua and Judges.

The gallery focusses on Jericho, one of the world's most ancient cities, occupied from before 6,000 BC; the Canaanite occupants of the land; and, in a sequence of pictures, the areas allotted to each of the twelve family-tribes of Israel, the descendants of Jacob's (Israel's) twelve sons. The closing scenes concentrate on the Philistines, one of the Sea Peoples who came from Crete and Cyprus and Greece to settle the eastern Mediterranean coastlands in the thirteenth century BC. These people gave the Israelites increasing trouble through the time of the Judges and on into the days of Israel's first kings.

At the time of the conquest the name 'Canaanite' covers a mixture of peoples grouped into small city-states, each with its own king. Their inter-tribal quarrels must have made Joshua's task easier than it might otherwise have been. They shared a language very similar to, if not the same as, Hebrew. And their life as farmers was not so very different from that of the Israelites during their time in Egypt. The temptation for the Israelites, once the initial thrust was over, was simply to settle in alongside. But Canaanite religion was worlds away from Israel's clear moral laws and worship of the one God. God's command was to destroy everything connected with it. Where this did not happen it posed a real threat to the new nation and seriously undermined its strength, as the stories in the book of Judges clearly indicate.

The physical evidence for the Israelite invasion of Canaan in the thirteenth century BC is sometimes disputed. On many sites there is evidence of destruction by fire at this time but, naturally, no indisputable proof that this was the work of Israelite rather than any other invaders. But the picture of attacks, sometimes on several Canaanite cities at once, over intervals of a number of years fits with the biblical descriptions in Joshua and Judges.

3.1
After the escape from Egypt and
forty years of desert wandering
the Israelites were about to enter
the Promised Land. From the
foothills of Moab the view
extends beyond the Dead Sea to
the Judean hills.

3.4*
This aerial view of the Jordan Valley, taken near Jericho, shows the river as a significant barrier to the advancing Israelites. They approached the crossing with the river in spate, swollen by melting snows. Joshua needed to be 'strong and courageous' as the people's leader.

3.2,3*
From the Sinai Desert, the Israelites moved up the eastern side of the Dead Sea to cross the River Jordan opposite Jericho.

Before Moses died, God showed him the whole of the Promised Land, from Dan in the north (left) to Beersheba in the south. An ancient town stood on the hill to the right. It is now called Tell Beersheba, although there is no proof that it was ancient Beersheba.

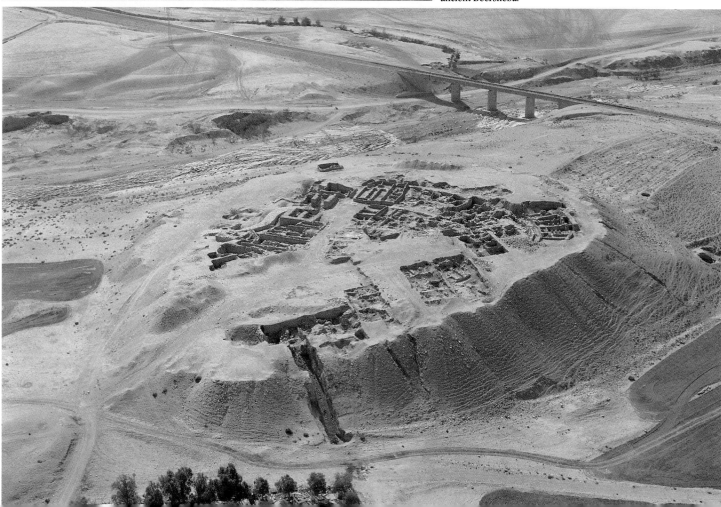

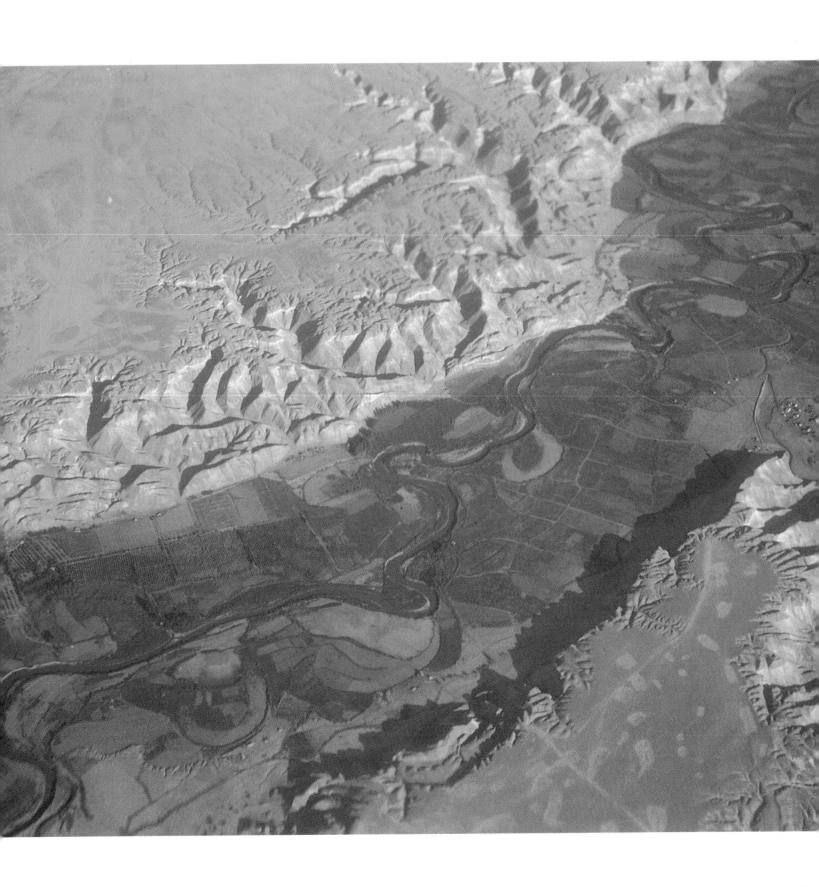

3.5*
Jericho, 'the city of palms', was the first obstacle in the path of the advancing Israelites. Watered by springs, Jericho is an oasis in the surrounding dryness.

3.6*
This aerial view from the north clearly shows the 'tell' (mound) of ancient Jericho. The city is one of the oldest in the world, occupied since before 6,000 BC.

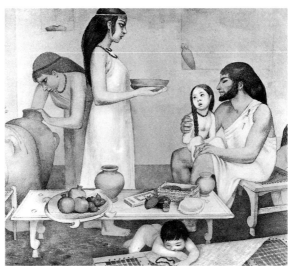

3.7*
This reconstructed room is based on furniture and pottery excavated from tombs of people who lived at Jericho some centuries before Joshua's time.

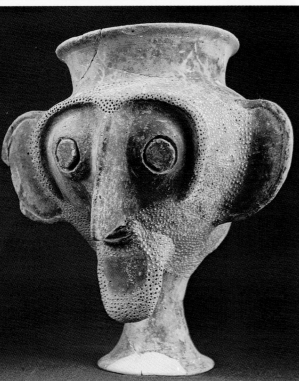

3.8
The vase shaped like a human head comes from Jericho, about 1700 BC.

3.9*
After the fall of Jericho and Ai, Joshua read God's laws to the people and the covenant was renewed. As Moses had instructed (Deuteronomy chapter 37), half the people stood on Mount Gerizim and half on Mount Ebal as the blessings and curses were recited. The view of Mount Gerizim is from the east.

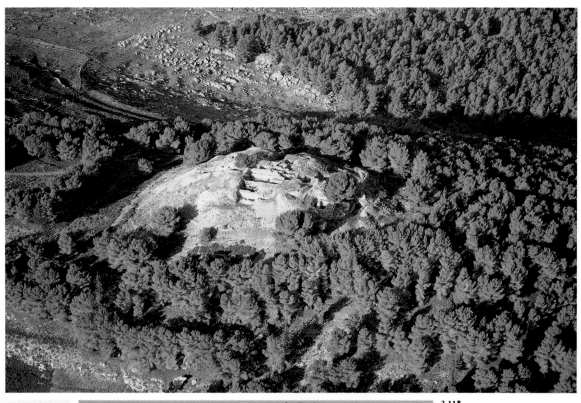

3.10*
At the time of the Israelite invasion, the Canaanites had long been established in fortified city-strongholds throughout the land. They were also well-armed, as these weapons from the fifteenth to thirteenth centuries indicate.

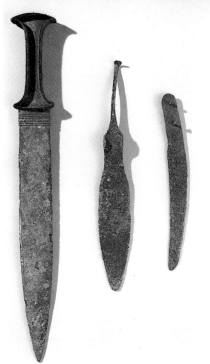

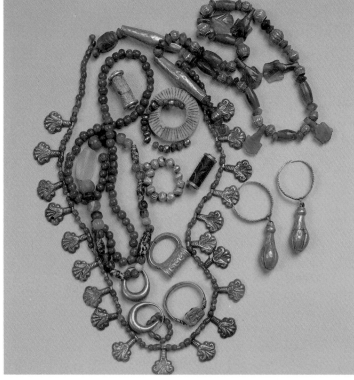

3.11*
Canaanite jewellers were skilled craftsmen, as can be seen in these examples of their art, from tombs at Acco and Deir el-Balah, fourteenth and thirteenth centuries BC.

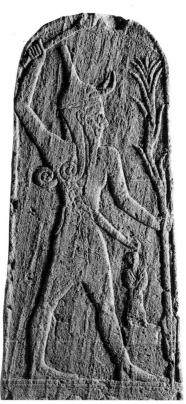

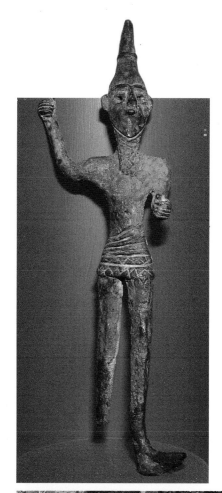

3.12,13*
In contrast to the one-god religion of Israel, the Canaanites worshipped many gods. Most important was Baal (or Hadad, the storm-god). The relief comes from Ras Shamra, in Syria. The god holds a club and staff (or stylized bolt of lightning). The second figure is of copper, overlaid and inlaid with silver and gold.

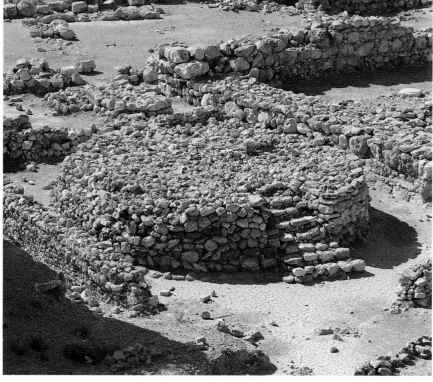

3.14
The Old Testament condemns the 'high places' associated with degenerate Canaanite religion. Shrines were often actually sited on hill-tops and high places, but the term was also used in a wider sense to indicate the sacred places where the rituals of Canaanite worship were carried out. The Canaanite 'high place' pictured here is at Megiddo. It was in use long before the Israelite conquest, in the third millennium BC.

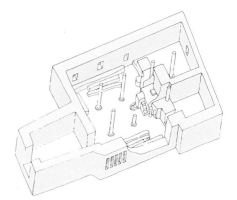

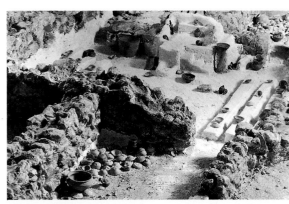

3.15*
Joshua's first campaign was against the kings of Jerusalem, Hebron, Jarmuth, Lachish and Eglon in the south. The city of Lachish with its temple-shrine (shown here in the photograph and reconstruction) was burnt, probably about 1200 BC.

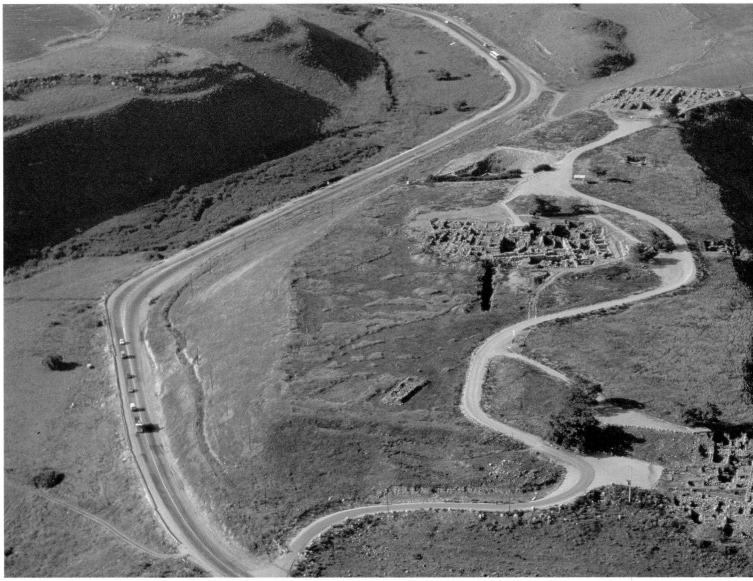

3.16*
After defeating the kings in the south, Joshua faced an alliance in the north led by the king of Hazor, the stronghold seen here from the air.

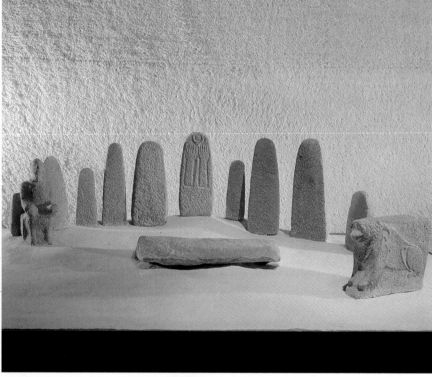

3.17*
At Hazor, archaeologist Yigael Yadin unearthed a Canaanite shrine. The central standing stone is carved with symbols thought to represent the moon-god and his wife. Temples in use during the late Bronze Age (about the time of Joshua's invasion) had been violently destroyed.

3.18*
These examples of pottery are also from Hazor, around the time of the Israelite invasion.

3.19
After the main campaigns there
was still much land to be taken.
But the country could be divided
amongst the tribes (family-clans)
of Israel.

The map shows the area
assigned to each tribe.

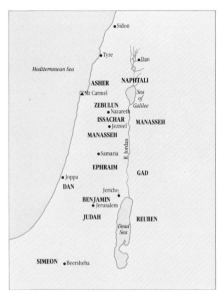

3.20*
To Asher was assigned the coastal
region of Acco, Tyre and Sidon.

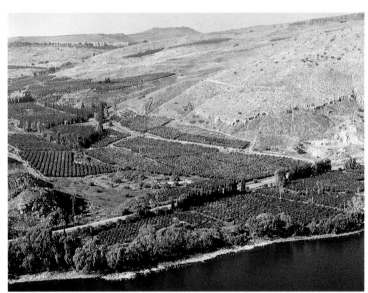

3.21*
Fertile Galilee, with its harp-
shaped lake, and Dan, the
northernmost town in the land,
was given to the tribe of Naphtali.

3.22
Zebulun inherited a hilly area
inland from Mount Carmel, well-
watered by rains carried on the
western winds. Nazareth stood
within its territory.

3.23
The River Jordan, south of Lake
Galilee, formed a natural
boundary: the land to the west
belonged to Issachar; to the east,
to Manasseh.

3.24*
Manasseh had land to the east
and to the west of the River
Jordan, including the Plain of
Esdraelon and Jezreel Valley,
shown here.

3.25
Ephraim's land included the
fruitful hills south of Samaria,
rising to 900 meters/3,000 feet
above sea-level.

3.26
Gad had land east of the Jordan
where there was good pasture
for the cattle.

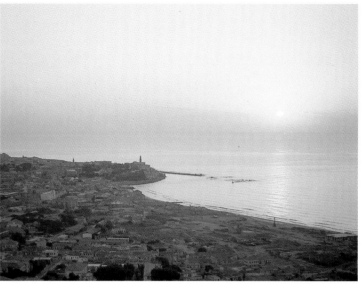

3.27*
Dan received land stretching to
Joppa, on the Mediterranean
coast.

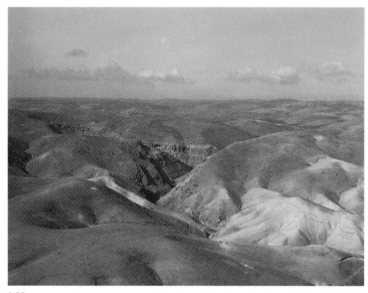

3.28
Benjamin's land included Jericho
and Jerusalem, the barren hills in
between, and the greener hills to
the west.

3.29
Reuben's territory lay to the
north-east of the Dead Sea. Sheep
and goats found pasture there.

3.30
The hill-country south of
Jerusalem was Judah's
inheritance. The western slopes
are suitable for growing grain,
olives and grapes.

3.31
Simeon's land was furthest south,
including Beersheba and
stretching into the semi-desert
region of the Negev.

3.32*

In 1896 a stone slab now known as the 'Israel Stele' was discovered at Thebes in Egypt. The inscription is a hymn ending with a list of Pharaoh Merenptah's conquests, Israel among them: 'Israel is devastated, having no seed . . .' This is the oldest evidence outside the Bible for the existence of Israel, and it firmly places the people in Canaan by 1210 BC.

3.33*

The Israelites failed to complete their conquest of the whole territory allotted to them. Some settled for co-existence with the Canaanite tribes. In the period of the Judges the Israelites suffered a succession of counter-attacks. On the steep slopes of Mount Tabor, seen here, Deborah and Barak's forces gathered to beat back one oppressor, King Jabin of Hazor, with a force of 900 iron chariots.

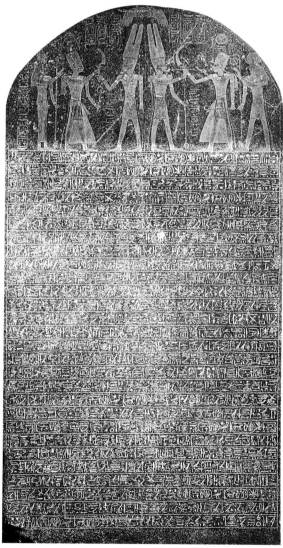

3.34

Gideon, with some reluctance, responded to the challenge of the invading hordes of camel-riding Midianites from the east. Beside the River Harod, obeying God's instructions, he whittled down his army to 300 men — those who lapped water from their hands, while the rest knelt to drink.

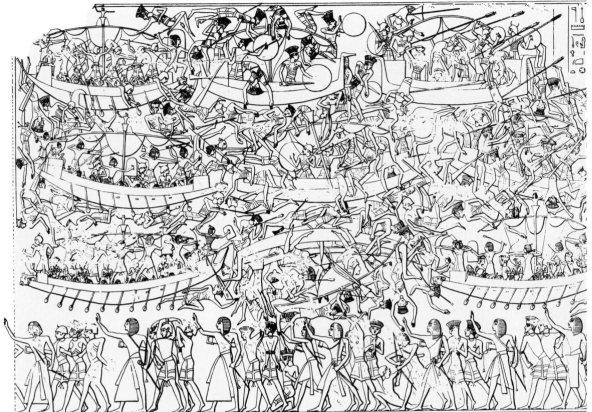

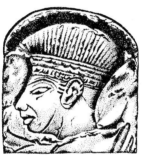

3.35,36*
In the time of the Judges and on into the reign of King David, the Philistines were among Israel's chief enemies. They were the Peleset, one of the 'Sea Peoples' who swept down the Mediterranean coast to invade Egypt itself. Philistine soldiers are pictured in victory sculptures commissioned by Pharaoh Ramesses III (about 1175 BC), wearing kilts and distinctive plumed or feathered helmets. A carving from Thebes shows the headdress in detail.

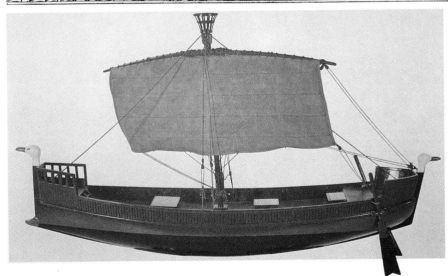

3.37*
The model is of a Philistine warship, from the twelfth century BC.

3.38*
The Philistines settled in five main city strongholds on the coastal plain of Canaan. One of them, Ashkelon, is shown here under attack from Pharaoh Merenptah or his father, Ramesses II.

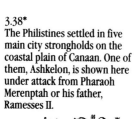

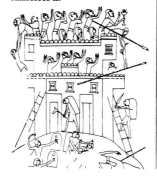

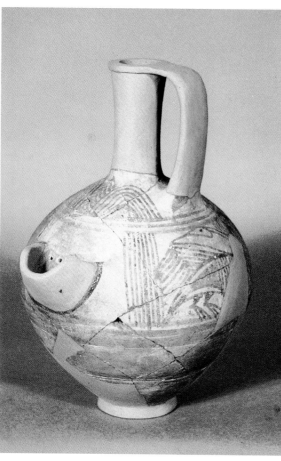

3.39*
Pots with red and black geometric designs and stylized birds, found on the coastal plain occupied by the Philistines, are a local imitation of Mycenaean ware.

A GOLDEN AGE

Israel's first kings: Saul to Solomon

During the time of the Judges the Israelites had been delivered from their oppressors by a series of local champions who, under God, had brought the people back from disobedience to God's laws and the worship of false gods. But the time came, inevitably, when the people clamoured for a king, a national leader like those of the nations around. It was about 1050 BC when the prophet Samuel gave in to the demand and, guided by God, anointed Saul as Israel's first king. The account comes in the first book of Samuel, chapter 8 and on.

Saul proved a good leader and a strong soldier, but he could not handle power and hold true to God as Israel's real King. So the later chapters of Samuel describe how God's choice fell on David, while he was still a boy, minding his father's flocks on the hills around Bethlehem.

Gallery Four focusses on David and his son Solomon, whose reign was a golden age unequalled in Israel's long history. It was David who at last took the Jebusite stronghold of Jerusalem and made it the nation's capital, the holy city of God where first the sacred 'ark' containing God's laws and later the Temple gave the nation a focal point for religious observance.

David's reign was one of constant battles. He established the firm frontiers and alliances which made possible the long peace under Solomon, with leisure and resources to undertake great building-works and pay for the skills of consummate craftsmen.

Although nothing now remains of the glorious cedar-lined, gold-covered Temple described in such loving detail in the first book of Kings chapters 5-8, the decorative styles used by the craftsmen brought in from neighbouring Phoenicia are known from later examples surviving in the palaces of Assyria. Excavation has also revealed the plans of gateways and walls at Hazor, Megiddo and Gezer, cities which King Solomon rebuilt. At Arad, in the south, archaeologists have discovered the remains of an Israelite shrine — an indication that although the Jerusalem Temple was the most important centre of national worship there were also sanctuaries elsewhere, even as early as Solomon's time.

4.1
When the people of Israel asked
for a king, the prophet Samuel
predicted trouble. Saul, the first
king, began well, but power soon
went to his head. While Saul was
still king, God chose David,
youngest of the eight sons of
Jesse, to succeed him. David's
home was the town of
Bethlehem, in the Judean hills.

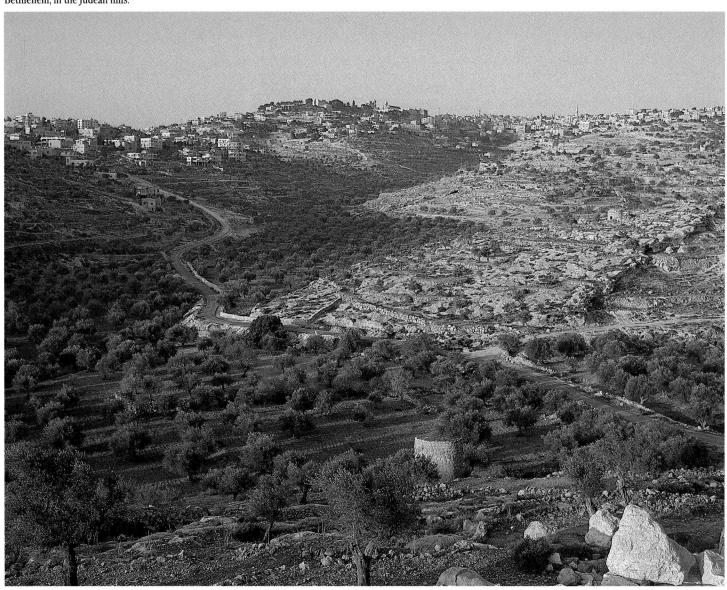

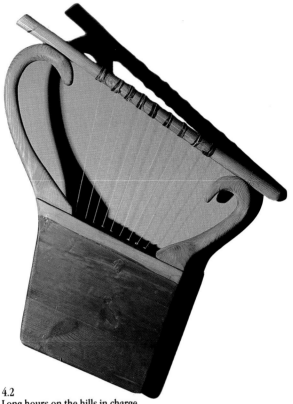

4.2
Long hours on the hills in charge of his father's flocks gave David time to develop his skill on the harp. The model shows the *kinnor*, the type of harp David would have played. His talent as a musician and poet brought him fame as the 'sweet Psalmist of Israel'.

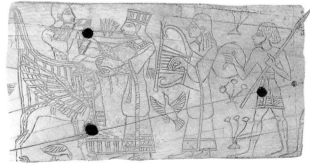

4.3
This Canaanite ivory from Megiddo shows the harp being played.

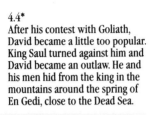

4.4*
After his contest with Goliath, David became a little too popular. King Saul turned against him and David became an outlaw. He and his men hid from the king in the mountains around the spring of En Gedi, close to the Dead Sea.

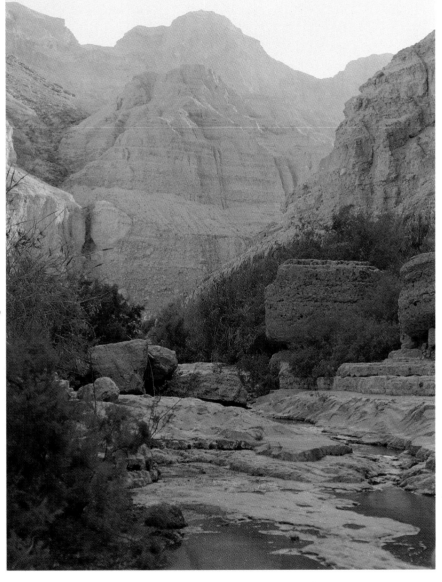

4.5*
Saul and his son Jonathan were killed in battle against the Philistines on the mountains of Gilboa. David grieved for the loss of his friend.

4.6*
The Philistines beheaded the dead King Saul, stripped him of his armour and took the body to the town of Beth-shan, where they fastened it to the wall (1 Samuel chapter 31). The aerial view shows the impressive mound of the ancient city.

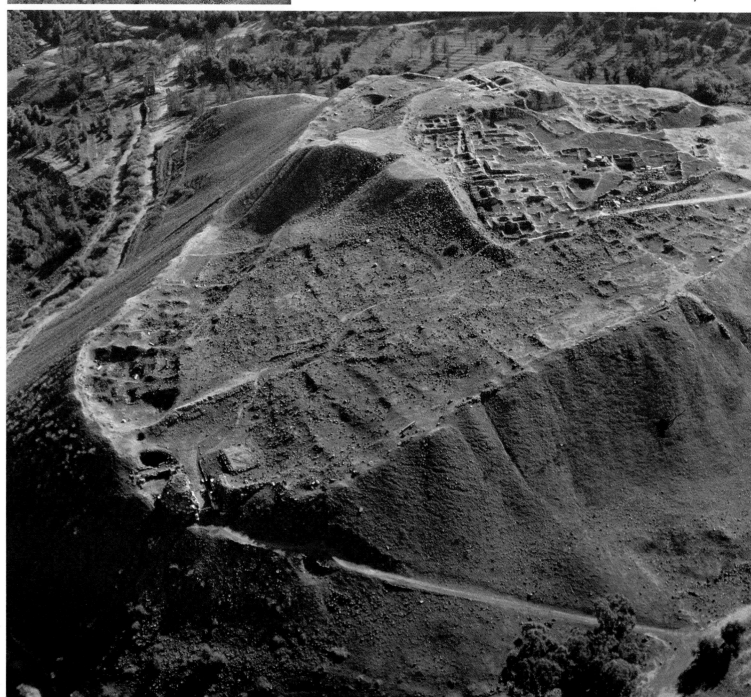

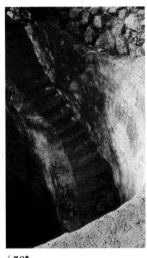

4.7,8*
David was anointed king at Hebron, but war continued between his men and those still supporting King Saul's family. The two forces met and fought at the pool of Gibeon. A deep cistern was found at Gibeon, approached by a steep flight of steps. This may be the one mentioned in 2 Samuel chapter 2.

4.9*
The 'city' that David conquered and made his new capital was a small area outside and just southeast of the present walls of the Old City. The ground falls away steeply on three sides: to the Tyropean Valley to the west, the Valley of Hinnom to the south, and the Kidron Valley to the east.

4.10*
Jerusalem remained a Jebusite stronghold. It was so well-fortified that the Israelites were unable to take it by storm. But David discovered a way. Many scholars believe it was a tunnel leading from an underground spring: his men took the city by means of the watershaft.

The picture shows part of the Jebusite city.

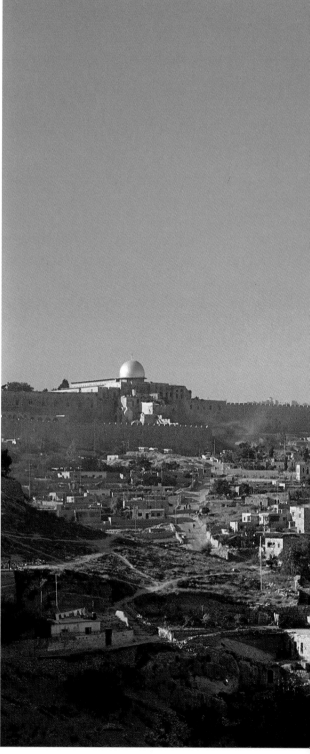

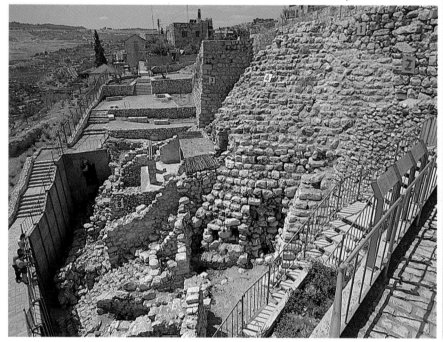

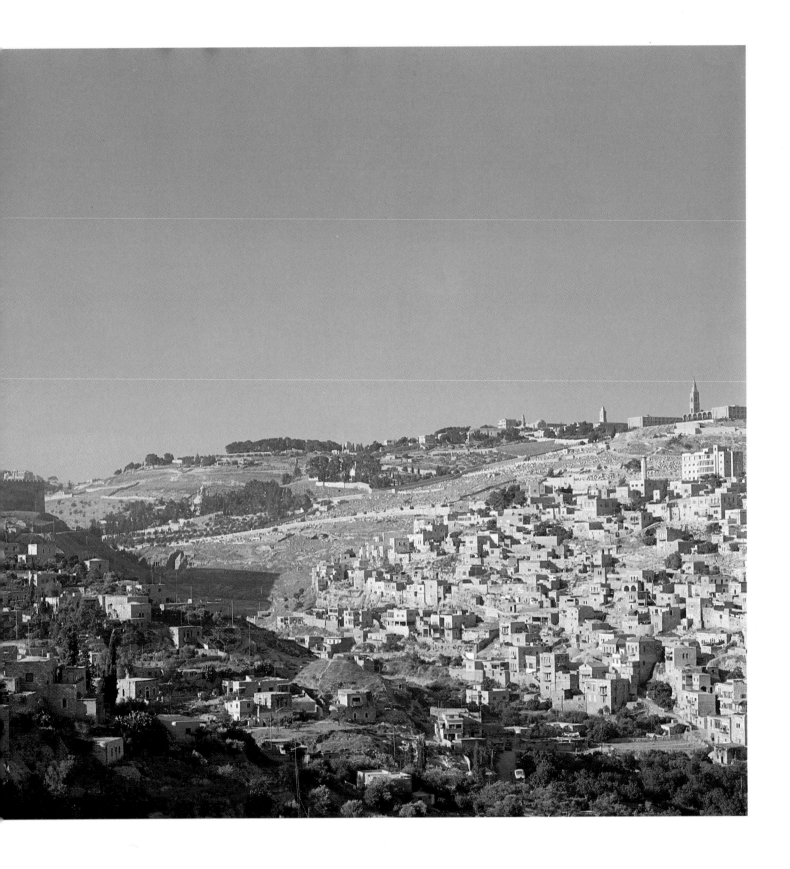

4.11*
The peace won by King David made possible the Golden Age of his son. Solomon's reign is notable for its great building projects, especially the Jerusalem Temple, which David had long planned. In a trade-deal with King Hiram of Tyre, cedar from Lebanon was floated in rafts down the coast and hauled overland to the capital. Only a few isolated groves now remain of the forests which once covered the Lebanese hills.

4.12
The stone quarries which supplied the Temple masonry are traditionally identified with these, which lie deep below the Old City of Jerusalem. Here the great blocks were prepared, so that no sound of hammer or chisel should be heard on site.

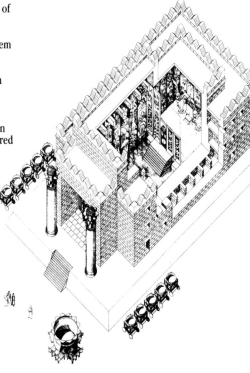

4.13*
The artist's reconstruction is based on the description of the temple in 1 Kings chapter 6. It was modest in size — a house for God, not a great cathedral built to shelter the worshippers. The Temple measured just 27×9×13.5 meters/89×30×44 feet inside. The inner room was a 9 meter/30 foot cube. The Temple was built of the local golden limestone, with cedar roof and beams. Inside, the walls were panelled throughout in cedar. The floor was pine. The inner sanctuary and everything in it was overlaid with gold.

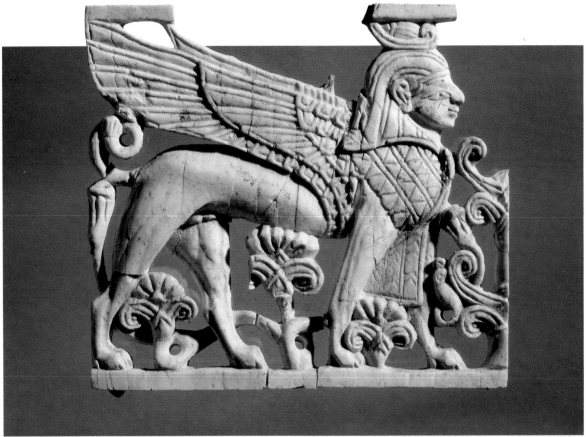

4.14,15*
The decorative style of the
Temple carvings can only be
guessed from contemporary
examples. Devices borrowed
from Egypt and Phoenicia were
widespread. The ivory carving of
the lion and lotus plants (below,
left) reflects both these
influences. The palm was a
decorative device used by King
Solomon. The 'winged creatures'
or cherubim which Solomon had
carved on the Temple walls may
have resembled this winged
sphinx. Both ivories come from
Fort Shalmaneser, Nimrud
(Assyria) and date from the ninth
or eighth centuries BC.

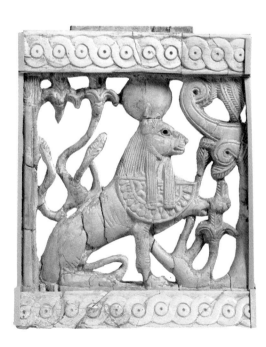

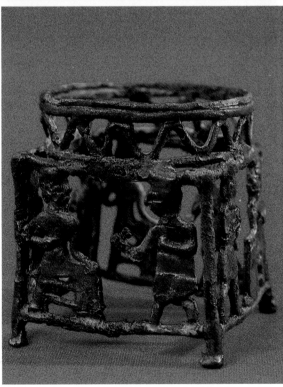

4.16*
From the Canaanite temple at
Megiddo around 1050-1000 BC
comes this bronze stand, showing
a worshipper approaching the
seated god. Many of the Temple
furnishings were of bronze,
fashioned by a skilled craftsman
called Huram — the son of a
Hebrew woman and a man from
Tyre. These included twelve
wheeled stands, much larger than
the Megiddo one, holding basins.

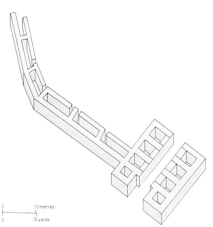

4.17*
In addition to the Temple and new palaces for himself and Pharaoh's daughter, King Solomon rebuilt three cities: Hazor and Megiddo in the north, and Gezer to the west of Jerusalem. Excavation of the three sites has revealed gateways of very similar plan and walls of the same special 'casemate' design. The photograph is of the gateway at Gezer. The plan of the Hazor gateway clearly shows the construction.

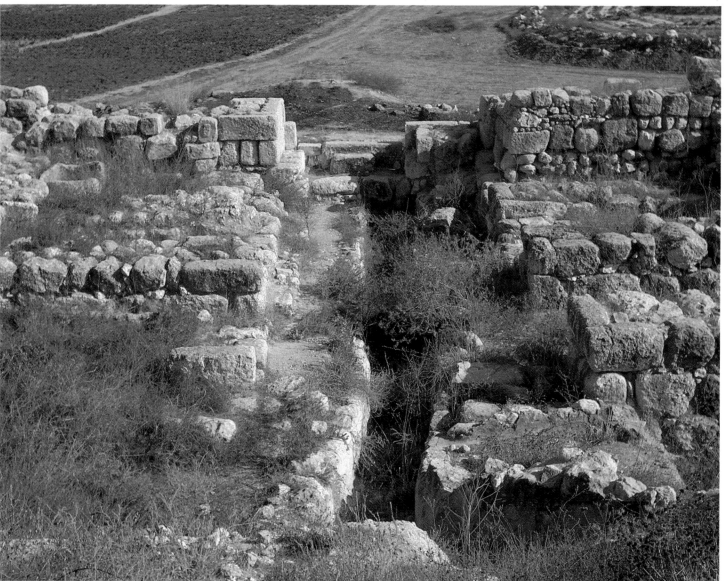

4.18*
A discovery of special interest, also from Gezer, is this small stone 'calendar' inscribed by a schoolboy, which lists the farmer's tasks for different seasons of the year. It dates from the tenth century BC and shows the handwriting of the time.

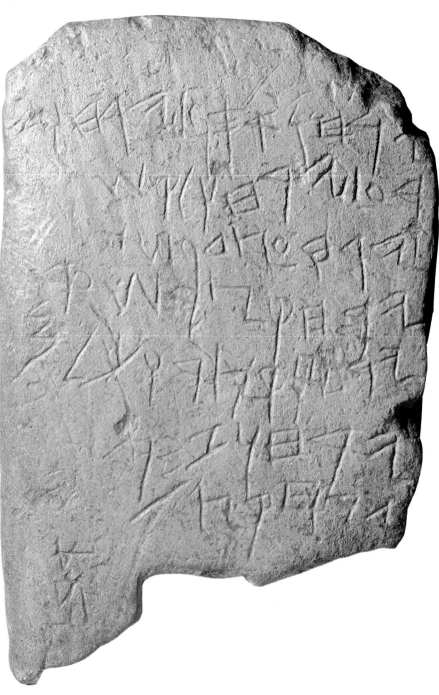

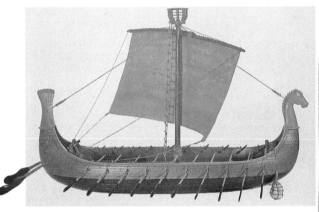

4.19
Solomon's trade links extended from Egypt to modern Turkey and Arabia. He had a fleet of trading ships operating out of the Red Sea with the fleet of King Hiram of Tyre. The model shows a long-range Phoenician merchant ship of the seventh century BC, a little later than King Solomon's time.

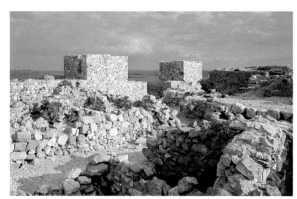

4.20,21,22*
Although Jerusalem with its Temple was the main centre of worship in King Solomon's day, it was not the only sanctuary in Israel. At Arad, between Beersheba and the Dead Sea, archaeologists have discovered the remains of an Israelite shrine.

The aerial view of Arad shows the extensive ruins. The lower city is Canaanite (about 2,850-2,650 BC). The later citadel belongs to Israelite times. The rebuilt gateway to the Israelite city is pictured close-up.

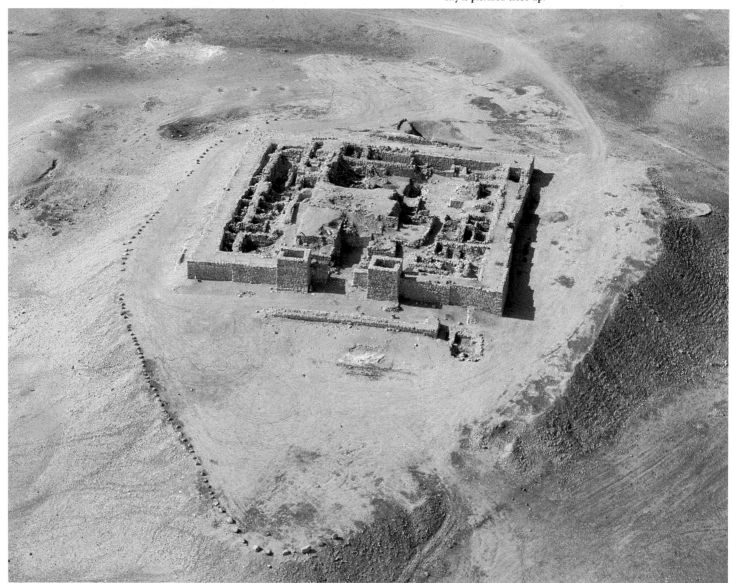

KINGS AND PROPHETS

The divided kingdom
and the Assyrian invaders

The Bible's account of King Solomon's reign applauds his wisdom, but also frankly reveals his folly. By the time of his death the seeds had been sown which would split the kingdom in two. Love for his many foreign wives and their gods led Solomon to compromise, and his eagerness for glorious buildings led to harsh taxation and even enslavement of his own people. His son's misjudgement of the nation's mood left him with a diminished state of only two tribes: the kingdom of Judah. The ten northern tribes broke free, under a king of their own, to form the kingdom of Israel.

The setting for Gallery Five is the divided kingdom, covering the period from Solomon's death (about 931 BC) to about 700 BC, just after the end of Israel. This is the time of the great Old Testament prophets, beginning with Elijah and Elisha, through to Isaiah. The biblical account of the period is to be found in the books of Kings and Chronicles, and Isaiah chapters 1-39.

The gallery opens with Pharaoh Shishak's invasion, and the contest between Elijah and the prophets of Baal on Mount Carmel. It features the fortress city of Megiddo and Samaria, the new capital of the northern kingdom of Israel.

To the north of the two kingdoms, Assyria grew in power, dominating the whole region as far south as Egypt in the eighth century BC.

After a three-year siege, Samaria fell to the Assyrians in 722 BC and the northern kingdom of Israel ceased to exist.

The Assyrians, like the ancient Egyptians, have left a remarkable pictorial record of the kings and their great victories which illuminate their own and the Bible's written records. The pictures have survived because they were engraved in relief on the walls of Assyrian palaces. The only thing lacking in most cases is the colour, which does not survive.

Gallery Five displays a selection of many marvellous scenes from Calah (Nimrud) and Nineveh, the Assyrian capital, in modern Iraq. King Shalmaneser III's Black Obelisk actually shows King Jehu of Israel (or his representative) making obeisance to his Assyrian overlord and bringing tribute. Numerous battle-scenes reveal the Assyrians as a fearsome fighting force, well able to terrify the inhabitants of Jerusalem, as the Bible and the inscribed prism of Assyrian King Sennacherib record them doing in King Hezekiah's reign. On his palace walls at Nineveh Sennacherib also had his craftsmen depict the siege and fall of Lachish, a Judean city too close to Jerusalem for comfort. But there was also another side to Assyrian life, reflected in some of the other scenes chosen for this gallery.

5.3*
The northern fortress of
Megiddo, rebuilt by Solomon,
was further strengthened by King
Ahab of Israel. The aerial view
(right) clearly shows the 'hill of
Megiddo' *(har-megiddon)* —
from which New Testament
Armageddon, the battle site of all
battle sites, is named. Megiddo
was a key fortress in the defence
of Israel, guarding the pass
through the Carmel hills.

5.1*
Soon after King Solomon's death,
Pharaoh Shishak invaded Judah
and plundered the Temple. Was
this gold armlet belonging to his
son made from Temple gold?

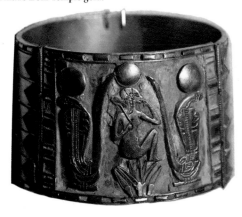

5.2*
The kingdom divided into north
and south in the reign of
Solomon's son. Israel, in the
north, set up new religious
centres to rival Jerusalem. Soon
the worship of God became
mixed with worship of local
deities. The scene was set for the
great contest between God and
Baal on Mount Carmel, led by the
prophet Elijah (1 Kings chapter
18).

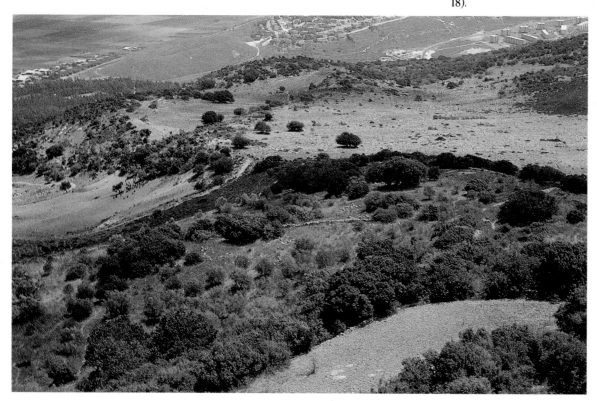

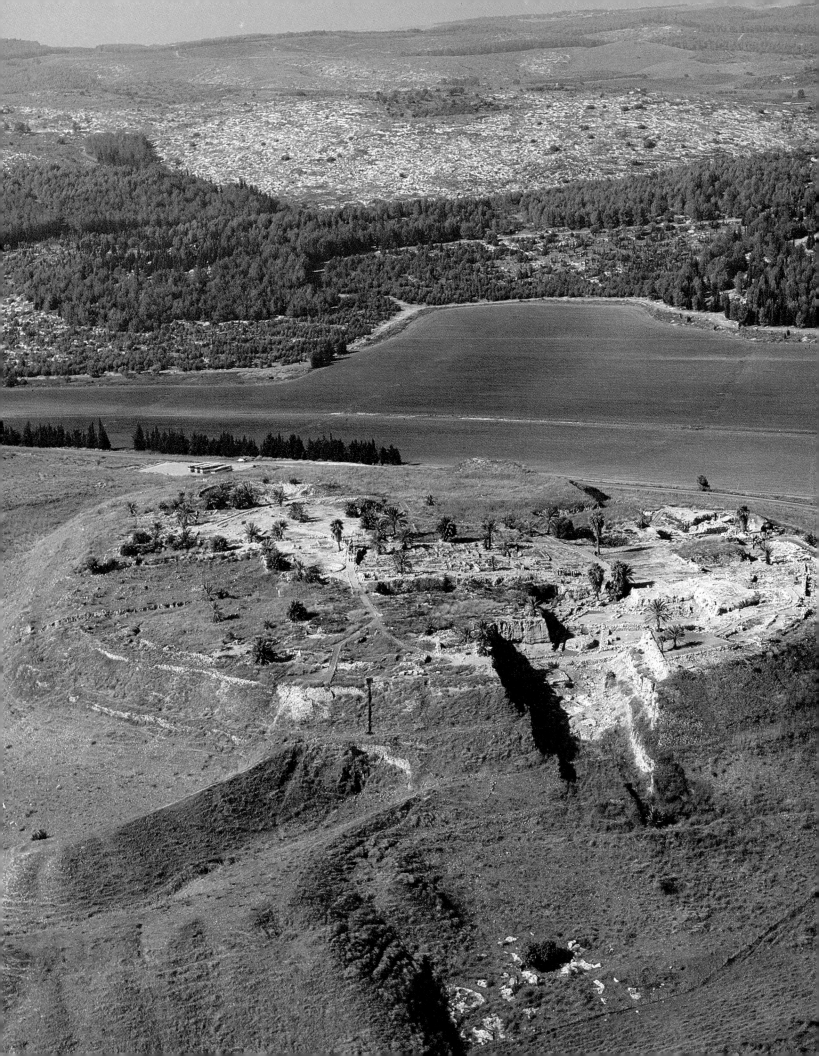

5.4*
At Megiddo archaeologists
uncovered buildings which they
thought were Solomon's stables,
but are now considered to have
been store-houses or barracks
built by King Ahab.

5.5
It was essential to ensure water
supplies in the event of a siege.
This tunnel at Megiddo gave
access to a great underground
cistern.

5.6
A box carved from a single piece
of ivory and decorated in the
Phoenician style with lions and
winged sphinxes was part of a
hoard found at Megiddo, dating
from the fourteenth-twelfth
centuries BC.

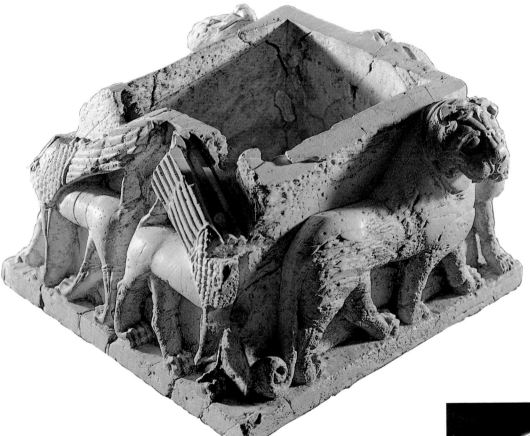

5.7*
Also from Megiddo comes the
Seal of Shema, who served King
Jeroboam II of Israel. The
inscription reads: '(belonging) to
Shema, servant of Jeroboam'. This
is a bronze cast of the jasper
original, lost in Istanbul.

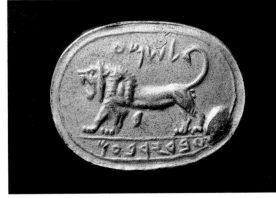

5.9
The reconstruction of the gateway gives some idea of the city's strength under attack. Despite this, in 722/1 BC Samaria fell to the besieging Assyrians, fulfilling the predictions of the Old Testament prophets.

5.8*
The capital of Israel was Samaria, chosen for its strong defensive position.

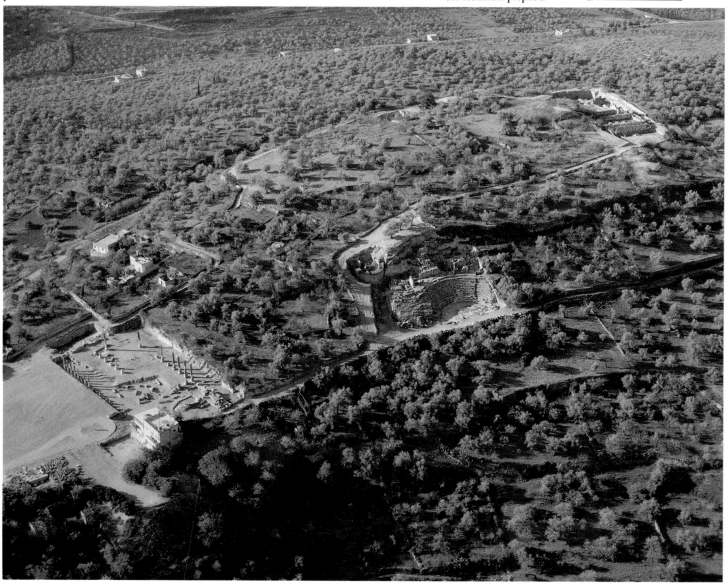

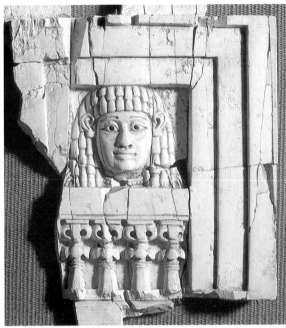

5.11*
The possession of ivory (from Syrian elephants) was a mark of luxury in the days of the kings. It was elaborately carved and used to decorate thrones, couches and other furniture. King Ahab had a 'house of ivory' in his capital, Samaria. And the prophet Amos roundly condemned those who 'lie on beds inlaid with ivory', enjoying luxuries bought at the expense of the poor. This famous ivory from Nimrud, of a woman at a window in Egyptian wig and dress, may be connected with the worship of Astarte in the character of a sacred harlot. In the view of the Old Testament prophets, luxury and the worship of false gods often went hand in hand.

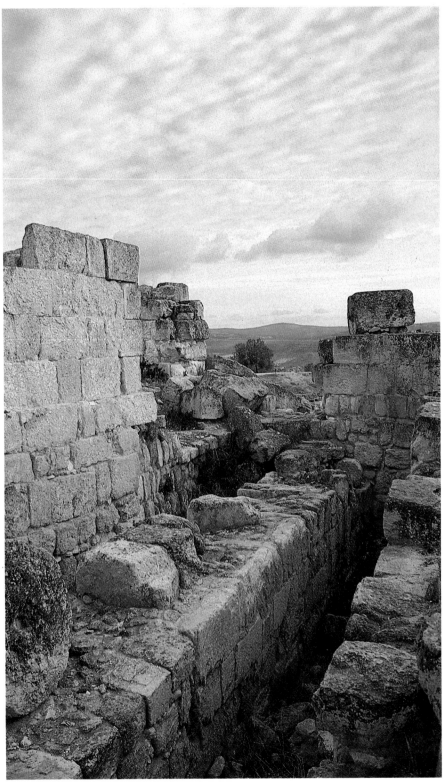

5.10*
Parts of the Israelite walls and King Ahab's palace can still be seen in the ruins of Samaria.

5.12*
2 Kings chapter 3 records that Mesha, king of Moab, who raised sheep, had to supply the king of Israel with 100,000 lambs and the wool of 100,000 rams. When King Ahab died, Mesha quite naturally rebelled. The Bible records Israel's revenge, but in the end they withdrew. Mesha celebrated his freedom from Israel by recording his deeds on a stone slab, erected at his home town of Dibon. The 'Moabite Stone' now stands in the Louvre, painstakingly pieced together following the energetic attempts of local people in the 1870s to break it open, thinking there was treasure inside!

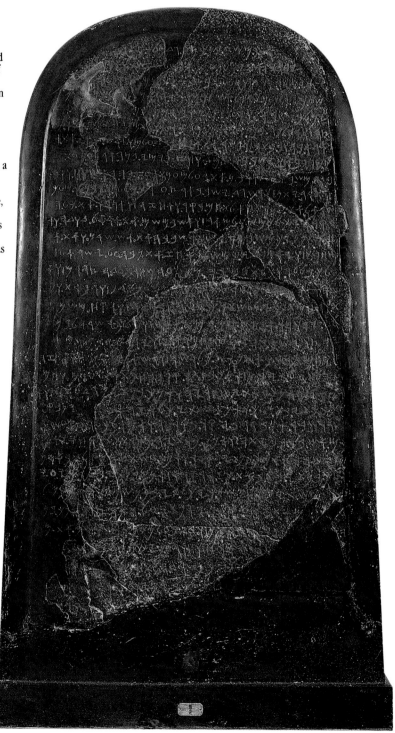

5.13
The photograph shows the hills of Moab, Mesha's land, across the Wadi el Hasa.

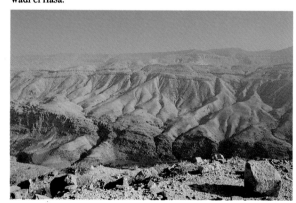

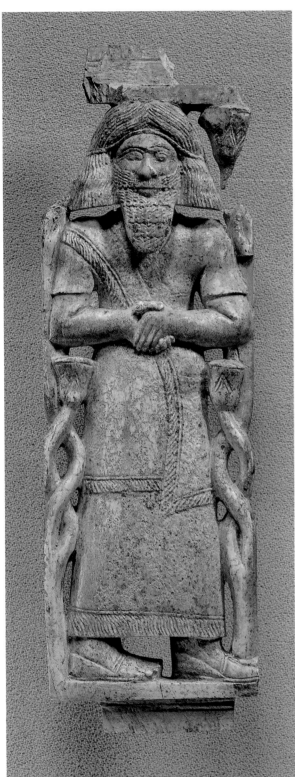

5.14
This ivory figure was found with others which decorated wooden furniture in a Syrian palace. One bore the name of Hazael, the powerful king of Damascus (Syria) who fought against Jehu and Jehoahaz of Israel. Even Jerusalem was threatened and paid tribute from the Temple treasures. In 841 and 837 BC Hazael fought against the Assyrian King Shalmaneser III. Thirty years later the ageing king submitted to the Assyrian power.

5.15*
The great power in the eighth century BC was Assyria, a civilization which has left a unique pictorial record, thanks to the survival of so many examples of the stone-carvers' art from the great cities of Calah (Nimrud) and Nineveh (the capital) in Iraq. The nineteenth-century artist's imaginative reconstruction of the palace walls of Calah (Nimrud) on the banks of the River Tigris is based on their work.

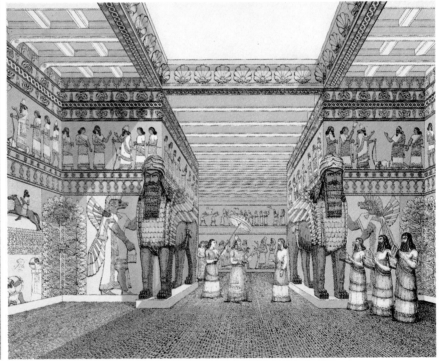

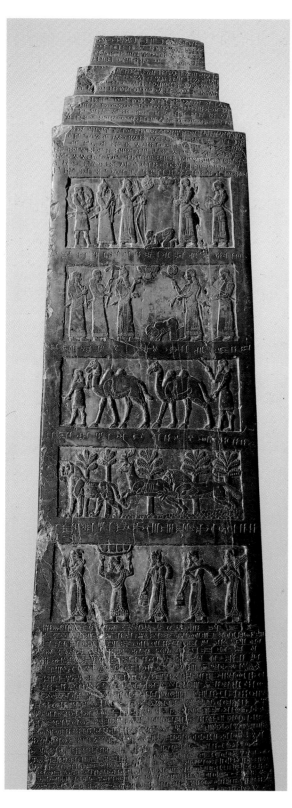

5.16,17*
Rulers of the kingdoms around
paid a high price for Assyrian
'protection'. A famous panel
(below) from the Black Obelisk
(which records the triumphs of
King Shalmaneser III) shows
Jehu, king of Israel, 'Son of Omri'
(or perhaps his representative)
bringing tribute to the Assyrian
king. The obelisk was discovered
in 1846 by men working for the
archaeologist Henry Layard at
Calah (Nimrud).

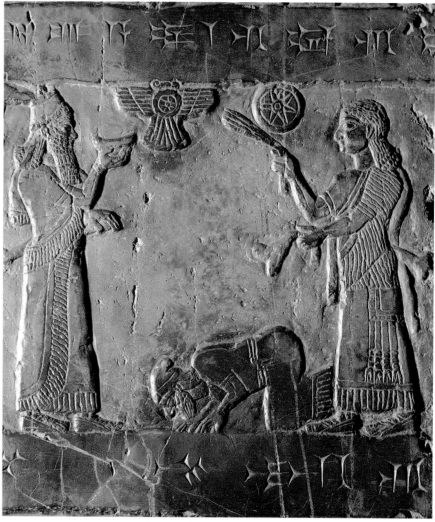

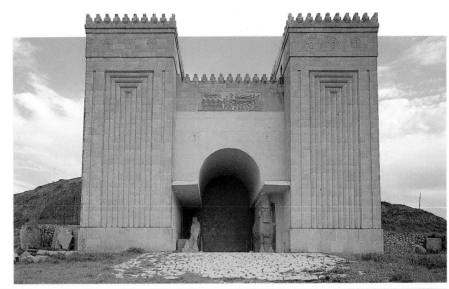

5.19*
A reconstruction of one immense gateway gives some idea of the scale and grandeur of ancient Nineveh.

5.18*
The site of ancient Nineveh, capital of Assyria, from the air. The city's inner wall measured some 12 km/7.5 miles around. It could have housed a population of 175,000 people. The comparison with Jonah's description in the Bible is an interesting one.

5.20*
This homely picture of a woman
giving a drink to her child shows
another side, to balance the
frequent scenes of kings and
battles. It comes from the palace
of King Sennacherib in Nineveh.

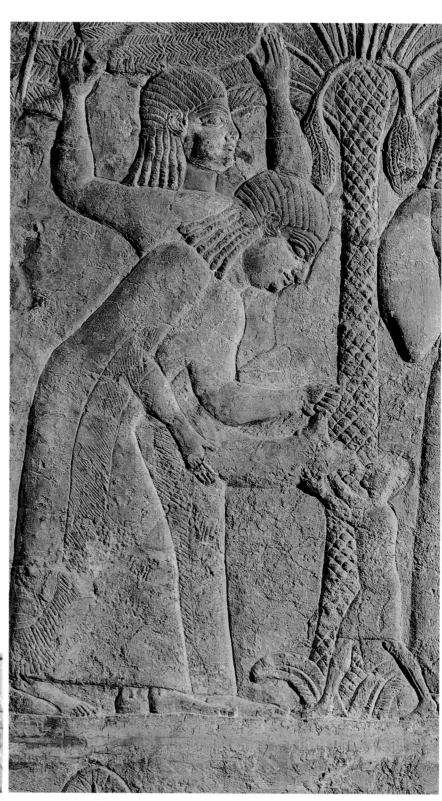

5.21*
Ishtar (Astarte), goddess of love
and war, was one of the major
deities worshipped by the
Assyrians. She is portrayed here
on a tiny cylinder seal — the
impression is shown alongside.

 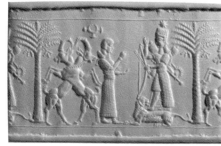

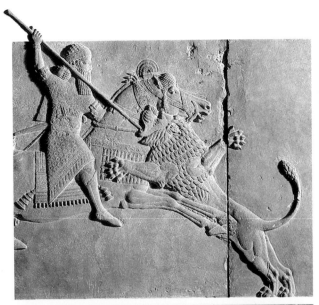

5.23*
The Assyrian kings both kept and
hunted lions. In this relief from
the north palace at Nineveh, King
Ashurbanipal uses his spear to
despatch the lion.

5.22*
In this relief, King Ashurbanipal is
seen feasting with his wife in the
royal garden.

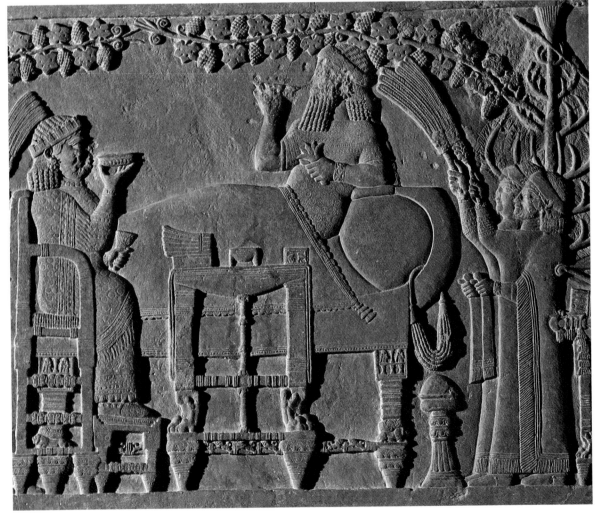

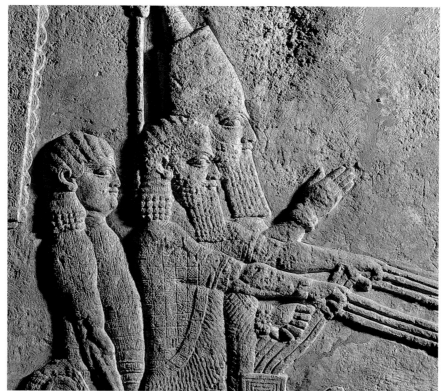

5.25,26*
These scenes are from reliefs decorating the walls of King Sennacherib's palace at Nineveh, about 690 BC: the king, in his chariot; and (right) gangs of men pulling ropes to haul a statue from the river to the king's new palace.

5.24
Elamite musicians celebrate King Ashurbanipal's capture of the town of Madaktu.

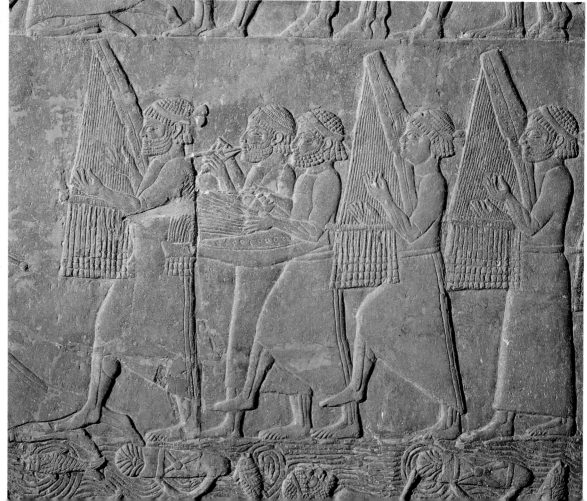

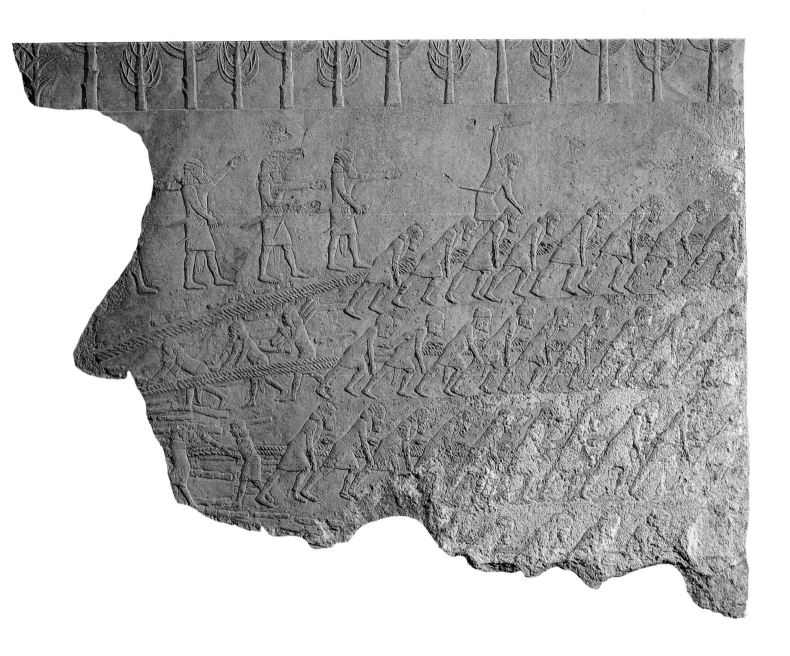

5.27*
Towards the end of the eighth
century, King Hezekiah of Judah
made a stand against his Assyrian
overlords. What happened is
recorded not only in the Bible
(2 Kings chapters 18 and 19;
Isaiah chapters 36 and 37) but
also by the Assyrian King
Sennacherib. The six-sided
pottery 'Taylor Prism' (37.5cms/
15ins high) is named after
Colonel Taylor, who acquired it
in Nineveh in 1830.

'As for Hezekiah, the Judean
who did not submit to my yoke,'
the inscription reads, 'I surroun-
ded and conquered forty-six of his
strong walled towns ... He himself
I shut up in Jerusalem, his royal
city, like a bird in a cage ...'

5.28,29,30,31,32*
King Hezekiah had secured his
water-supply in readiness for the
siege. A tunnel 620 meters/1700
feet long was cut through the
rock to bring water from the
Gihon Spring to the Pool of
Siloam, within the city walls.
(The diagram shows the route.)
By a remarkable feat of
engineering, the workmen,
starting from both ends, met in
the middle. An inscription (top
right), discovered in 1880 by a
boy bathing in the Pool and now
in the Archaeological Museum at
Istanbul, records: 'This is the
story of the piercing through.
While (the stone-cutters were
swinging their) axes, each
towards his fellow, and while
there were yet three cubits to be
pierced through, (there was
heard) the voice of a man calling
to his fellow, for there was a
crevice (?) on the right ... And
on the day of the piercing
through, the stone-cutters struck
through each to meet his fellow,
axe against axe. Then ran the
water from the Spring to the Pool
for twelve hundred cubits, and a
hundred cubits was the height of
the rock above the head of the
stone-cutters.'

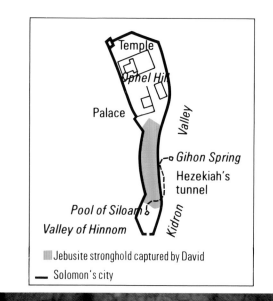

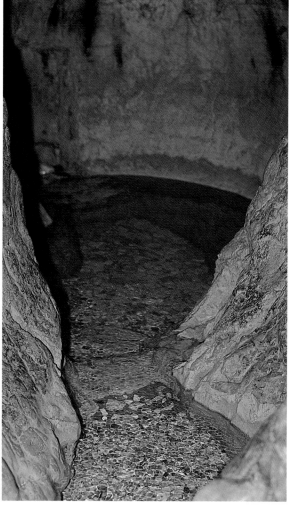

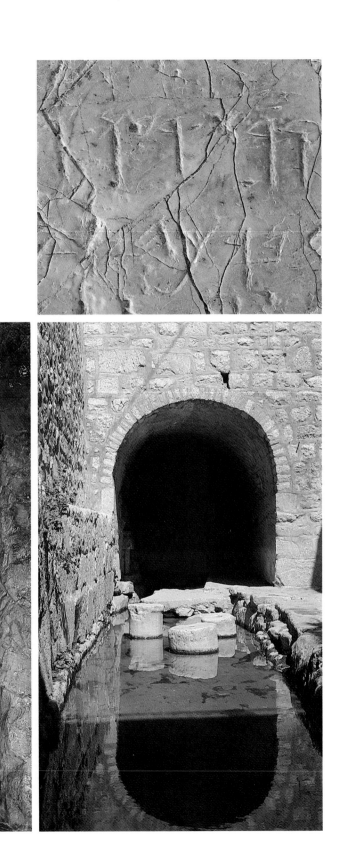

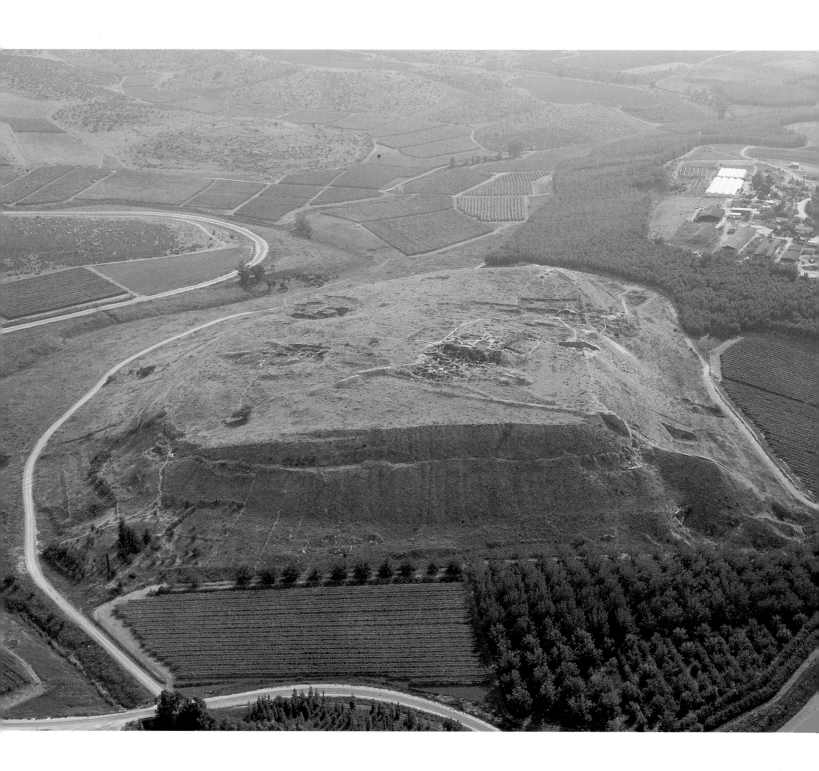

5.33
The Assyrian army surrounding
Jerusalem was a fearsome sight.
Tales of horror went ahead, to
terrify the rebels. Jerusalem was
saved, the biblical accounts
record, because of King
Hezekiah's trust in God. But
nearby Lachish (left) was not so
fortunate.

5.34*
King Sennacherib of Assyria had
his stone-carvers reproduce the
dramatic final scenes of the fall of
Lachish on his palace walls at
Nineveh (right; about 700 BC).
Here some of the inhabitants
leave as the defenders try to
drive away the Assyrians with
missiles and flaming torches.

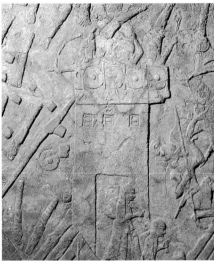

5.35
The drawing, from Assyrian
reliefs, clearly shows the armour
and weapons of Assyrian archers
and soldiers.

5.36*
While some of King
Sennacherib's soldiers carry off
the booty (below left) others
lead prisoners away from
Lachish.

5.37*
King Sennacherib of Assyria
(below), seated on his throne,
receives the surrender of
Lachish.

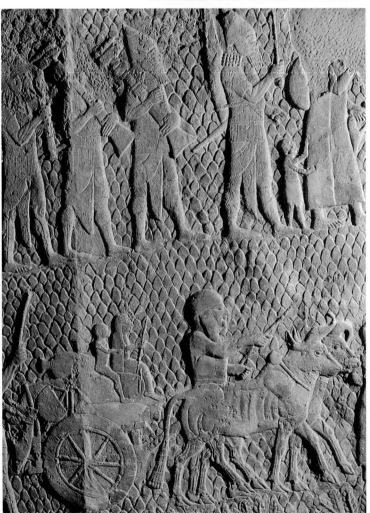

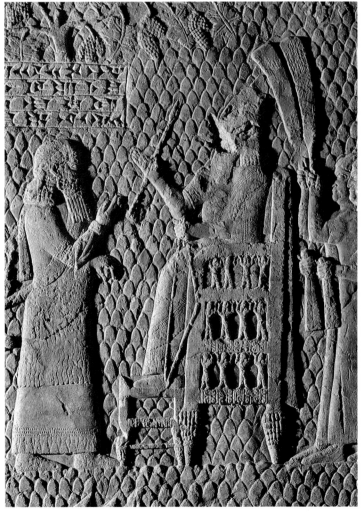

5.38
This letter, one of a number
discovered in the fortress of Arad
in the far south of Judah, dates
from the late seventh century BC.
The sender was away in
Jerusalem, inquiring about a
certain person, of whom he says:
'It is well; he is in the House of
God.' This is the first reference in
a letter to the Temple in
Jerusalem. The scribe writes in
the ancient Hebrew script, using
good biblical Hebrew.

5.39,40,41*
The Israelites were just one
among many nations who fell
subject to Assyria in the eighth
century BC. Impressive
Phoenician warships like the
model (below left) did not save
the cities of Tyre (below)or
Sidon.

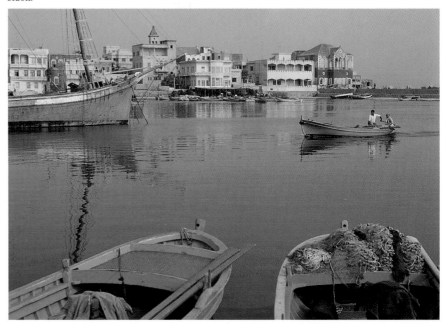

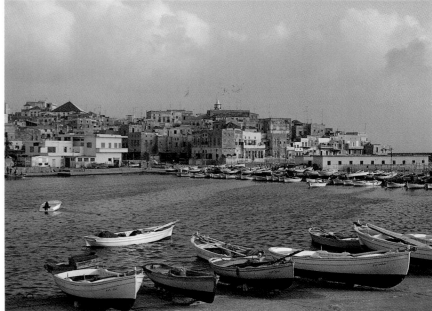

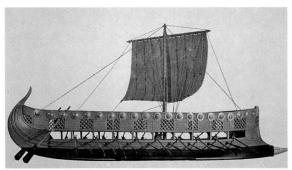

5.42*
Magnificent bronze panels from
the gates at Balawat (near Calah),
commissioned by King
Shalmaneser III. The upper-
middle section shows tribute
from the fortified island-city of
Tyre being ferried across to the
mainland for the benefit of the
Assyrian overlords.

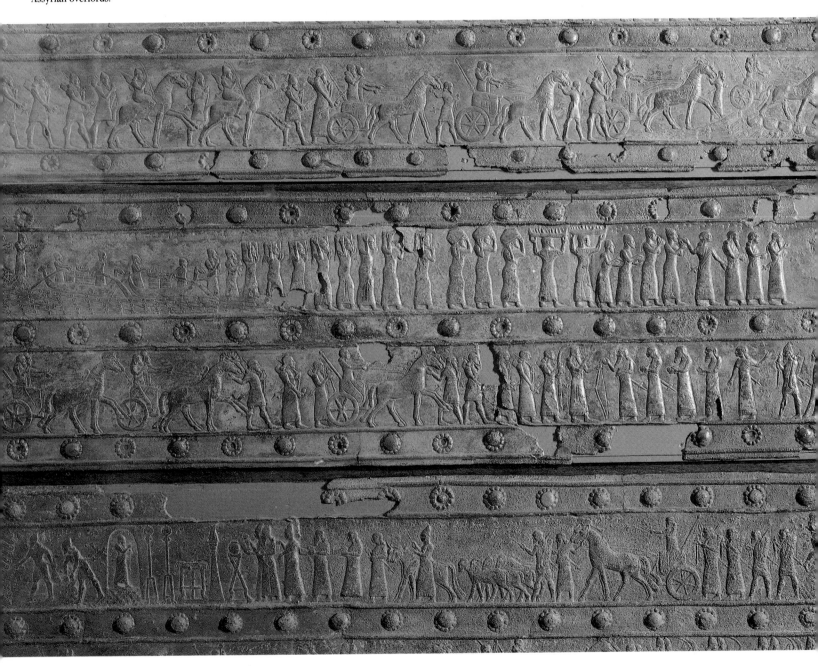

5.43*
About 700 BC, when Sennacherib was recording his triumph over Lachish, this inscription was written on the lintel of a tomb found at Siloam in Jerusalem. It bears the name of a royal steward, possibly Shebna (mentioned in Isaiah chapter 22 as a high official in King Hezekiah's court).

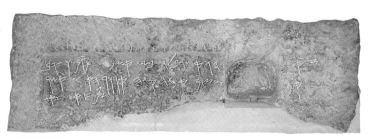

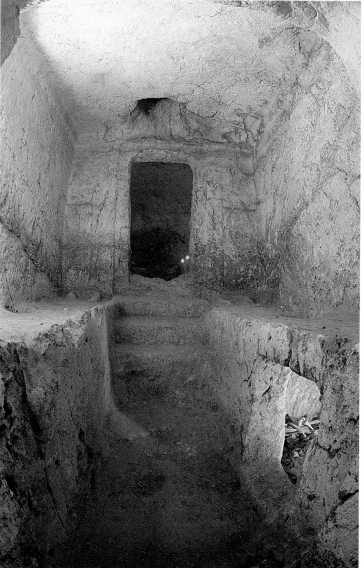

5.44*,45
Recent excavation in Jerusalem has uncovered a tomb, now thought to date from the eighth-seventh centuries BC. This finely burnished small jug shaped like a pomegranate, from about 700 BC, may have been specially made for use in shrines and in the houses of the wealthy.

'GREAT BABYLON'

The power of the Assyrians, who dominated the lands of the Near East in the eighth century BC, was short-lived. In 612 the Babylonians captured the Assyrian capital, Nineveh, and the tiny kingdom of Judah had a new overlord to fear.

The Old Testament prophets made it plain that Israel had been destroyed by the Assyrians as a judgement for their repeated refusal to listen to God and return to him. Their kings had consistently led God's people away from him, introducing the worship of false gods from the nations around. If Judah failed to learn the lesson, they too would suffer invasion and conquest — at the hands of the Babylonians. The prophet Jeremiah hammered God's warnings home: to no avail. In 597 King Nebuchadnezzar II took Jerusalem. Ten years later, following further rebellion, he destroyed the city and its Temple, plundering the treasures and taking the people captive into exile.

Nebuchadnezzar, like Ramesses II in Egypt and Solomon in Israel, was a great builder as well as a great soldier. He masterminded the reconstruction of Babylon, his capital city on the River Euphrates in the south of modern Iraq. The biblical book of Daniel, the prophet-in-exile, reveals the power of Nebuchadnezzar and his megalomania: 'Look how great Babylon is! I built it as my capital city to display my power and might, my glory and majesty.'

But for all his pride, the city was destined to be abandoned, to crumble away. As Gallery Six reveals, we must resort to reconstructions to glimpse the glory that was Babylon.

6.1*
In the eighth century BC the great
northern power in the ancient
Near East was Assyria. Then in
612 the Babylonians captured
Nineveh, the Assyrian capital, to
become the new overlords. The
aerial photograph shows the site
of ancient Babylon, on the River
Euphrates. Clear in the
foreground is the outline of the
great Etemenanki ziggurat.

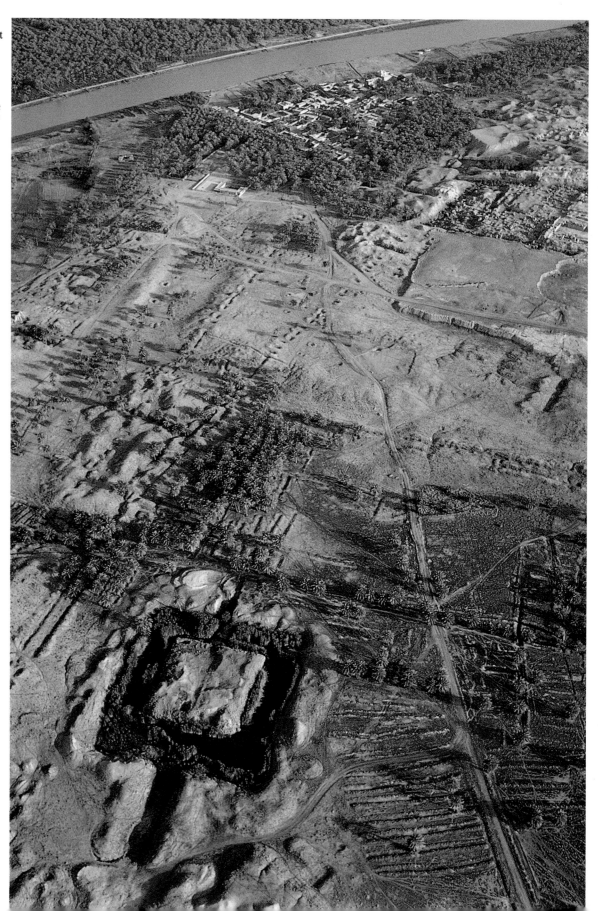

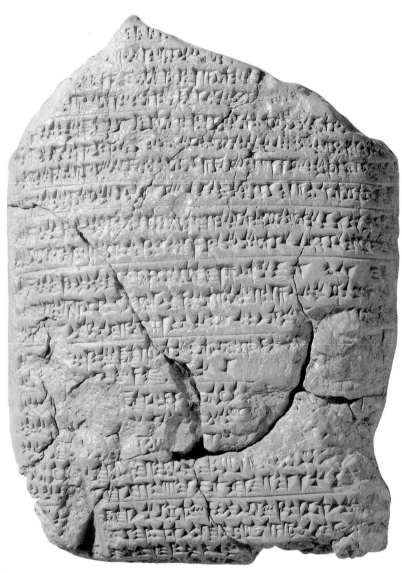

6.2*
This small sixth-century clay
tablet, 8cms/3.25 ins high, is part
of the Babylonian Chronicle, for
the years 605-594 BC. It records,
among other events, the defeat of
the Egyptians at the Battle of
Carchemish in 605; the accession
of King Nebuchadnezzar II of
Babylon; and the defeat of Judah
in 597, followed by the
appointment of puppet-king
Zedekiah in Jerusalem.

6.3*
These bronze arrowheads from
about 600 BC have been
recovered from Carchemish, site
of the decisive battle between
Pharaoh Neco of Egypt and the
Babylonian army led by
Nebuchadnezzar.

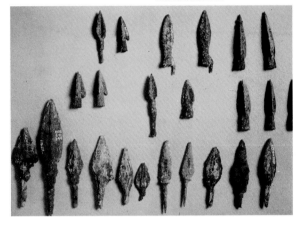

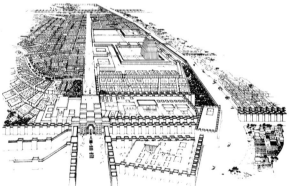

6.4
King Nebuchadnezzar II had
much of Babylon rebuilt. A
protective moat 80 meters/262
feet wide enclosed the inner city,
and double walls over 8 kms/5
miles long and wide enough for
chariots to be driven along the
top, were built. These were
pierced by eight fortified
gateways. The drawing shows the
Processional Way leading to the
Ishtar Gate and the Temple of
Marduk.

6.5*
This reconstruction shows the
Ishtar Gate as it was in King
Nebuchadnezzar's day: decorated
with magical beasts moulded in
relief in the brickwork. The
bricks were glazed blue, with the
animals picked out in yellow and
brown.

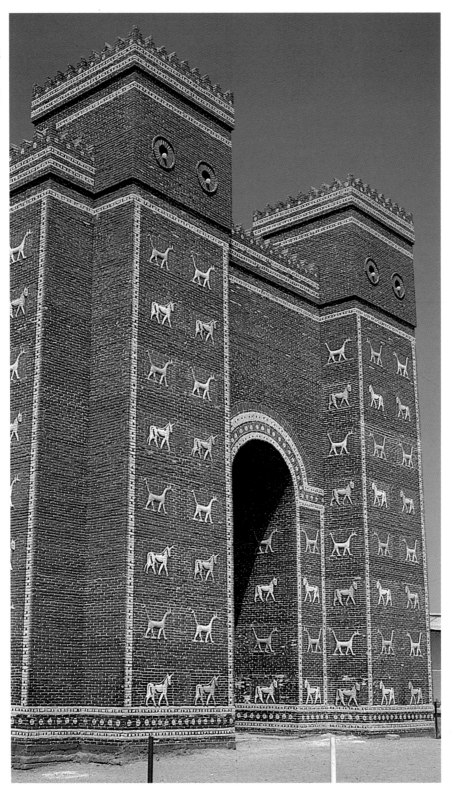

6.6
A figure of a bull in glazed brick,
from the Ishtar Gate at Babylon.

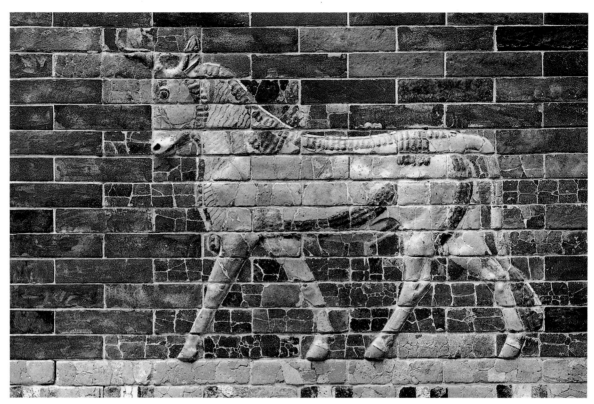

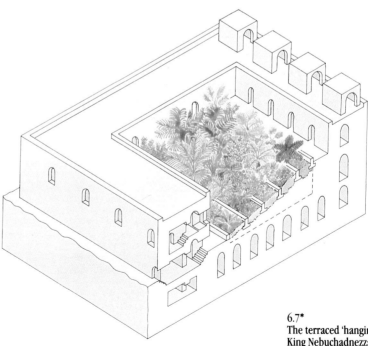

6.7*
The terraced 'hanging gardens' of
King Nebuchadnezzar's Babylon,
reconstructed here, were among
the seven wonders of the ancient
world.

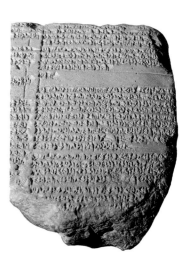

6.9*
The Babylonian Chronicle names
Nabonidus, portrayed on this
stele, as the last king of Babylon.

6.8*
In Jerusalem King Zedekiah,
ignoring the warnings of the
prophet Jeremiah, became
involved in political intrigue with
the Egyptians. The Babylonians
marched south once again.
Jerusalem was besieged and fell
in 587 BC. The Temple was
ransacked and destroyed. It is all
described in the biblical records.
Again, as in the days of Assyrian
power, Lachish suffered for
Jerusalem's defiance.
Archaeologists have discovered
burnt walls and broken utensils.
In the gatehouse, written on
pieces of broken pottery was a
collection of eighteen notes and
messages, among them letters
from a Judean soldier to his
commanding officer at Lachish,
from those final days as the
Babylonian forces advanced.

6.10*
This tablet of the Babylonian
Chronicle records the reign of
Nabonidus and the fall of
Babylon to the Persians led by
Cyrus in 539 BC.

PERSIAN SPLENDOURS

and the return to Judah

When the exiles from Judah — among them the prophets Daniel and Ezekiel — had been in captivity in Babylonia for fifty or sixty years the balance of power shifted again. Babylon fell to the combined forces of the Medes and Persians, under Cyrus II (the Great), in 539 BC. It had been the policy of both the Assyrians and the Babylonians to deport the nations they conquered and resettle their lands. Cyrus reversed this, restoring the exiles to their homelands and even helping them to re-establish worship of their own gods.

A group of Jewish exiles took advantage of Cyrus' clemency. They returned to Jerusalem, rebuilt the Temple and restored the worship of God. Later a second group returned. These events are recorded in the biblical book of Ezra. The returned exiles faced much opposition from the people who had in the interim occupied their land. It took the genius and dedication of Nehemiah, with the permission of the Persian king Artaxerxes, to rebuild the walls of Jerusalem and restore its pride. A third biblical book — Esther — also belongs to the Persian period.

The Persian Empire was far more extensive than its predecessors. Present-day Turkey and Egypt were under Persian control and the empire stretched east to India. For two centuries Persian kings ruled these lands, each province having its own local governor and with a new postal system to aid communication. Aramaic, the language used by the Assyrian officials in speaking to King Hezekiah of Judah, was the international diplomatic language of the Persian Empire.

Gallery Seven focusses on the magnificent palace built by King Darius I at Persepolis and on the treasures recovered from the River Oxus, which help to flesh out the description of Persian splendour in the book of Esther.

7.1*

In 539 BC Cyrus II of Persia captured Babylon. The special significance of this event for the Jews and other exiles was a change of policy. Cyrus gave orders for the repatriation of the exiled peoples. He also returned goods plundered from their temples and aided the reinstatement of their own religions. The king's decree is recorded at the end of 2 Chronicles and again in the first chapter of Ezra. About 100 years ago a clay cylinder 25 cms/9.75 ins long, known as the Cyrus Cylinder, was uncovered in Babylon. It dates from 536 and records how Cyrus took the city by surprise, without a battle, and how he returned the gods taken from various Babylonian cities to their homes, together with their servants.

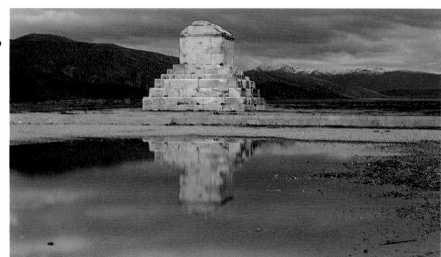

7.2
This tomb at Pasargadae in Iran, built of limestone blocks, is reputed to be that of King Cyrus II of Persia.

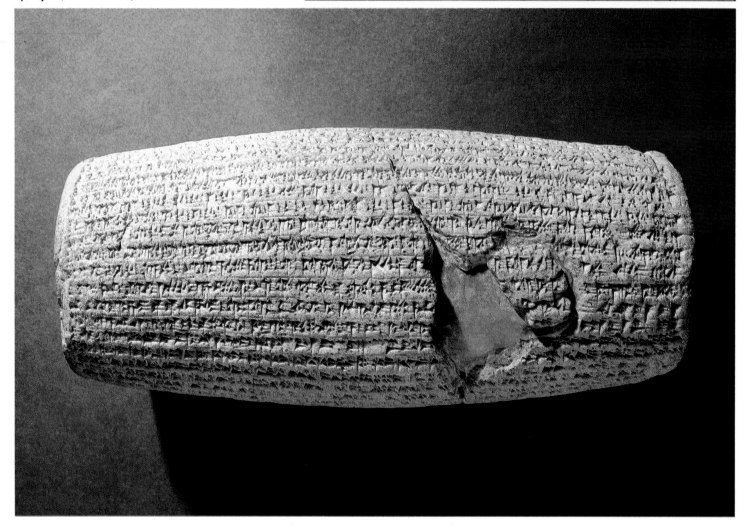

7.5*
Under Persian rule the centre of government shifted from Babylon to Susa, in Elam. The famous figure of a Persian guard, in glazed brick, comes from the walls of the palace of King Darius I at Susa, about 500 BC.

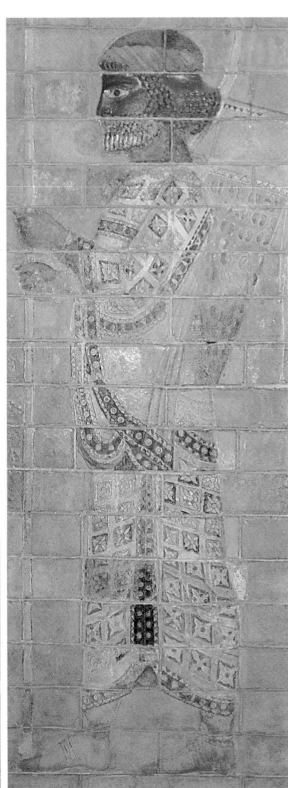

7.3*
This cylinder, 3.7 cms/1.5 ins high, is the seal of King Darius I of Persia, for use by an official, about 500 BC.

7.4*
Carved on the rock of Behistun (near Kermanshah in Iran), 300 feet above the ground, is a scene showing rebels submitting to King Darius I. The deciphering of the inscription by Edward Hincks and Sir Henry Rawlinson in the 1840s stabilized the study of Old Persian and provided a vital key to understanding the Babylonian cuneiform script.

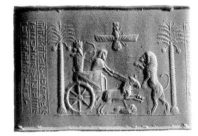

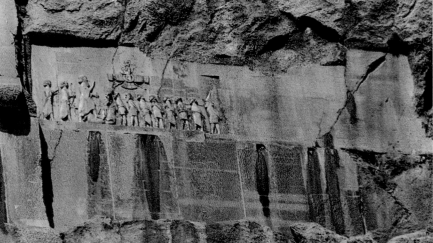

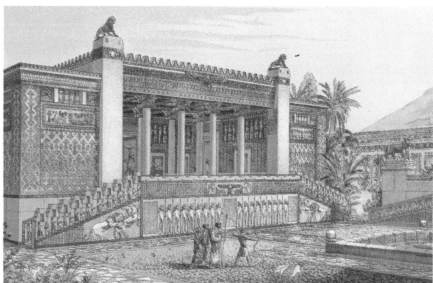

7.6,7*
In addition to the palace he had built at Susa, King Darius began a new palace at Persepolis. A wide stone staircase led to a courtyard. Then visitors climbed more stairs, with elaborate carvings on the walls, to a pillared porch and audience hall 65 meters/200 feet long and 20 meters/65 feet high. Here, in great luxury, the king sat in state, surrounded by his courtiers. The nineteenth-century artist's reconstruction catches something of the splendour and colour of the palace as it might have looked in Darius' time.

7.8*
King Darius himself is also portrayed on a stone column (right) at Persepolis.

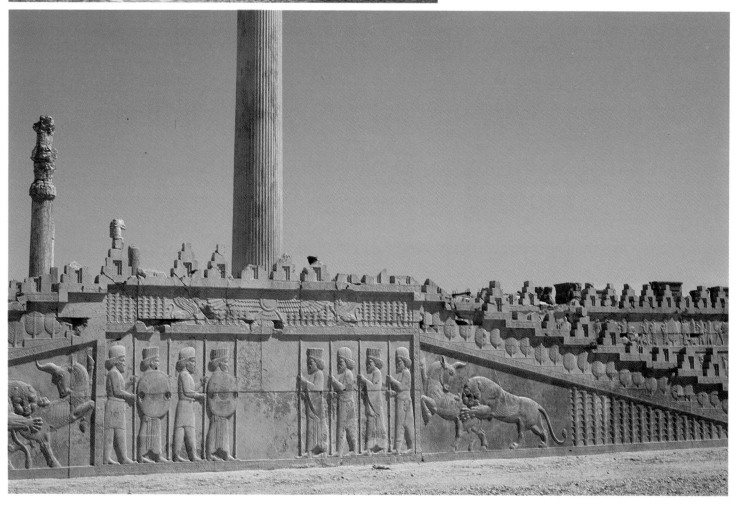

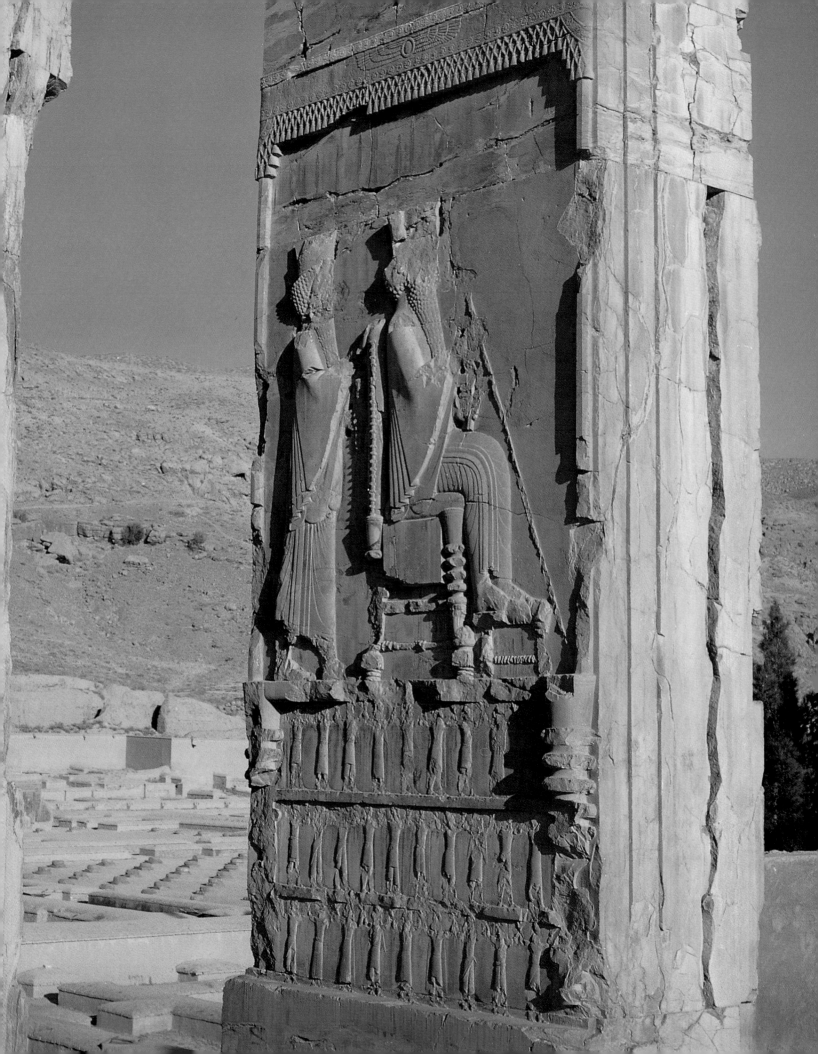

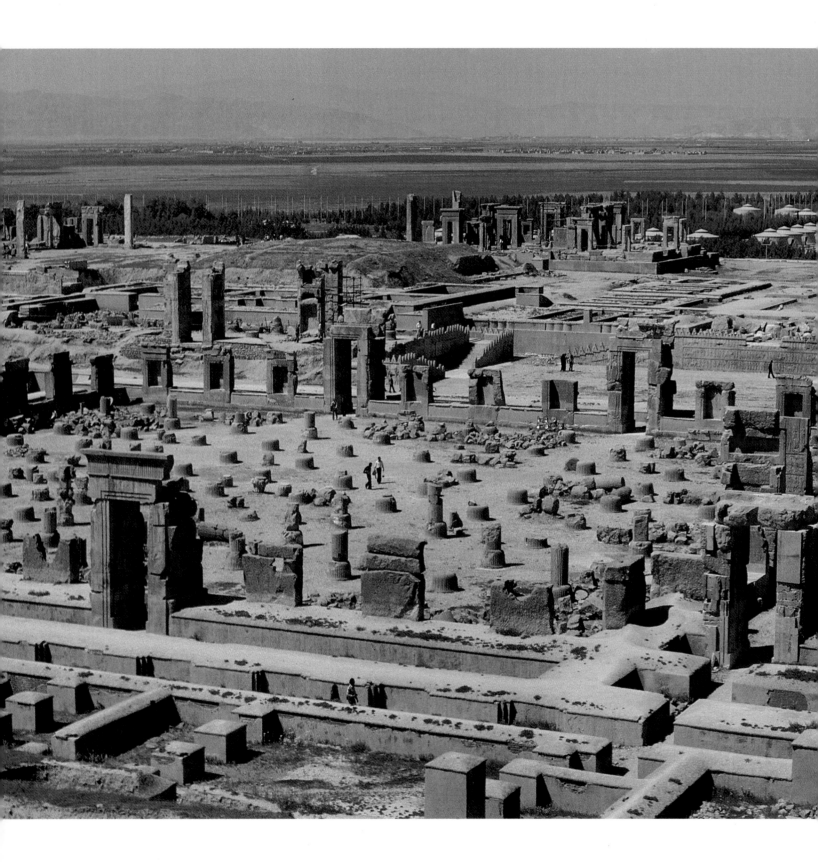

7.9*
Persepolis was sacked by
Alexander the Great and left to
decay, but enough still remains to
show the staggering scale and
splendour of the buildings.
Darius' palace with its great
stairway is centre right in the
picture (left).

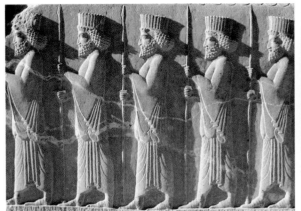

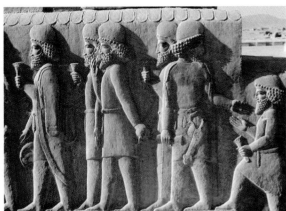

7.10,11,12,13*
In carved relief, long lines of men
approach the centre: Persian
guards and nobles, Medes and
representatives of the provinces
of the Persian Empire, each
bearing produce typical of the
region as tribute to the king.

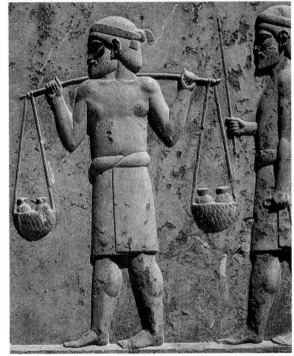

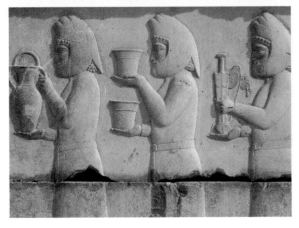

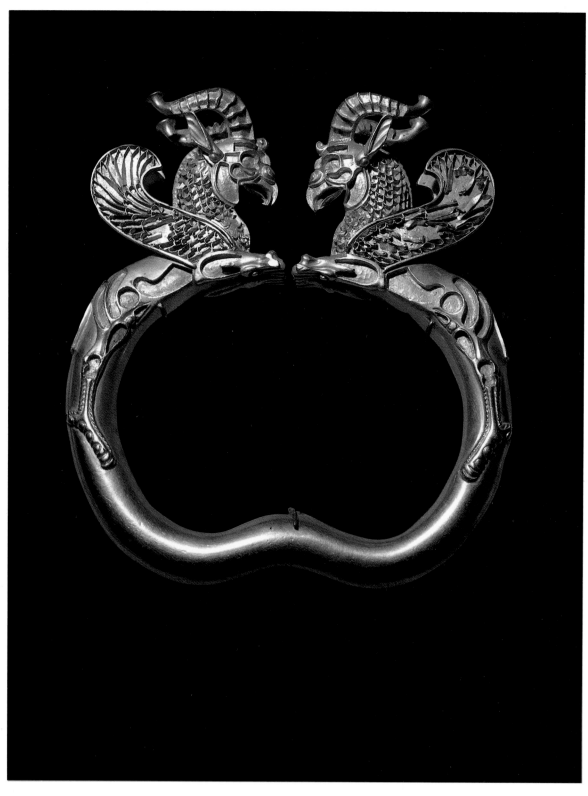

7.14*
The biblical book of Esther —
whose story is set in the time of
the Persian King Ahasuerus/
Xerxes — describes the glories of
the palace at Susa, with its
couches of gold and silver, and
goblets of gold. In 1887, at the
site of an ancient town on the
River Oxus (which runs into the
Aral Sea in the USSR), the river
water uncovered Persian
treasures of gold and silver,
including this gold armlet.

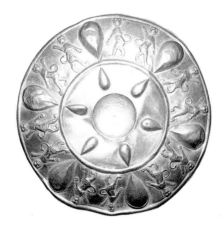

7.15,16*
This beautifully tooled silver
goose (with eyes inlaid with
gold) and bowl of beaten gold
dating from the sixth-fifth
centuries BC, were recovered as
part of the Oxus Treasure. The
treasure is a mixed collection of
items which may have been
presented to a temple, as gifts to
the god or goddess.

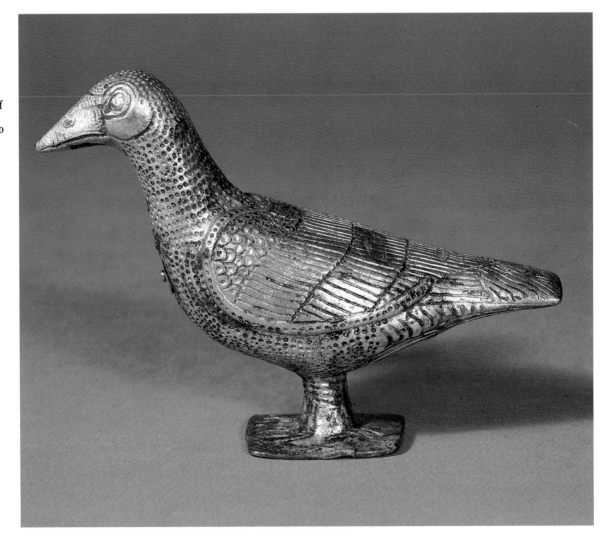

7.18
The Persian Empire stretched
from Greece to India. The king
ruled supreme: his word was law.
Each province had its own
governor, responsible to the king.
Communication was clearly vital,
and couriers sped along the great
highways from province to
province, carrying official
messages in diplomatic bags like
the one pictured here. The
biblical book of Ezra, chapter 5,
records just such an instance:
correspondence from the far-
flung province of Judah,
requesting King Darius' official
confirmation that they have his
authority to rebuild the Temple
in Jerusalem.

7.17*
The name of the Persian King
Ahasuerus/Xerxes is engraved on
this alabaster vase from the
mausoleum at Halicarnassus in
Old Persian, Babylonian
cuneiform and Egyptian
hieroglyphs. It is about 29 cms/
11.5 ins high.

7.19*
The governors of the Persian
Empire ruled a mixture of
peoples who spoke many
different languages. But the
normal language for the king's
officials throughout the empire
was Aramaic — the language in
which this letter was written.

Aramaic had been the
common language of the
Assyrian Empire. 'Speak to us in
Aramaic,' King Hezekiah's officials
had said to the envoys of the
Assyrian King Sennacherib (2
Kings chapter 18). 'Don't speak to
us in Hebrew in the hearing of
the people.'

The letters to and from the
Persian king in Ezra chapters 4-7
are recorded — as one would
expect — in Aramaic.

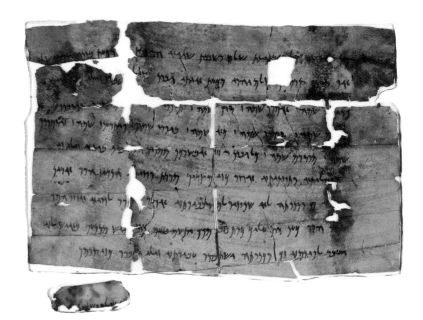

THE INFLUENCE OF GREECE

Between the Testaments: the spread of hellenistic culture

The biblical books of Ezra, Nehemiah and Esther cover the last century of Old Testament history to around 433 BC. Several centuries elapse before the beginning of the New Testament. These are covered in part by some of the Deuterocanonical books (the Apocrypha). What happened to Judah during this time is important for any understanding of the background to the New Testament.

In 490 BC the Persians were defeated by the Greeks at Marathon. For the first time their supremacy was threatened. But more than a century passed before Alexander's Greek army began to demolish the Persian Empire. It took just ten years to win total control, from Egypt to India. Alexander died in 323 BC, only thirty-two years old. The Empire was divided among his four generals. The Seleucid rulers controlled Palestine from Antioch in Syria. The Ptolemies ruled Egypt.

The effect of Greek rule was quite different from that of the earlier overlords. For the Greeks were not simply interested in power. They deliberately set out to impress Greek ('hellenistic') culture and ideals on their subjects, and there was much to attract. Greek replaced Aramaic as the international language. City-states were established everywhere on the Greek pattern, each with its public 'square' *(agora),* its theatre where plays were performed as part of the religious festivals, its temples and public buildings. In Palestine the influence of Greek thought and culture penetrated deep into Jewish society. It remained, even when Greek rule gave way to Roman. This is clearly evident in the New Testament records.

The opening scenes in Gallery Eight represent the glory of classical Greece. A sequence of vase paintings illustrates different aspects of Greek life. Photographs from the 'Ten Towns' district adjoining Galilee illustrate hellenistic influence within Palestine itself, continuing into New Testament times.

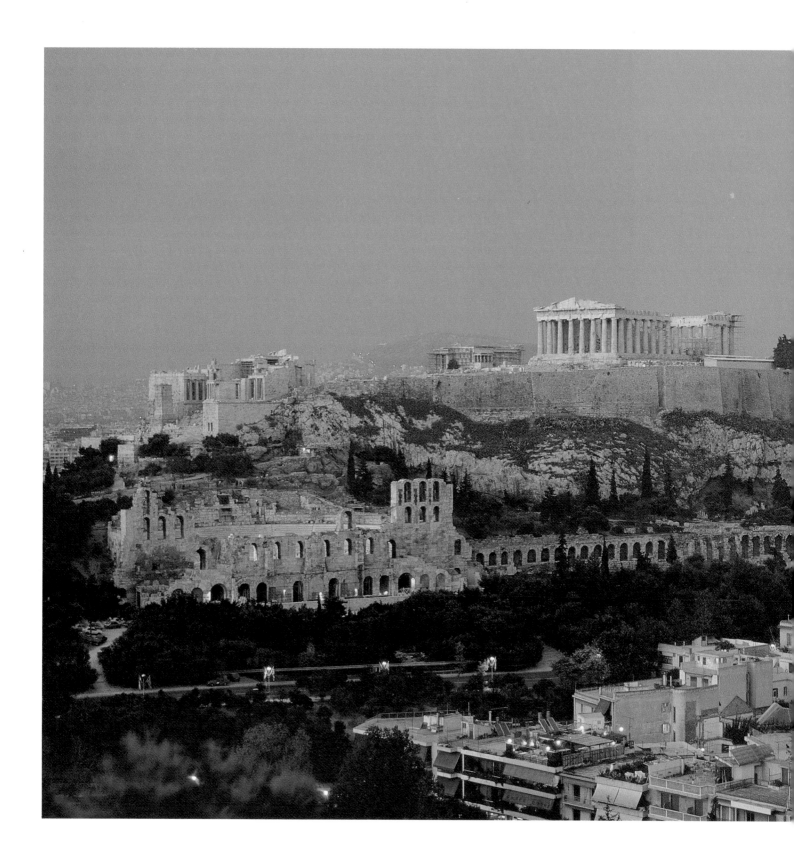

8.1*
The Parthenon, built high on the acropolis at Athens, is one of the great glories of Greek architecture.

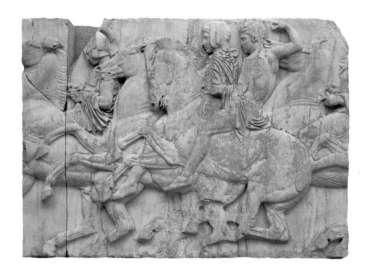

8.2*
This procession of riders is part of the sculptured frieze from the Parthenon at Athens.

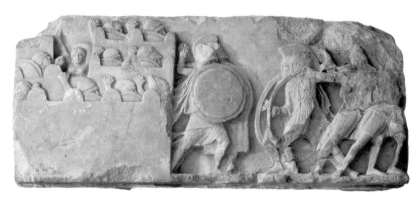

8.3*
A sculptured frieze from the monument of the Nereids at Xanthos (about 400 BC) shows an attack on a city.

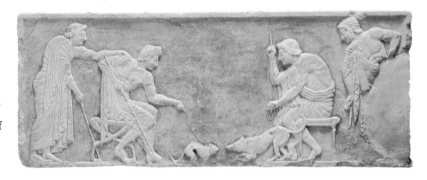

8.4
Fashions may change, but human nature varies little. This sculptured relief from the base of a Greek statue (about 510 BC) shows youths of the time setting dog against cat.

8.5,6*
From Macedon in Greece the
twenty-one-year-old Alexander
— portrayed in this mosaic from
Issus — marched his army across
the Near East to conquer Persia.
By the time of his death in 323 BC
at the age of thirty-three his
empire stretched east to the
Indus and south through Syria to
Egypt. His motivation was not
simply conquest but the spread
of Greek culture and thought.

In the wake of Alexander's
conquests came the universal
spread of the Greek language —
taking over from Aramaic — and
the Greek way of life. The
sequence of Greek vase-paintings
illustrates many aspects of Greek
life.

An amphora from Camirus
(right) dating from about 520 BC
pictures the chariot race. The
modern Olympic Games are
derived from the ancient Greek
games, associated with religious
festivals.

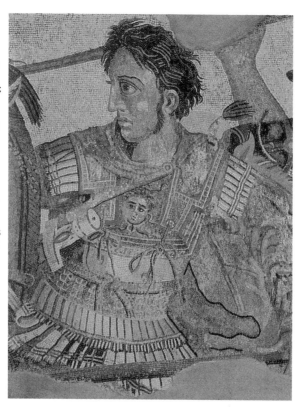

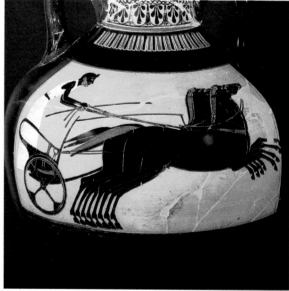

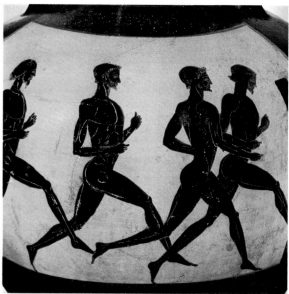

8.7
Another Greek vase (about 470
BC) shows long-distance athletes
approaching the turning-post.

8.8*
On this sixth-century vase, spectators applaud as the seated figure is crowned with a wreath.

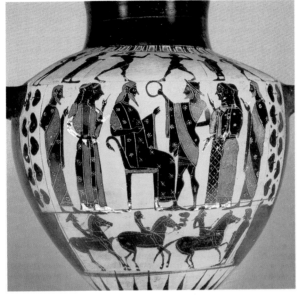

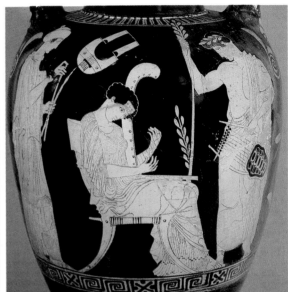

8.9*
Greek culture was rich in music and the arts. A vase from Vulci (right), about 440 BC, shows Terpsichore, the muse of dance and song, playing the harp. Melousa holds a double flute *(aulos)* and Musaios a lyre.

8.10*
Women fill their water-jars at the fountain in this scene from everyday life. The vase dates from about 520 BC.

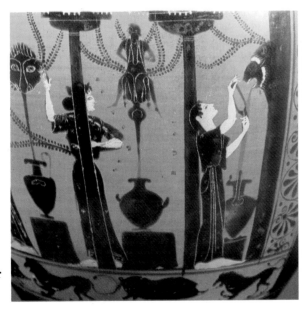

8.11*
Both merchant-ships and warships, pictured on this vase (right; about 540 BC), played their part in the spread of Greek influence.

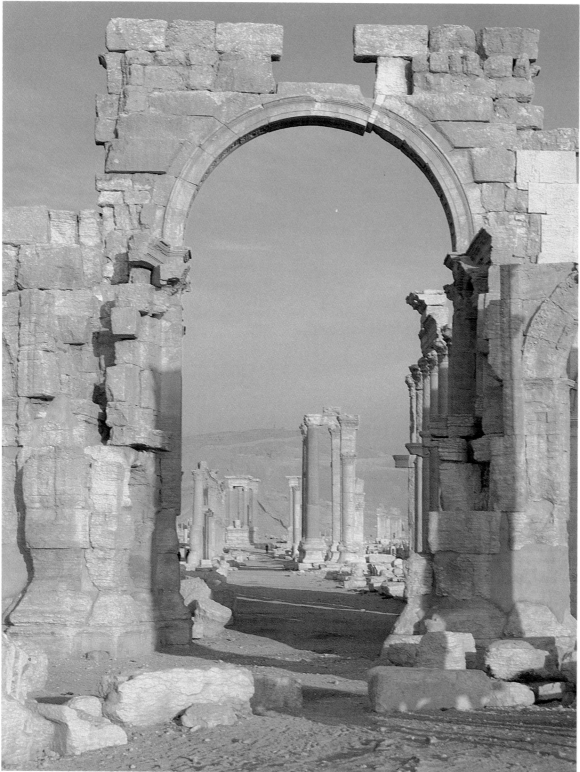

8.12
Throughout the empire city-states organized themselves on the Greek pattern. Greek influence was particularly strong in Syria and Palestine where Alexander's generals ruled from the time of his death. It continued on into the time after the Romans came. Everywhere, even today, the ruins of magnificent cities built by the Greeks remain to impress. This picture is of Palmyra in Syria (second or third century AD).

8.13*
Massive temple columns from the first or second century AD still stand at Baalbek in Lebanon (right). Distant snow-capped mountains form a backcloth to the city.

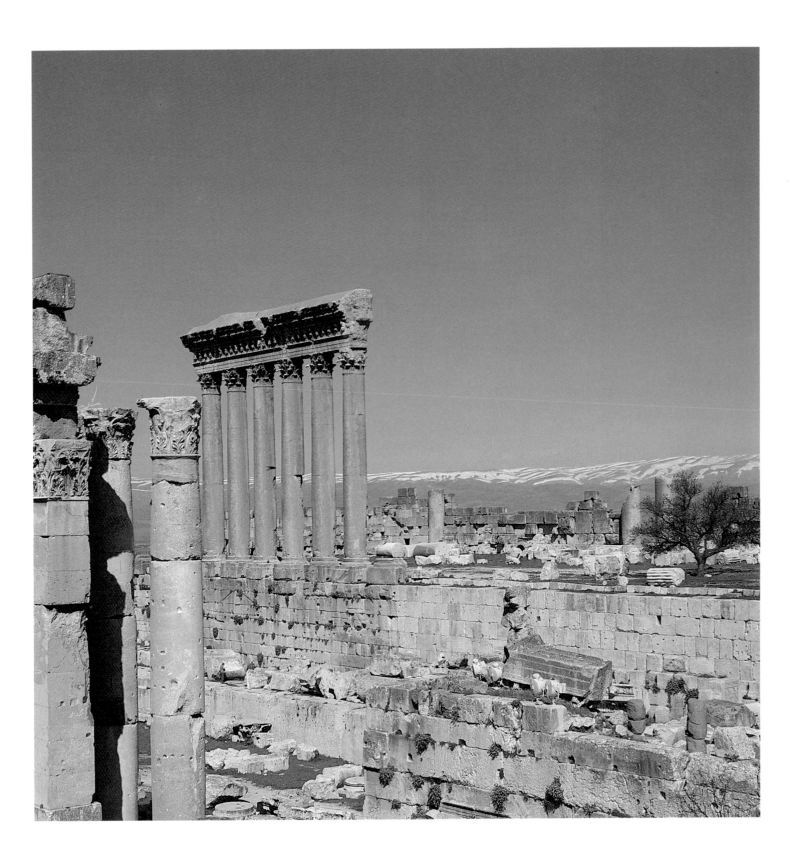

8.14,15*
About the time of the birth of
Jesus, ten Greek towns occupying
a large area south of Lake Galilee
and (mainly) east of the Jordan,
formed a league for trade and
defence. Known collectively as
the Decapolis or Ten Towns, they
included Gerasa (Jerash, right)
and Gadara (below) in present-
day Jordan. People from this area
joined the crowds of Jesus'
followers, and he visited the
region during his ministry.

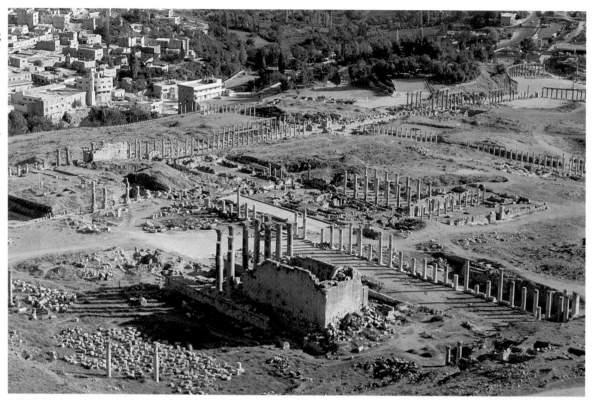

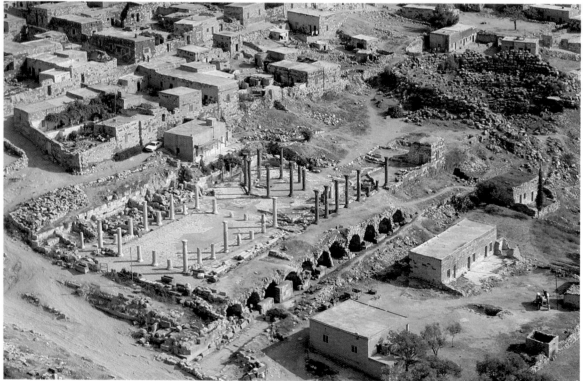

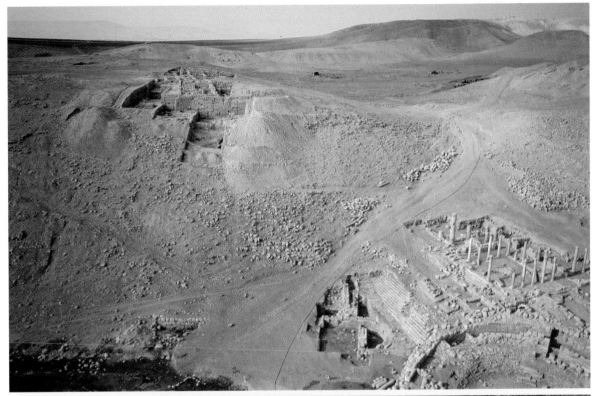

8.16
Pella is another of the Ten Towns. The site is seen here in course of excavation.

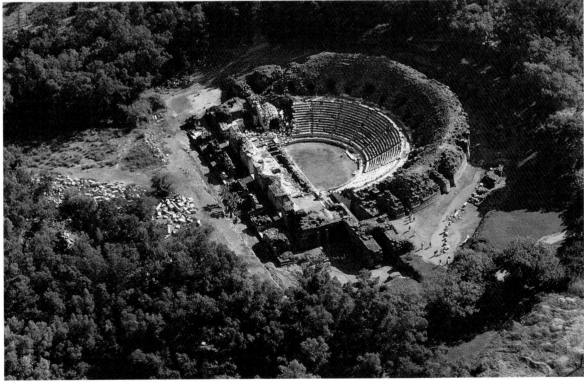

8.17*
Each major town built to the Greek pattern had its market-place and theatre. Greek theatres were built to seat the huge crowds which gathered for the annual religious festivals at which the plays were staged. The photograph shows the theatre at Beth-shan, refounded as the hellenistic city of Scythopolis.

8.18*
Greek religion, with its pantheon of gods, spread its influence along with the rest of Greek culture. The Romans annexed the gods, with so much else that was Greek — simply giving them Roman names. A hellenistic copy of a fourth-century BC sculpture portrays Zeus, ruler of the gods.

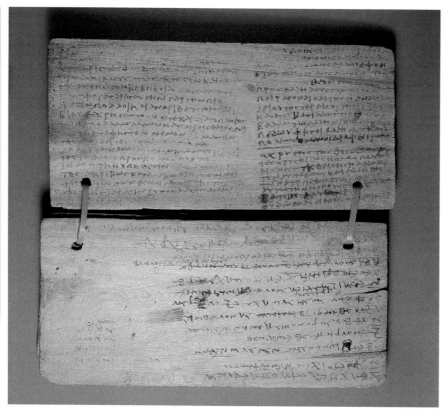

8.19*
The most important single unifying factor of the Greek Empire was the Greek language as a *lingua franca,* making communication possible between peoples of many different races and languages. It was in everyday *(koine)* Greek that the New Testament Gospels and letters were written: making their message instantly accessible from east to west, from north to south of the great Roman Empire.

The wooden pages pictured here are part of the work book of a Greek schoolboy.

TEMPLE AND SYNAGOGUE

The religious background to the New Testament

There can be little understanding of the New Testament without some knowledge of Jewish religious background. From the time when God first called Abraham to father a new nation, faith was central. The people of Israel were God's people, charged with obeying his laws, worshipping as he instructed in tabernacle and Temple. They were bound by covenant-agreement to him. God was their true King. The vital core remained, through disobedience, judgement and exile. But the Temple was destroyed, its festivals and sacrifices abandoned, and the exiles were far from home. During this testing time new forms of worship evolved, focussed now on the local synagogue. Here children could be instructed in the faith by teachers of the Law, and Sabbath by Sabbath people could gather to hear the scriptures read and explained, and to worship God in prayer and song.

The exiles returned. The Temple was rebuilt. The old sacrifices and festivals were re-established. But the synagogue became the focal point for the local community, with visits to Jerusalem once or twice a year for the great festivals, when this could be managed. This pattern is reflected in the New Testament Gospels. As a boy, Jesus went with Mary and Joseph to celebrate the Passover in Jerusalem. As a man, his ministry began in the local synagogue. And his life ended on the eve of another Passover in Jerusalem. The Gospels make frequent mention of the teachers of the Law, and of two religious 'parties': the Pharisees with their strict adherence to the Law, and the conservative but politically compromising Sadducees.

Gallery Nine begins with the outward signs of the individual's commitment to God's laws. The Temple built by King Herod and demolished by the Romans is shown in reconstruction. At the end of the gallery we see a synagogue in reconstruction and as it can still be seen in Capernaum.

9.1
From the earliest days of Israel's
religion the sound of the ram's-
horn trumpet *(shofar)* called
God's people to the great
religious festivals. Here an
orthodox Jew sounds the *shofar*
at the Western Wall in Jerusalem.
Today the *shofar* still calls the
people to assemble for worship
in the synagogue on the eve of
the Day of Atonement *(Yom
Kippur)*.

9.2*

'Fix these words of mine in your hearts and minds; tie them as symbols on your hands and bind them on your foreheads. Teach them to your children . . . Write them on the doorframes of your houses and on your gates.' These are the commands of Moses, according to Deuteronomy chapter 11. They were observed literally by the Law-keeping Pharisees at the time of Christ and are still observed by orthodox Jews today.

This Jewish boy was photographed at his Bar Mitzvah (admission to manhood in the Jewish religious community) at the Western Wall in Jerusalem. He wears a prayer shawl, and the small box (phylactery) on his forehead contains passages from God's Law.

Inside the phylacteries worn by orthodox Jews are the tephillin, tiny scrolls on which are written four passages from the Law: Exodus 13:1-10 and 11-16; Deuteronomy 6:4-9 and 11:13-21.

9.3

The wooden *mezuzah*, containing a parchment scroll on which is written the words of Deuteronomy 6:4-9 and 11:13-21, is fastened beside the door of orthodox Jewish households, in literal obedience to Deuteronomy chapter 11.

9.4*
From the time when King Solomon built the first Temple, Jerusalem, the city of God, became the centre and focal point of Jewish religion. The Islamic Dome of the Rock, built on the place where it is believed Abraham was about to offer Isaac in sacrifice, now stands on the sacred site once occupied by the Temple.

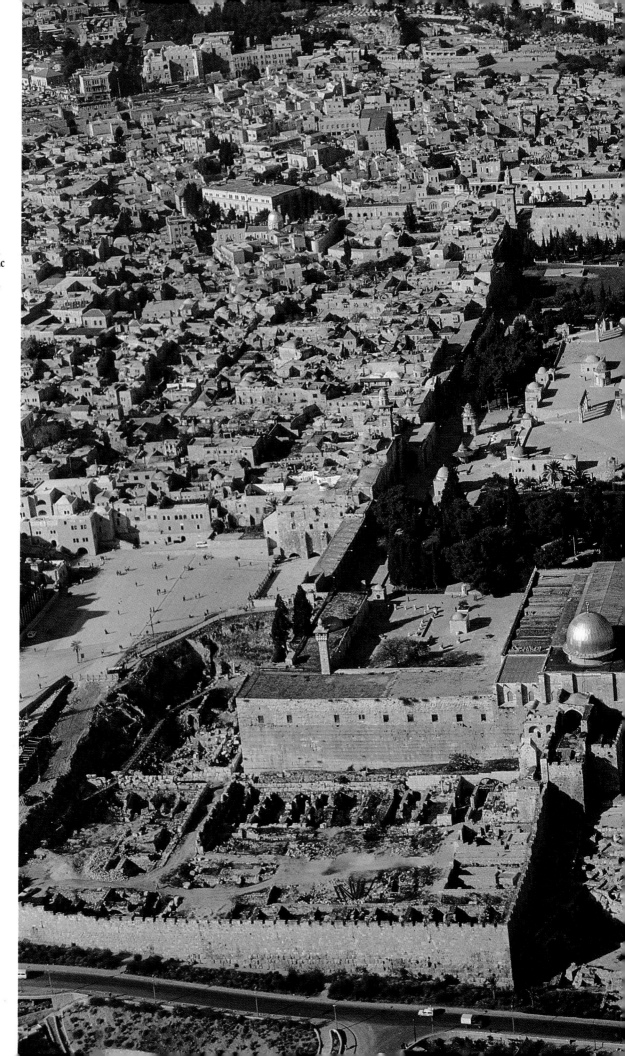

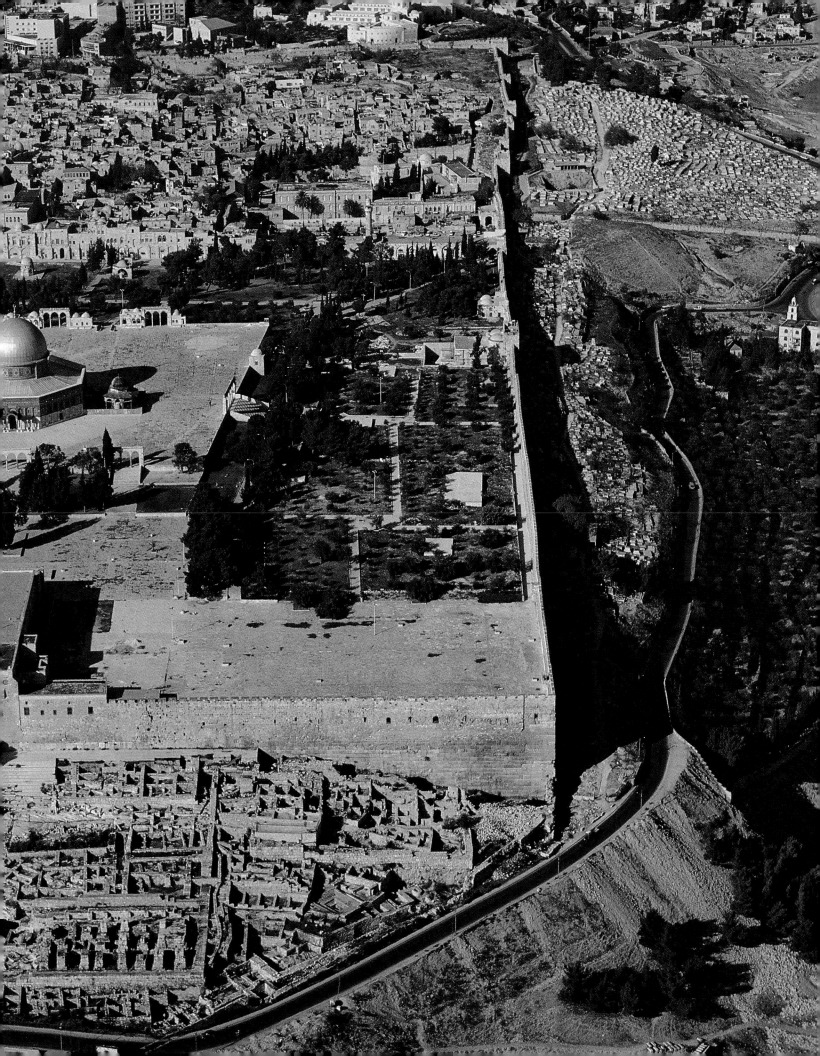

9.5
Solomon's Temple was destroyed
by the Babylonians. A second
Temple, much less splendid than
the first, was built by the exiled
Jews who returned to their
homeland under the Persian
kings. Then in 19 BC King Herod
the Great began work on a third
Temple. The main structure took
ten years to complete, and work
continued until AD 64. This
architect's drawing is based
on various plans and recon-
structions.
 Under the colonnades of the
outer court the teachers of the
Law had their schools and held
debate. (This was where Mary
and Joseph found the missing boy
Jesus, on his first visit to
Jerusalem.) Here too the
merchants and moneychangers
had their stalls (overturned by an
angry Jesus on a later visit to the
Temple, because they cheated the
people, turning God's house into
'a den of thieves').
 Inside, the Court of the
Women contained the chests for
gifts towards Temple expenses.
(Here Jesus watched the widow
give her only coins, and
contrasted her generosity with
the showy but far less sacrificial
gifts of the rich.)
 Men were allowed into the
raised Court of Israel. But the
innermost Court around the
sanctuary was the province of
the priests.
 The Temple itself was built to
the same plan as King Solomon's,
with two inner rooms separated
by a curtain — the 'veil of the
Temple' which, according to the
Gospels, was torn from top to
bottom at the time of Christ's
death on the cross. By his
atonement, all were now able to
come directly to God.
 In AD 70, six years after the
completion of this magnificent
building of cream stone and gold,
it was totally destroyed by the
Romans, as Christ predicted.

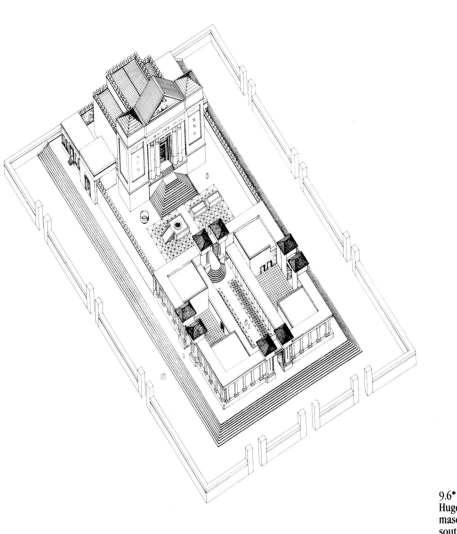

9.6*
Huge blocks of Herodian
masonry can still be seen at the
south-east corner of the city wall.

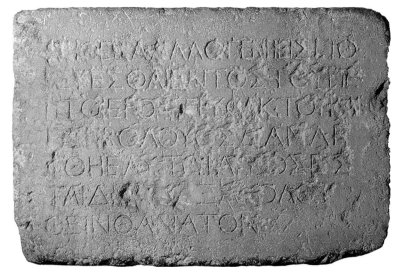

9.8*
Only Jews were allowed to pass beyond the outer courtyard of the Temple. Notices written in Greek and Latin forbade others to enter on pain of death. The book of Acts records a near-riot when the Jews thought that the apostle Paul had taken one of his Greek friends into the Temple court. Amazingly, in 1871, one of these Greek notices, engraved on a limestone block, was found in Jerusalem. And in 1936 part of another came to light.

9.7*
The Arch of Titus in Rome shows Roman soldiers carrying the great candlestick and other treasures from the Temple, after the sack of Jerusalem in AD 70.

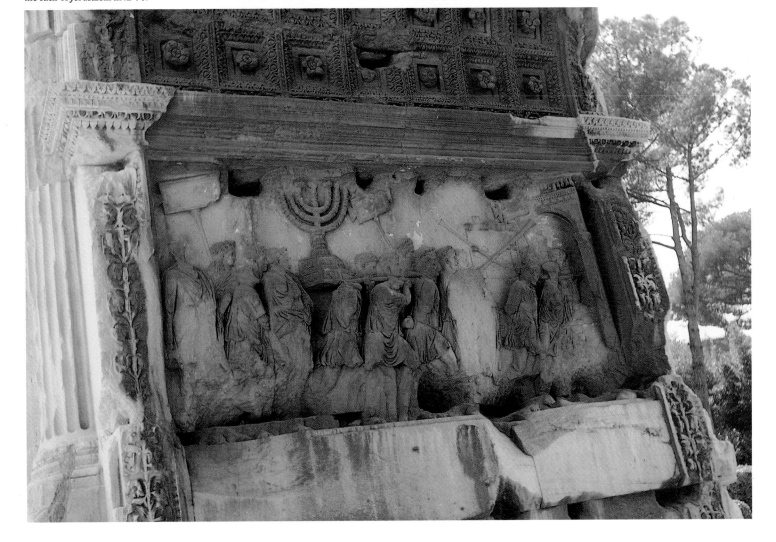

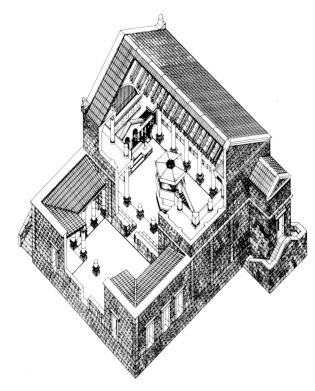

9.9*
Starting at the time of the exile —
when the Temple had been
destroyed and the Jewish people
were far away from Jerusalem —
a new kind of religious gathering
developed. Groups of Jews (a
minimum of ten men was
required) formed local
congregations or synagogues.
Here, on the Sabbath and on holy
days, people met for prayer and
the reading of God's Law.

The synagogue became the
centre of the local Jewish
community and the place where
boys were instructed in the faith.
By the first century there were
synagogues wherever Jews lived.

In the synagogue at Nazareth,
Jesus read from the scroll of
Isaiah, 'The spirit of the Lord is
on me . . .' Then he made an
electrifying announcement:
'Today this Scripture is fulfilled.'
Paul, travelling from place to
place with the Good News, began
with the Jews in the local
synagogues.

The diagram shows a fairly
lavish synagogue of the third or
fourth century. At one end is the
ark or tabernacle containing the
rolls of Hebrew Scriptures. The
men stood around the central
pulpit, from which the Scriptures
were read and explained. The
women were normally
segregated from the men: here
they have a special gallery.

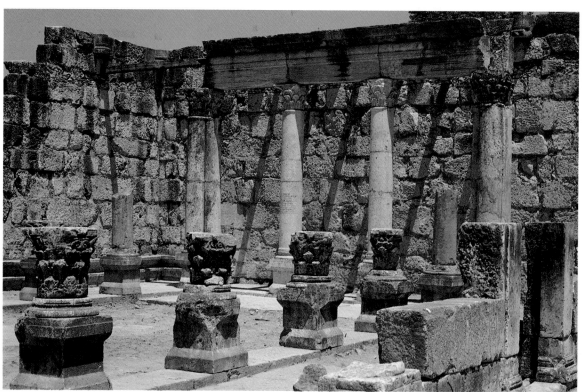

9.10*
The Gospel of Luke chapter 7
mentions a Roman centurion at
Capernaum whom the people
asked Jesus to help because 'he
loves our nation and has built
our synagogue'. The remains of a
synagogue can still be seen at
Capernaum, though they date
from the third century at the
earliest.

9.11,12,13*
Interestingly, the Capernaum
synagogue shows a mix of Roman
architectural style and
characteristic Jewish symbolism:
a device of grapes and a Jewish
star; the capital of a column,
carved with the seven-branched
candlestick, *shofar* and an
incense-shovel; and the palm
tree.

9.14*
On 1 April 1948 news broke of 'the greatest manuscript discovery of modern times'. Shepherds had discovered, hidden in a cave at Qumran on the edge of the Dead Sea, leather rolls of manuscript, written in Hebrew. One was a copy of the biblical book of Isaiah, 1,000 years older than any other copies of the Bible. There were fifty-four columns of Hebrew writing on a leather roll 7.34 meters/24 feet long and 26 cms/10 ins high, made of seventeen sheets sewn end to end. Scholars reading the scroll found that the Hebrew text on which modern Bible translations are based had hardly changed since the time of Christ. The column shown is part of Isaiah 49:17-51:4.

9.15*
Some of the Dead Sea scrolls were discovered in these caves just opposite the monastic settlement.

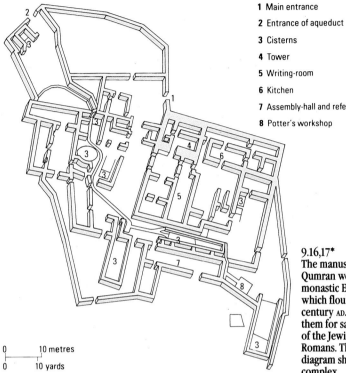

1 Main entrance
2 Entrance of aqueduct
3 Cisterns
4 Tower
5 Writing-room
6 Kitchen
7 Assembly-hall and refectory
8 Potter's workshop

0 ___ 10 metres
0 ___ 10 yards

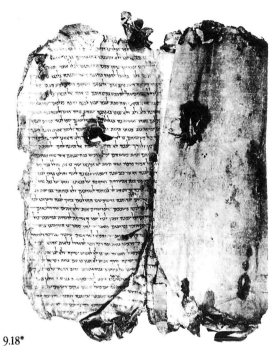

9.16,17*
The manuscripts found at Qumran were the library of the monastic Essene community, which flourished in the first century AD. They had hidden them for safe-keeping at the time of the Jewish revolt against the Romans. The photograph and diagram show the settlement complex.

9.18*
The partially rolled 'Thanksgiving Scroll' from Qumran.

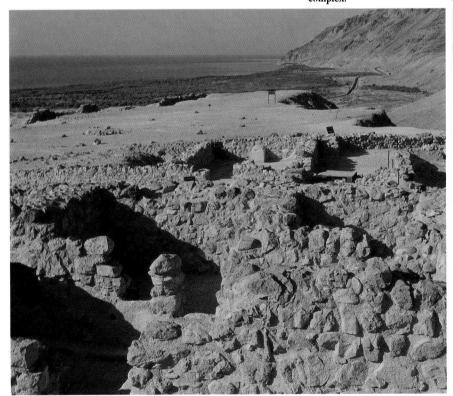

9.19*
Great skill and care is needed to avoid damage as a scroll is opened.

OCCUPATION AND RESISTANCE

Under Roman rule

Rome succeeded Greece as a world power, and the focus shifted west, away from Persia, gradually including the entire Mediterranean. Corinth fell in 146 BC, Athens in 86. While Julius Caesar fought in the west, Pompey subdued Syria and Palestine. Jerusalem was occupied in 63 BC. The legacy of Greece remained: in hellenistic culture, the Greek language, city-states built to the Greek pattern. The Romans themselves copied the Greek theatres and adopted the Greek gods, giving them Roman names. They imposed an enforced peace and order, with garrisons everywhere. There were four legions stationed in Palestine alone. They built roads and aqueducts, baths and amphitheatres. They imposed heavy taxes. In 27 BC Octavian received the title 'Augustus' and became the first ruler of the Roman Empire. Rome was the seat of government for the whole Mediterranean world.

Jesus Christ was born in the reign of Augustus, who died in AD 14. His ministry, death and resurrection took place under the rule of the next emperor, Tiberius. Paul's travels belong to the time of Claudius and of Nero.

Palestine was governed first through Herod the Great and his three sons. This failed in Judea and a Roman governor (a 'procurator') was appointed. The first emperors encouraged respect for their subjects, but the Jews and their religion were hard to understand. Pontius Pilate and the governors who succeeded him provoked anger by their harshness. At length the Jews rose in full-scale rebellion in AD 66, holding out until Titus finally destroyed Jerusalem and its Temple in AD 70.

The pictures in Gallery Ten move from Rome to illustrations of Roman life. The scene then changes to Palestine and the occupation which forms the background to the New Testament; King Herod's strongholds; and the last bastion of Jewish resistance at Masada. The gallery closes with images from a remarkable civilization, that of the Nabataeans in and around Petra in the last century BC and the first century AD.

10.1*
From the middle of the second century BC, the Romans began to take control of other countries. In the first century, while Julius Caesar fought in Gaul, Pompey conquered Syria and Palestine. In 63 BC he occupied Jerusalem. The eastern Mediterranean now fell under the control of Rome. This statue of a Roman consul epitomizes the authority of Roman rule.

10.3
The Colosseum in Rome was built in AD 80. Here up to 45,000 people could watch the gladiators fight, or witness simulated sea battles. The name 'Colosseum' comes from the gigantic statue of the Emperor Nero, which stood nearby.

10.2
The photograph shows the forum (town centre) of ancient Rome, with the arch of Septimus Severus in the foreground and the Temple of Castor and Pollux behind.

10.4*
The Roman peace *(pax Romana)* was bought and maintained by military force. Trajan's column in Rome, erected early in the second century AD, depicts scenes from the Dacian campaign.

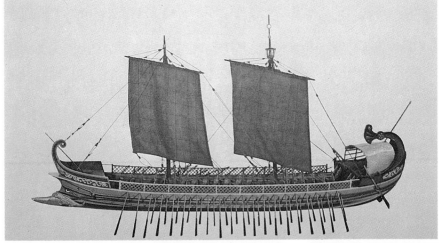

10.5
The model represents a Roman warship from the first century BC.

10.7*
The Emperor Claudius (below) was on the throne when the apostle Paul made his first church-planting journeys. In AD 54 Claudius died and the reign of Nero began.

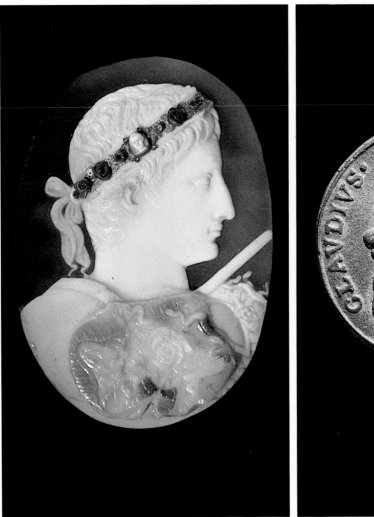

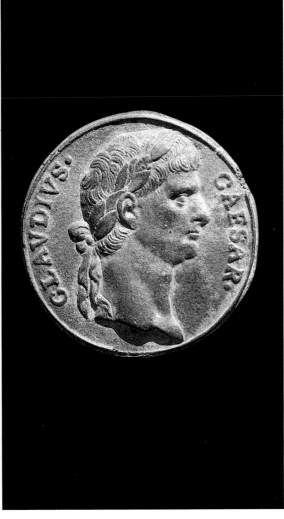

10.6*
Augustus Caesar was the first Roman emperor, ruling from 27 BC to AD 14. It was during his reign that the decree was issued 'for all the world to be taxed'. In far-off Palestine, Mary and Joseph journeyed to Bethlehem, where, in fulfilment of the ancient prophecies, Jesus Christ was born.

10.8
This head of a Roman lady gives
some idea of the elaborate
hairstyles of the wealthy in New
Testament times.

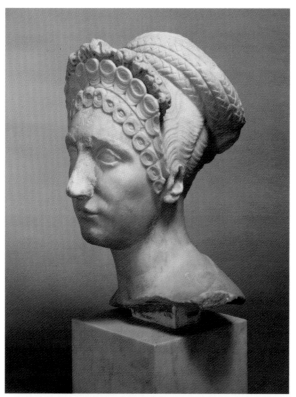

10.10
The fresco from Naples (right)
shows a group of musicians from
Roman times.

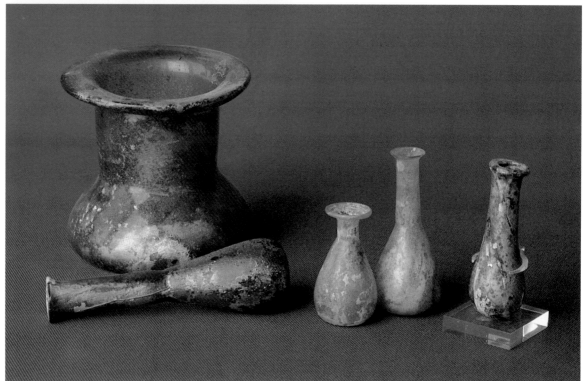

10.9
These lovely examples of Roman
glass have survived from the
first-second centuries AD.

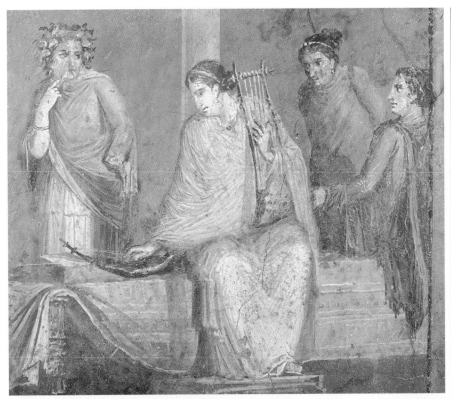

10.11*
The Romans are remembered for their buildings, baths, roads — and spectator sports. This Roman lamp found at Paphos in Cyprus depicts a gladiator.

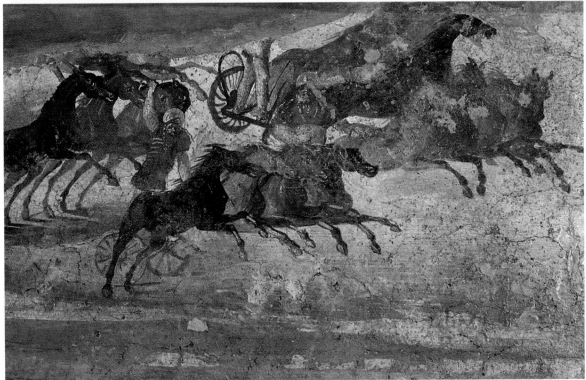

10.12
The wall-painting from Pompeii shows a Roman chariot race. The apostle Paul, in the New Testament letters, uses the images of the athlete and the charioteer to encourage his fellow-Christians. 'Forgetting what is behind and straining toward what is ahead, I press on toward the goal to win the prize for which God has called me' (Philippians chapter 3).

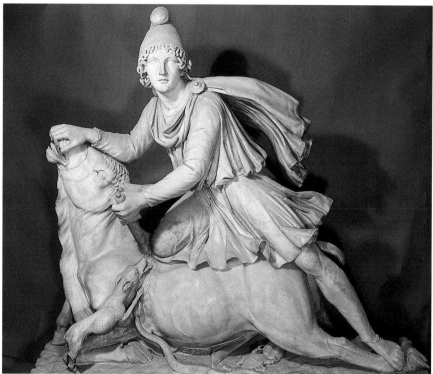

10.13*
One of the foreign cults which made its mark on the Roman world of the first century was that of the Persian Mithras, who became the soldiers' god. Mithraism was, for a time, a serious rival to Christianity. The sculpture shows Mithras slaying the bull.

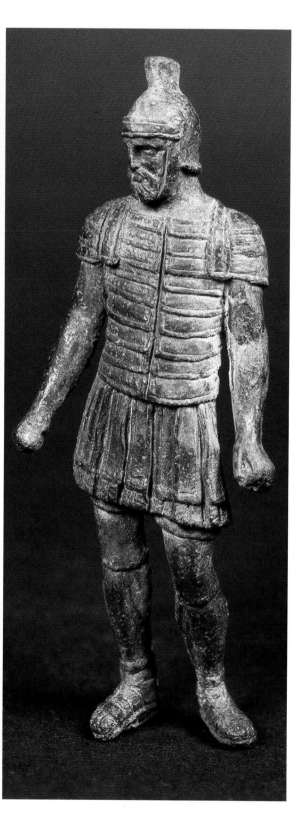

10.14*
Soldiers of the Roman legions were needed to keep the peace throughout the empire. Not for a moment could the Jewish people forget that Palestine was an occupied country. There were Roman soldiers everywhere.

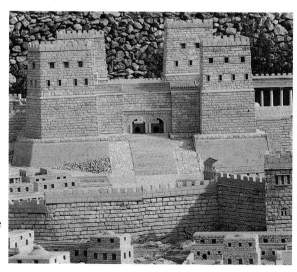

10.15*
The model shows the Fort of Antonia, the Roman garrison in Jerusalem, close to the Temple. Troops were quickly on the scene when trouble broke out, as in the case of the riot which led to Paul's arrest (Acts chapter 21).

10.16
Inscriptions describe King Herod
the Great as 'the friend of Rome'
and 'Caesar's friend'. He rebuilt
the city of Samaria, naming it
Sebaste ('Augustusberg'). His new
city of Caesarea (pictured here)
was built in Roman style and also
named in honour of the emperor.

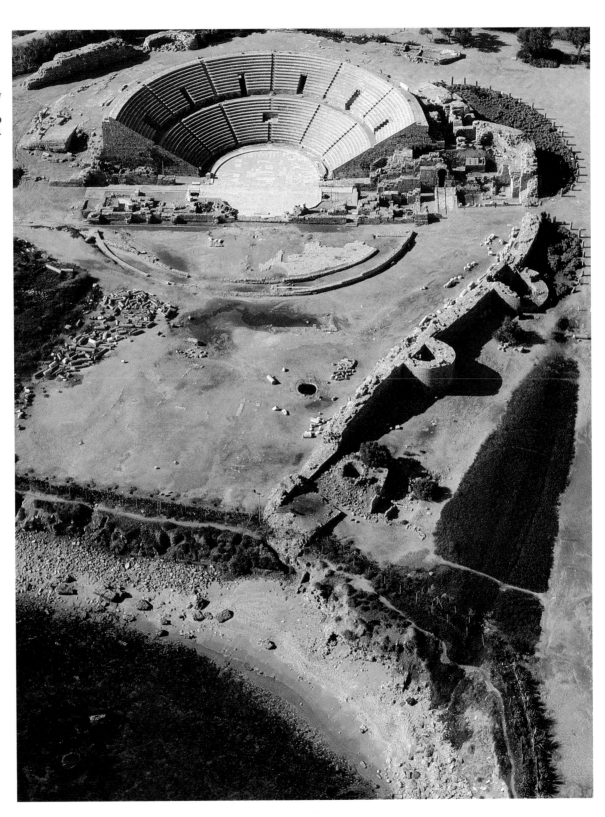

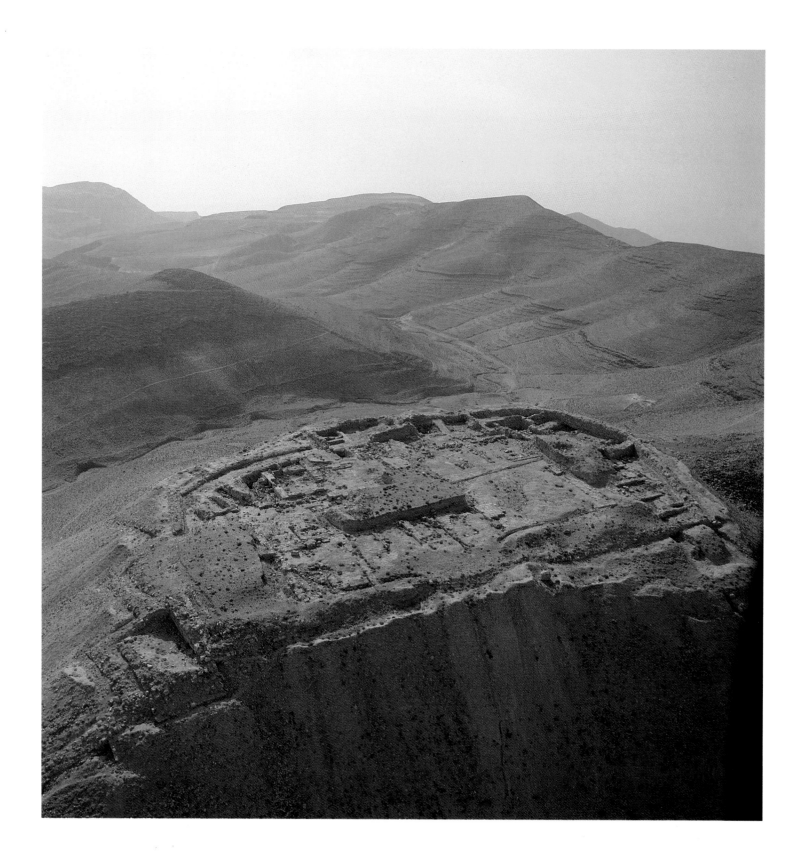

10.17*
The Romans may have trusted Herod, but all his life he lived in fear of the Jews, who hated him. To ensure his safety, he built one castle-fortress after another. The photograph (left) shows his hill-top stronghold at Machaerus, east of the Dead Sea. Here John the Baptist was executed.

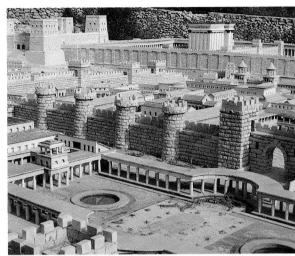

10.19*
The model suggests the style of King Herod's palace in Jerusalem. To escape the winter cold, Herod also rebuilt a palace near Jericho, where the temperature stayed 10 degrees warmer.

10.18*
The aerial view highlights the defensive position of another of Herod's fortresses, Herodium, in the hills south of Jerusalem. Inside the walls were a garden, a suite of baths, dining-hall and private apartments. There was a second palace at the foot of the hill.

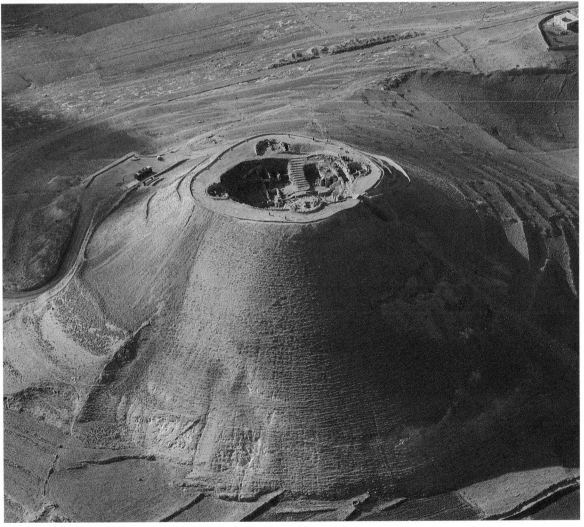

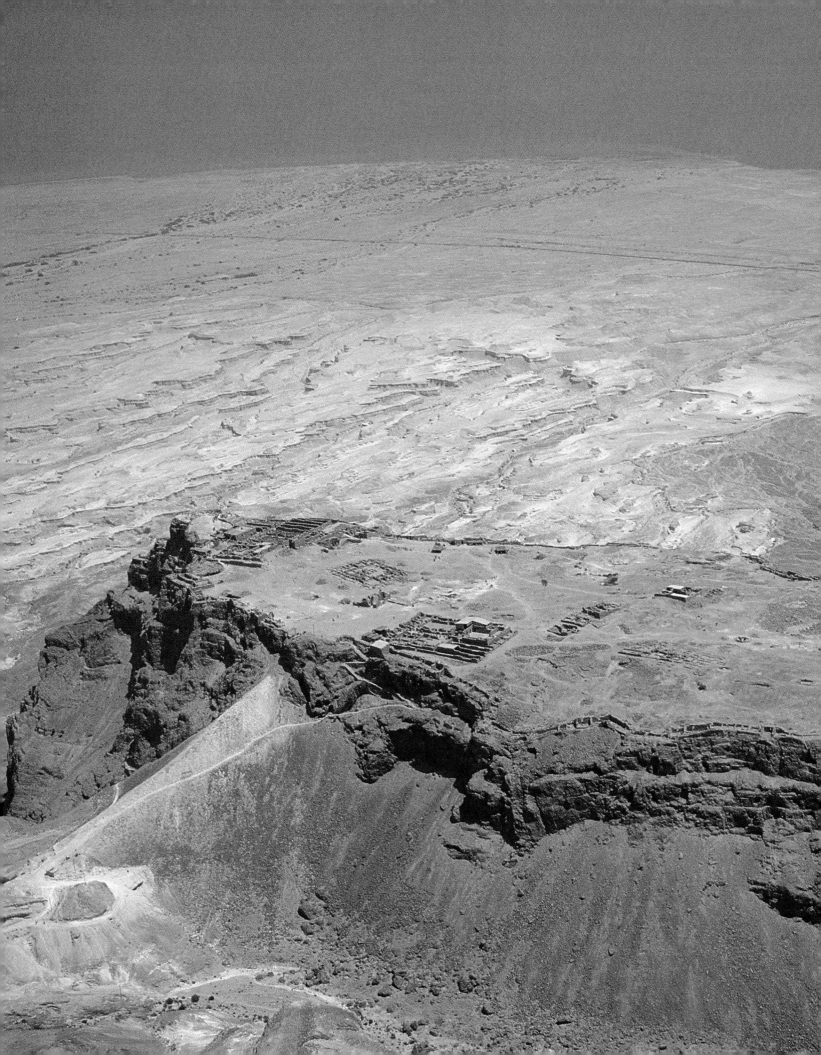

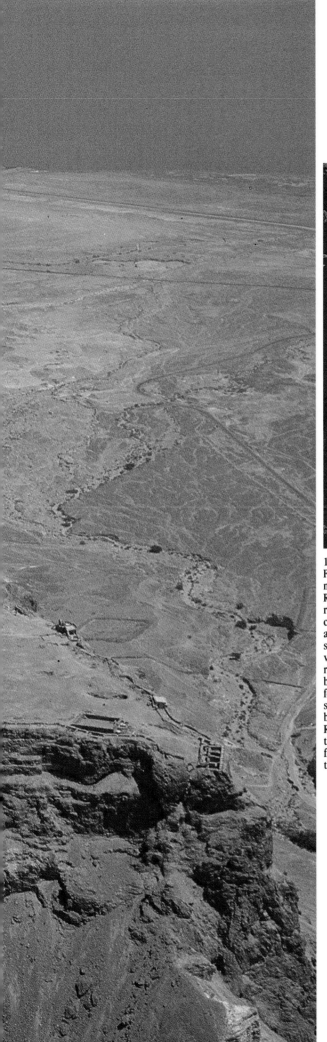

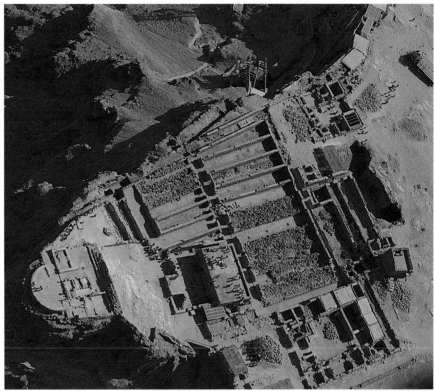

10.20,21*
From AD 70-73 Jewish rebels
made a last stand against the
Romans at Masada, an isolated
rock-fortress in the barren area
close to the Dead Sea, and
another of King Herod's
strongholds. The wider aerial
view clearly shows the great
ramp which the Romans had to
build in order to capture the
fortress. But victory brought little
satisfaction. When they had
broken through the wall, the
Roman soldiers discovered that
the defenders had killed their
families and one another, rather
than surrender.

10.22*
In the bath-house at Masada,
beside the skeletons of a man,
woman and child, archaeologists
uncovered fragments of a prayer
shawl, and the woman's sandals
and braided hair.

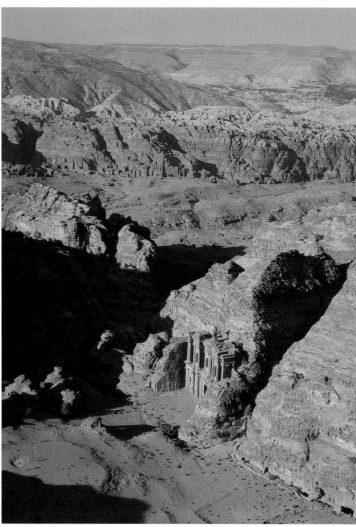

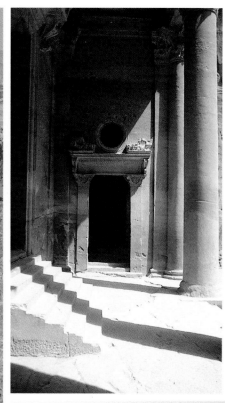

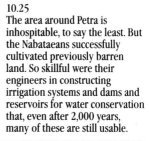

10.24*
The Nabataeans controlled important trade routes, levying tolls on merchants who brought luxury goods — spices and silks — from India and China to the Mediterranean to satisfy the increasing Roman demand. The photograph shows part of one of the magnificent tombs, 'the Treasury', at Petra, hewn out of the red-rock cliffs.

10.25
The area around Petra is inhospitable, to say the least. But the Nabataeans successfully cultivated previously barren land. So skillful were their engineers in constructing irrigation systems and dams and reservoirs for water conservation that, even after 2,000 years, many of these are still usable.

10.23*
In the last century BC and the first century AD, a remarkable civilization — that of the Nabataeans — flourished in the region to the south and east of the Dead Sea. The Nabataean capital, Petra, surrounded by high cliffs and deep ravines, was almost impregnable.

IN THE STEPS OF JESUS

The New Testament Gospel of Mark begins with these words: 'This is the Good News about Jesus Christ, the Son of God. It began as the prophet Isaiah had written: God said, "I will send my messenger ahead of you to clear the way for you." Someone is shouting in the desert, "Get the road ready for the Lord; make a straight path for him to travel!" '

For some 500 years since their return to their own land the Jews had lived under foreign occupation. Throughout that time they had nursed the hope of a Deliverer, the Messiah whom God would one day send according to the predictions of Isaiah and other Old Testament prophets.

The Gospel writers were in no doubt that Jesus Christ was God's promised Messiah, the fulfilment of the ancient prophecies, sent at God's appointed time — though the accounts of his life make it plain that the method and terms of his deliverance were not as anyone expected. The Jews were hoping for a leader to throw off the yoke of Rome. Jesus declared he had come to set mankind free from the burden, guilt and consequences of sin, to offer a new and abundant life. To do so, it was necessary for him to die.

Gallery Eleven follows in the steps of Jesus, from his birthplace of Bethlehem to Nazareth, where he grew up; to the banks of the Jordan where he was baptised and into the Judean desert, the scene of his testing; to the country and towns of Galilee where so much of his ministry took place; to the foothills of Hermon which saw his transfiguration; to the well at Samaria; to Jerusalem and the Temple precincts where the last momentous days of his life were spent; to Gethsemane, Golgotha and a first-century tomb like the one whose stone was mysteriously rolled back on the joyous morning of his resurrection.

11.1

In the year 4 BC, or a little before, Magi from the East arrived in Jerusalem in search of a new-born king. 'Where do the prophets say the Christ will be born?' King Herod asked the teachers of the Law. 'In Bethlehem in Judea,' came the reply. And they quoted the words of the prophet Micah:

'But you, Bethlehem, in the land of Judah, are by no means least among the rulers of Judah; for out of you will come a ruler who will be the shepherd of my people Israel.'

The little town of Bethlehem, 8 kms/5 miles south-west of Jerusalem, is set on a hill-top, surrounded by terraced slopes of olive-trees. It was here, because of a census ordered by the Roman Emperor Augustus which brought Mary and Joseph south from Nazareth, that Jesus Christ was born.

11.2,3

Jesus grew up in the northern town of Nazareth, in Galilee, where Joseph worked as a carpenter. Nazareth lay close to several major trade routes, and the road which the Roman legions travelled. There was easy contact with the outside world.

After his baptism in the River Jordan (right), Jesus went as usual to the synagogue in Nazareth on the Sabbath. The scroll of the prophet Isaiah was handed to him, and he read: 'The Spirit of the Lord is on me, because he has anointed me to preach good news to the poor, to proclaim freedom for the prisoners and recovery of sight for the blind.' But when he claimed to fulfil these words, the people of Nazareth turned on him in anger.

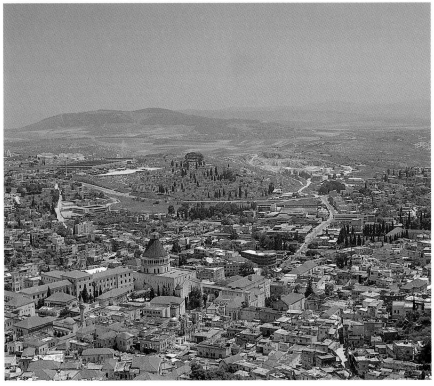

11.4
After his baptism Jesus spent forty days alone in the desert. Amongst these barren hills he faced every test Satan could devise to turn him from God's appointed path.

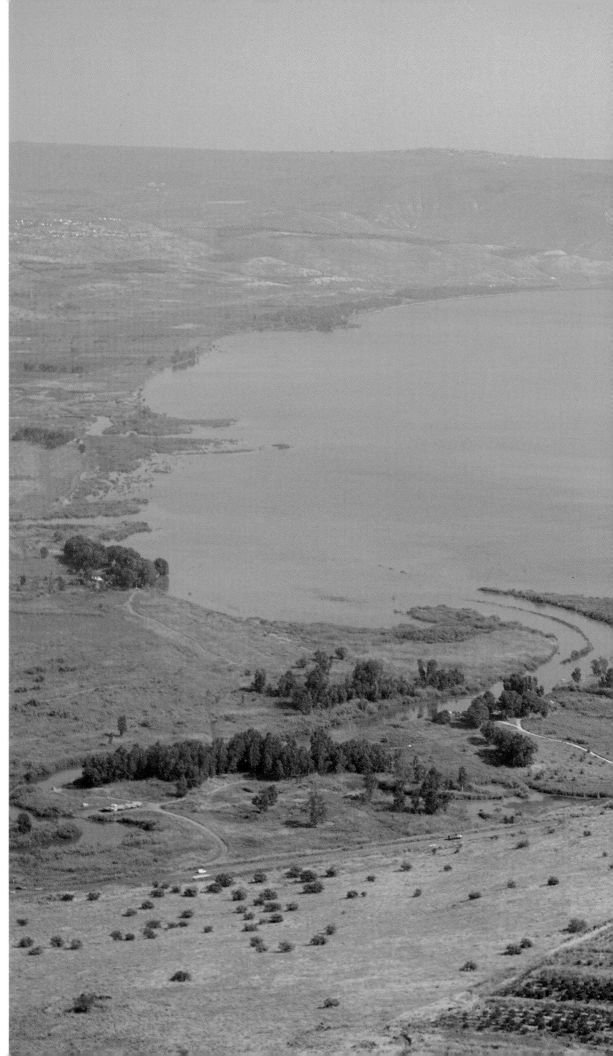

146

11.5

Much of Jesus' teaching and many of his healings took place in the towns and villages set in the fertile hills and valleys around Lake Galilee. The lake itself is not always peaceful, but is subject to sudden fierce squalls, as the wind funnels down between the hills. Lake Galilee is 21 kms/13 miles long and up to 11 kms/7 miles wide and 211 meters/690 feet below sea level. The River Jordan flows through the lake from north to south and its fresh waters abound in fish. In Roman times there was a flourishing export trade from the fisheries.

Jesus taught in the open air in Galilee. He spoke to the crowds of people sitting around him on the hillsides, using familiar country scenes as object lessons: the farmer, sowing his seed; the shepherd, searching for a lost lamb. The flowers 'that do not labour or spin' are clothed by God in a splendour greater than King Solomon's glory — so no one need be anxious over material needs. God knows all about them. 'Seek first his kingdom,' Jesus said, 'and all these things will be given you.'

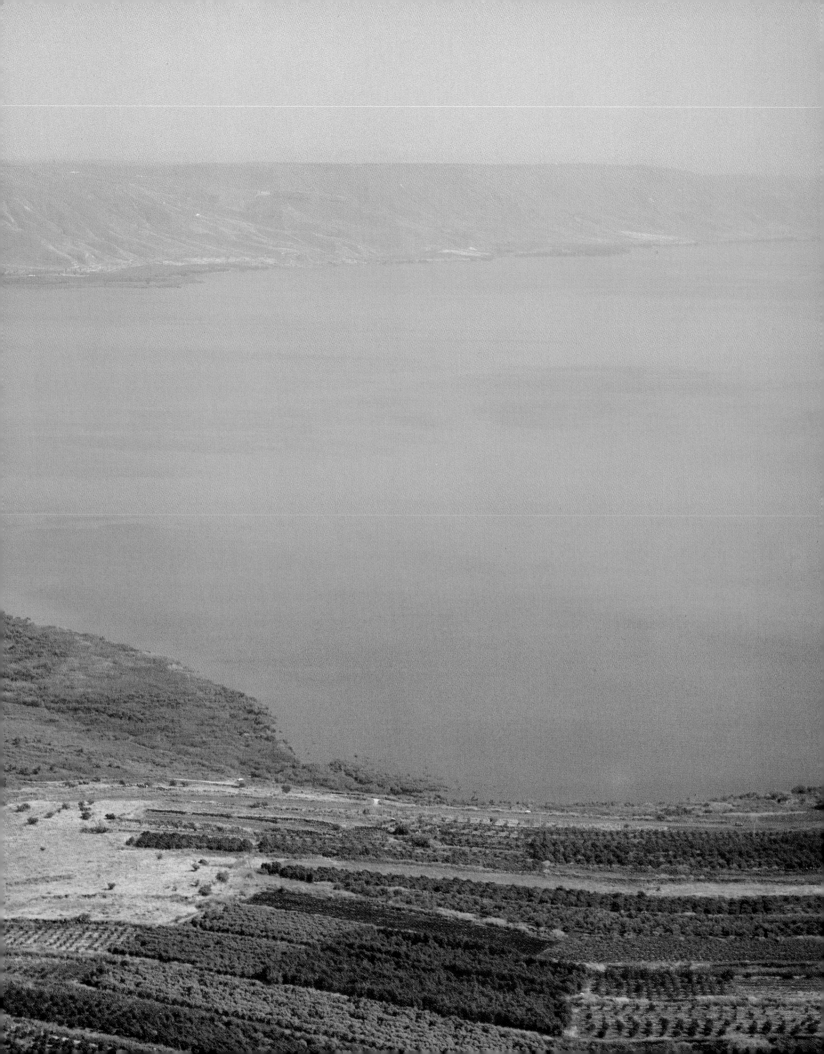

11.6*
According to John's Gospel, the village of Cana in Galilee was the place where Jesus performed his first miracle. When they ran out of wine at a friend's wedding, Jesus' mother, Mary, turned to him for help. And he changed the water in the great stone jars the Jews kept for ceremonial washing, into wine.

11.7*
Capernaum, on the north-west shore of Lake Galilee, became Jesus' base while he was teaching in the region. Matthew, the tax-collector who became one of Jesus' close friends, lived at Capernaum. Here Jesus healed the apostle Peter's mother-in-law, and the servant of a Roman centurion who had helped the Jews to build their synagogue. But although they heard Jesus often and saw what he did — so the Gospel writers record — the people of Capernaum did not believe God's message.

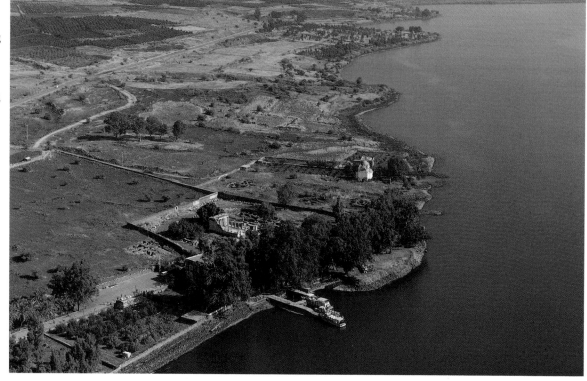

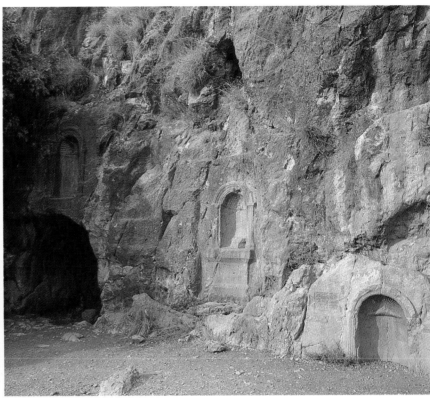

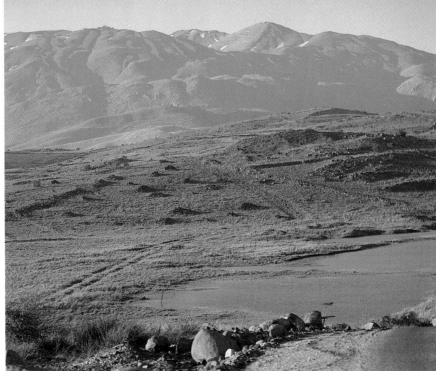

11.8
On one of his journeys from Nazareth to Jerusalem, Jesus chose to take the short route through Samaria. Jews regarded the Samaritans as 'untouchables'. But John's Gospel chapter 4 describes how Jesus, sitting beside the well, engaged a Samaritan woman in conversation. At the end of it: 'I know that Messiah is coming,' the woman said. 'When he comes, he will explain everything to us.' Jesus answered, 'I who speak to you am he.'

The well from which the woman came to draw water had a long history. Known as Jacob's well, it can still be seen today.

11.9
Caesarea Philippi was a town in the far north of Galilee, at the foot of Mount Hermon. The name honoured the Romans. But in Old Testament times the place had been a centre of Baal worship, then — under the Greeks — a shrine to the god Pan, whose image once occupied the niches shown in the photograph. It was here, at a strategic point in Jesus' ministry, that the apostle Peter first acknowledged him as the Messiah, or Christ.

11.10
From Caesarea Philippi, Matthew's Gospel records that Jesus took Peter, James and John with him to a 'high mountain' where they saw him radiantly transfigured. The highest mountain in northern Galilee, and close to Caesarea Philippi, is Mount Hermon (on the Lebanon/Syria border), whose melting snows feed the springs of the River Jordan.

11.11
Jesus visited Jerusalem on a number of occasions during his three-year ministry, often for the great religious festivals. Escaping the crowds, he stayed with friends — Lazarus and his sisters, Martha and Mary — in the nearby village of Bethany.

11.12
From Bethany Jesus took a path around the shoulder of the Mount of Olives, from which he would have had a breath-taking view (left) across the Kidron Valley to the great Temple built by King Herod. The Dome of the Rock today occupies the central site of the old Temple area.

11.13*
'There is in Jerusalem, near the Sheep Gate, a pool, which is called Bethesda, which is surrounded by five covered colonnades.' This description (in John's Gospel chapter 5) made it easy for archaeologists to identify the place where Jesus once offended the strict Sabbatarians by commanding a man long-paralysed to pick up his mat and walk.

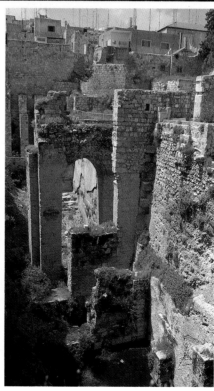

11.14
The aerial photograph (right) focusses on the Old City of Jerusalem, where Jesus spent the last week of his life.

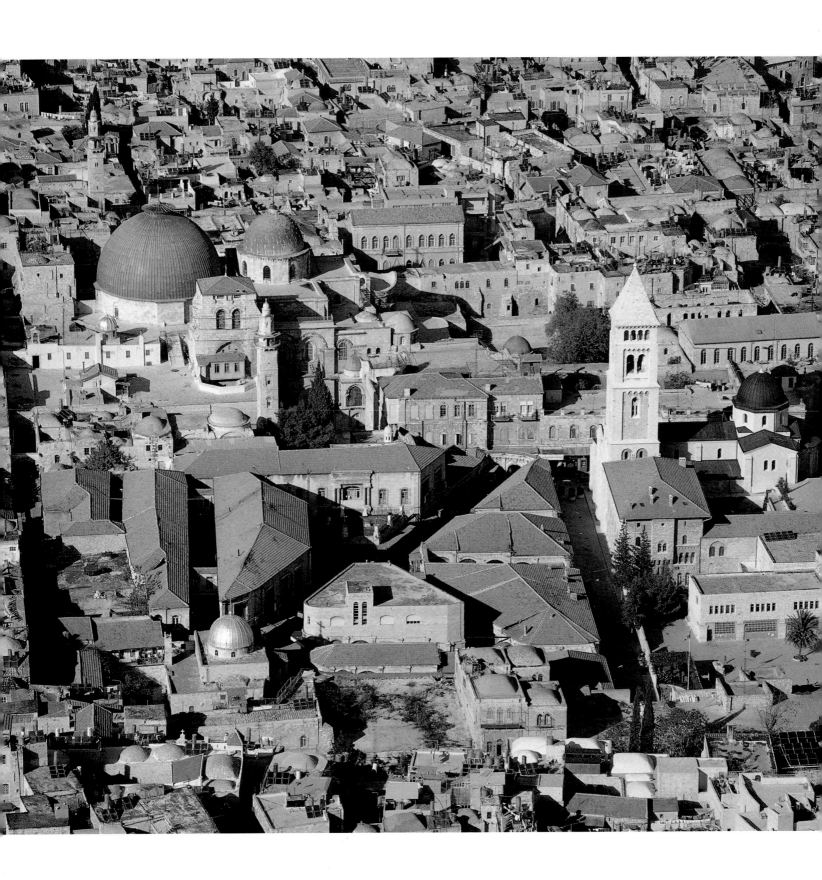

11.15
Jesus had come to Jerusalem
knowing that he was facing
death. On the last evening, after
supper and a long discussion
with his friends, he poured out
his heart in prayer to God under
the olive-trees in a favourite
place — the Garden of
Gethsemane: 'My Father, if it is
possible, let this cup be taken
from me. Yet not as I will, but as
you will.'

The original trees were cut
down by the Romans, under
Titus. But many of the olive trees
which can be seen today are
hundreds of years old.

11.16*
Below the Ecce Homo convent in
Jerusalem is the pavement from
Roman times, rutted, and
scratched with the games the
soldiers played. On such stones
Jesus endured his captors' rough
horseplay.

11.17*
Until 1961 there was no
contemporary evidence for
Pilate's existence, outside the
four Gospels. Then archaeologists
at Caesarea discovered a stone
slab bearing the names 'Pontius
Pilatus' and the title of a building
in honour of Tiberius.

11.18*
False witnesses, a rigged trial, and the threat of riot to force the Roman governor's hand — the sentence passed on Jesus was a travesty of justice. Yet Jesus had known from the first that he had to die. 'As Moses lifted up the snake in the desert, so the Son of Man must be lifted up, that everyone who believes in him may have eternal life,' he told Nicodemus. He was crucified outside the city walls at a place called Golgotha, the 'place of a skull'. It has been suggested that this strange rock formation is Skull Hill; the traditional site lies beneath the Church of the Holy Sepulchre.

11.19*
The body of Jesus was placed in a rock-cut tomb, with a great stone rolled across to seal the entrance. Various examples of just such tombs from the first century have been discovered, in Jerusalem and elsewhere. This one is at Nazareth. There were many witnesses who could swear to the fact that on the first Easter Sunday the tomb was empty. The despairing disciples, even the most unbelieving of them, had to face the amazing fact: Jesus had risen from death.

'INTO ALL THE WORLD'

Peter, Paul and the young churches

Christ's final commission to his followers, recorded at the end of Matthew's Gospel, was to go into all the world, telling people everywhere the good news of forgiveness and new life. The first chapter of the book of Acts adds these words: 'You will be witnesses for me in Jerusalem, in all Judea and Samaria, and to the ends of the earth.' The rest of the book documents how this began to come about after the Day of Pentecost when God's Holy Spirit touched the followers of Jesus with new power. Other historical records affirm the detailed reliability of Luke's account.

Gallery Twelve provides a visual record of the places to which Peter and more especially Paul carried the good news in the years that followed. The starting-point is about AD 30, when the church in Jerusalem was founded. Paul's first missionary journey, from Syrian Antioch to Cyprus and the south and centre of modern Turkey, took place in AD 46 or 47. The second journey, overland from Antioch to northern and southern Greece, returning by sea via Ephesus to Caesarea, can be dated around 48-51. The third journey took Paul first by land to Ephesus, then on to revisit northern and southern Greece, returning the same way. From Troas he took ship on a coastal vessel which travelled by stages down the west coast of Turkey to Tyre and Caesarea. In AD 58 Paul reached Jerusalem, where he was arrested. After two years' imprisonment at Caesarea he exercized his right as a Roman citizen to appeal to Caesar. On the way to Rome Paul's ship was caught in a storm and wrecked off Malta. He reached the capital in AD 61, living under house arrest for the next two years.

The letters Paul wrote to the young churches of Asia Minor and Greece throw further light on the narrative of Acts. Some were clearly written from prison.

The gallery closes late in the first century, with the seven churches addressed in the book of Revelation. The background is one of persecution, with the rise of emperor-worship; the message is one of encouragement. God is in control of human history; victory over evil is certain, if only his people keep faith with him.

12.1*
'Go and make disciples of all nations,' Jesus commanded his followers. They began in Jerusalem on the Day of Pentecost. Persecution scattered them throughout the province of Judea. Then, at Joppa on the coast, Peter experienced a dream or vision (recorded in Acts chapter 10) which confirmed God's calling to make disciples of non-Jews (the Gentiles) as well as Jews.

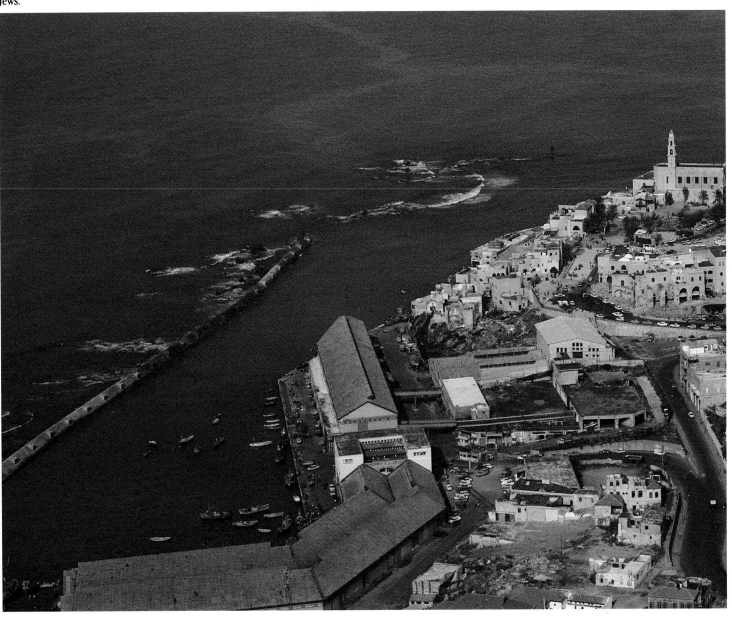

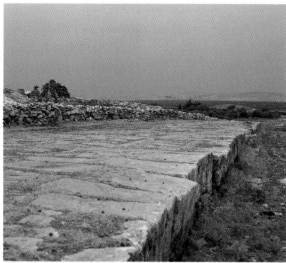

12.2*
Some time during the years AD
32-35, Saul (Paul) was on his
way from Jerusalem to Damascus,
bent on persecuting the followers
of Jesus, when he experienced an
encounter with the living Christ
which changed his life. What
happened is described in Acts
chapter 9 and again in chapters
22 and 26.

12.3*
In Straight Street in Damascus
Paul's sight was restored. Seeking
out the Christians, he began at
once to preach in the synagogues
'that Jesus is the Son of God'.

12.4*
Paul's home-town was Tarsus in Cilicia (southern Turkey), an important university city of the day with a population of half a million.

12.5*
Christians scattered by the persecution which followed the stoning of Stephen brought the gospel message to Antioch (modern Antakya on the Turkey/ Syria border). In this, the third largest city of the Roman Empire, capital of the province of Syria, the Christian faith took root. Soon there was a large group of believers, both Jews and Gentiles. Saul was brought from Tarsus to help Barnabas in the ministry there, and from Antioch the two men set out, commissioned by the church elders, on the missionary work to which God had called them.

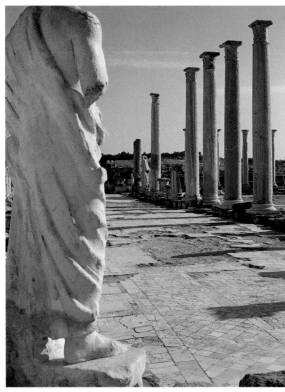

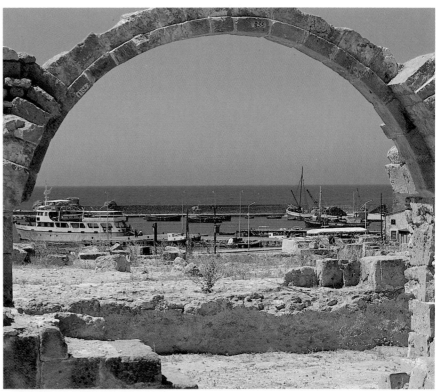

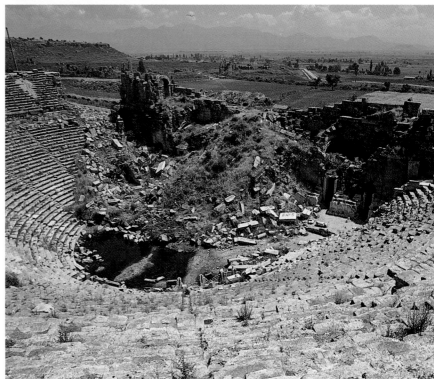

12.6*
Cyprus was the first stop for Paul and Barnabas on the first missionary journey in AD 46 or 47. Arriving in Salamis 'they proclaimed the word of God in the Jewish synagogues'.

12.7*
At Paphos (right), at the other end of the island of Cyprus, a Jewish sorcerer was severely dealt with before Paul and Barnabas set sail again, for Perga.

12.8*
From Perga, on the south coast of Turkey (the Roman province of Pamphylia), Paul and Barnabas began a long trek inland, over mountain roads.

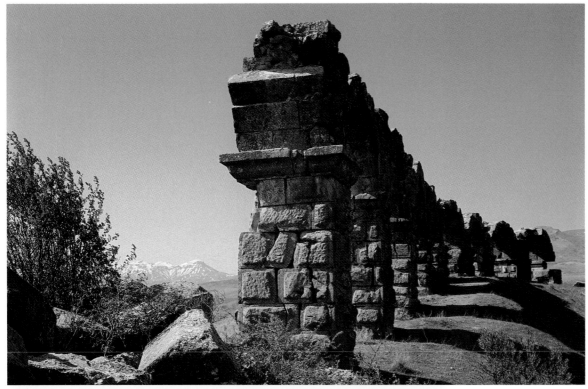

12.9*
Antioch in Pisidia, set in a
glorious area of lake and hills,
was a stopping point on Paul's
first missionary journey. He
spoke in the synagogue and at
first received a good hearing.
Trouble followed, but a church
was planted. Two or three years
later Paul revisited the Christians
on his second missionary
journey.
 The picture shows the
remains of a Roman aqueduct.

12.10*
Paul and Barnabas moved on
from Antioch to Iconium, Lystra
(where Paul was stoned and left
for dead) and Derbe, returning
by the same route. From the
harbour at Attalia (Antalya),
pictured here, they set sail for
Antioch in Syria, and home.

12.11
In AD 48 Paul set out with Silas on
his second journey. In the years
since the first journey, a
conference at Jerusalem had
faced the challenge and fully
accepted the non-Jewish
Christians, whom some had
wanted to make subject to the
Jewish Law. The two men
travelled overland, revisiting
Derbe, Lystra, Iconium and
Pisidian Antioch. At Troas Paul
received a vision of a man from
Macedonia, calling for help. So
they crossed to Greece, arriving
at Neapolis.
 The route from Neapolis to
Philippi lay along the great
Roman east-west highway, the
Via Egnatia, which can still be
seen today.

12.12,13*
Philippi, 12 kms/8 miles inland from Neapolis on the coast of northern Greece, was named after Philip of Macedon. In 42 BC it was the site of a famous Roman battle: Antony and Octavian (Augustus) against Brutus and Cassius. Octavian later made the town a Roman colony, with the same rights and privileges as a city in Italy itself. Against Roman law, Paul — a Roman citizen — and Silas were thrown into prison and flogged without a hearing — to the great embarrassment of officials the next day.

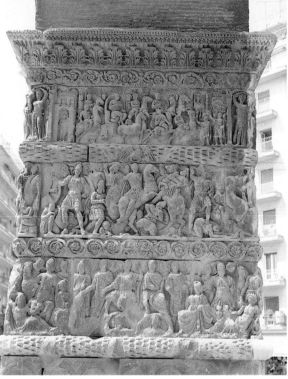

12.14*
From Philippi, in the summer of AD 50, Paul travelled along the Egnatian Way to Thessalonica, the chief city of the region and still a major city. The arch of Galerius stands beside the old Roman road which has become a modern highway.

12.15*
In Paul's day Thessalonica was governed by 'politarchs', six of whom are named in this Greek inscription from a Roman arch in the city.

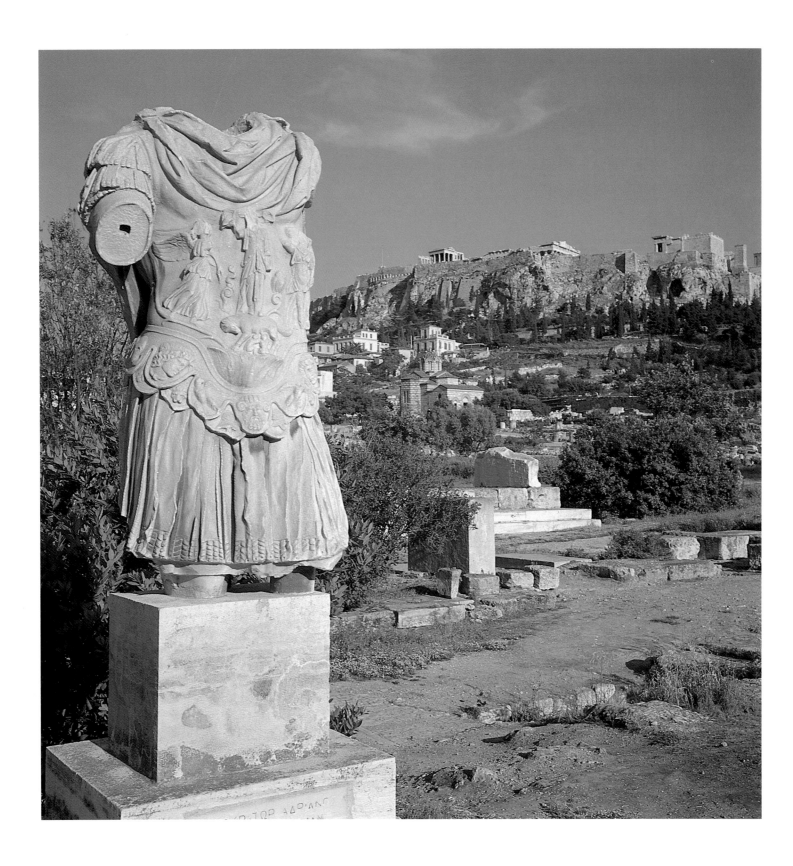

12.16*
In New Testament times, Athens — the home of the great Greek dramatists and philosophers of the fourth and fifth centuries BC — was an independent university city, linked to Rome by special treaty. Here, on his second missionary journey, Paul debated with the Epicurean and Stoic philosophers in the public square. The photograph (left) shows the *agora*, or main square, with a statue of Hadrian in the foreground, and the acropolis on the skyline.

Because Paul preached 'about Jesus and the resurrection' the Athenians thought he was speaking of two new deities. He was called before the city Council, the Areopagus, to explain the new teaching. 'For,' as Acts chapter 17 explains, 'all the citizens of Athens and the foreigners who lived there liked to spend all their time telling and hearing the latest new thing.'

12.17*
From Athens Paul went to Corinth, a city destroyed and rebuilt by the Romans, which stands on the narrow land-bridge connecting mainland Greece with the southern peninsula. It was in a good position for trade between the Aegean and Adriatic Seas, and its large, cosmopolitan population gave it an unsavoury name. Two New Testament letters witness to the vigour, and the problems, of the young church Paul founded there.

12.18
The acro-Corinth with its temple dedicated to Aphrodite, goddess of love, dominated Corinth. It is seen here from the Temple of Apollo.

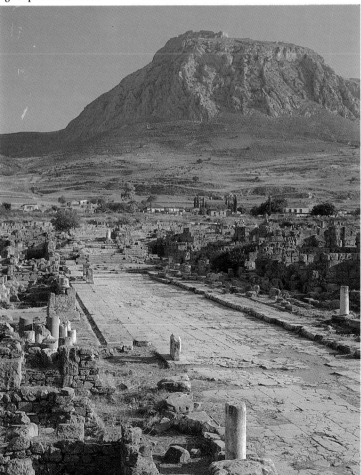

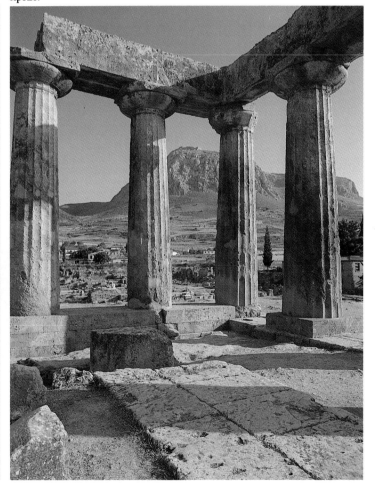

12.19*
A brief visit to Ephesus on his way back to Antioch, at the end of the second missionary journey, was clearly not enough. Paul returned and spent two years there.

Ephesus was a bridge between East and West. It was the most important city in the Roman province of Asia. A third of a million people lived in Ephesus in New Testament times and Paul was quick to see the strategic importance of the city as a centre from which the good news he had to communicate could spread far and wide. The New Testament Letter to the Ephesians, and the seven churches mentioned in Revelation, show how well Paul's strategy worked.

Roman Ephesus was a magnificent city, with marble-paved streets, temples, baths, libraries . . .

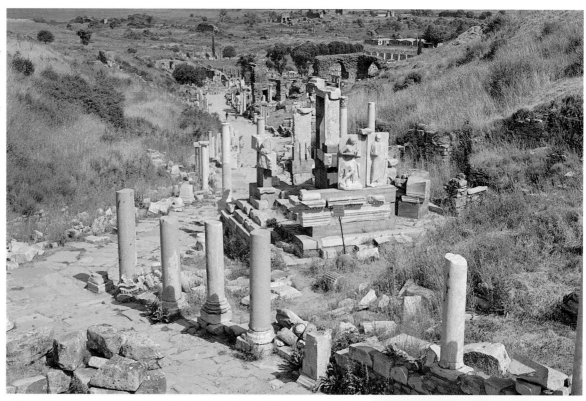

12.20*
Although little remains today, the Temple of Diana (Artemis) at Ephesus was one of the seven wonders of the ancient world.

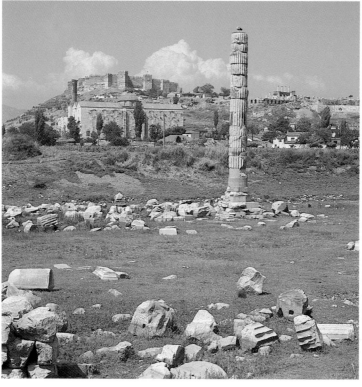

12.21*
Paul's preaching was so effective that sales of the silver images of Diana, from which many traders earned a living, began to fall off. Acts chapter 19 describes the riot that followed. This statue of the goddess, found at Ephesus, dates from the second century AD.

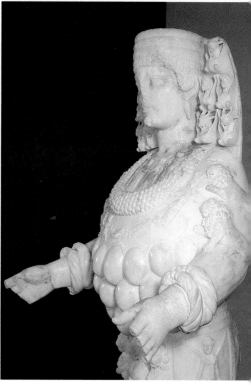

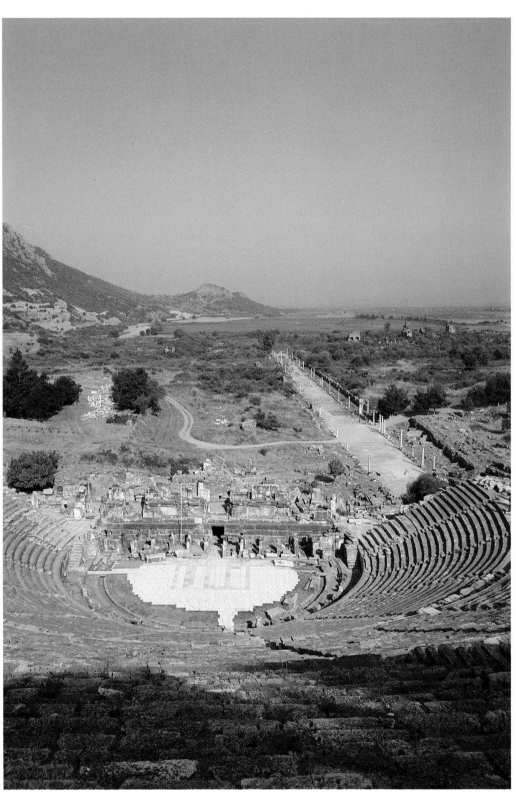

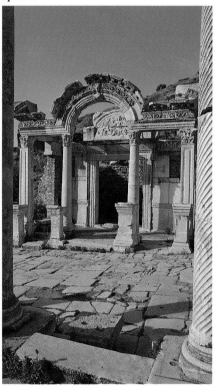

12.22*
The theatre at Ephesus could seat more than 25,000 people. At the time of the riot described in Acts, a great crowd of Ephesians seized Paul's two companions and dragged them to the theatre, where the city clerk eventually succeeded in quieting the rabble. The Arcadian Way, on the right of this picture, led from the theatre towards the sea, although by Paul's day the harbour was already silting up.

12.23
The Temple of Hadrian was one of the magnificent buildings which lined the main street at Ephesus.

12.24*
The Christian message probably
reached Colossae, in the Lycus
Valley, while Paul was staying at
Ephesus, although he had still not
been there personally when he
wrote his letter to the Colossian
Christians.

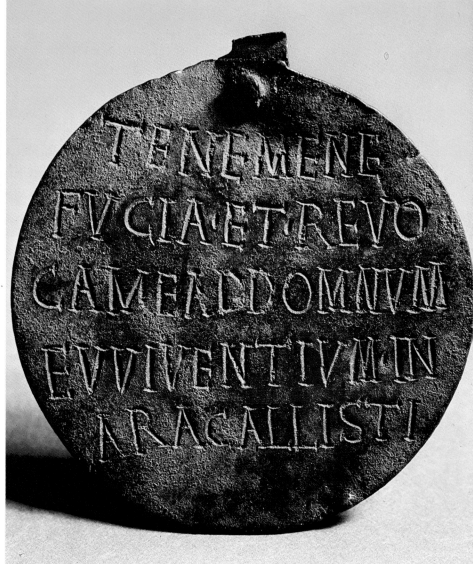

12.25*
Among the Christians at Colossae
was a slave owner named
Philemon. Onesimus, one of his
slaves, ran away to Rome where
he met the apostle Paul and was
converted. Paul sent him back,
with a plea to his owner to treat
him now as a brother in Christ.
This Roman slave badge reads:
'Seize me if I should try to escape
and send me back to my master.'

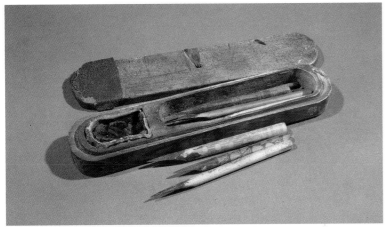

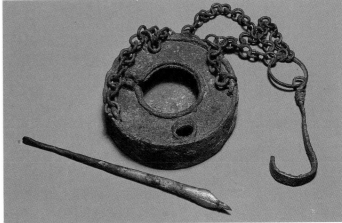

12.26,27
Conscious of how little time he had spent with them, and deeply concerned for the young churches, Paul wrote often, giving advice, answering questions, encouraging them in their faith and praising all that was good. The secretary to whom he dictated must have used much ink and many pens. The pens in the pen case are from Roman Egypt. There are traces of black ink in the well. The inkpot and pen (top right) date from the first century AD and were found in the River Tiber.

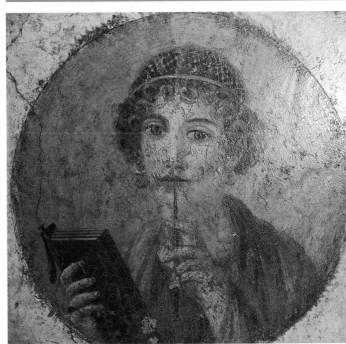

12.28*
This letter in Greek, written on papyrus, begins, 'Greetings from Procleius to his dearest Pecysis'. It continues with instructions to sell good quality drugs, warning that if Pecysis does not he will have to bear the expense. The letter ends, 'Greet all your family. Farewell.'

12.29
The portrait of a girl with writing-tablet and pen comes from Roman Pompeii.

12.30,31*

When Paul sailed from Assos (in north-west Turkey) bound for Judea, at the end of his third missionary journey, he knew that he was running into great danger.

From Miletus, on his way down the west coast of Turkey, Paul sent for the church elders from Ephesus. It was an emotional goodbye: all knew of the risks Paul ran.

Miletus boasted a fine theatre. A reservation inscribed on one of the seats read: 'For Jews and God-fearers only.' It highlights the revolutionary nature of the Christian message Paul proclaimed: 'All one in Christ Jesus.'

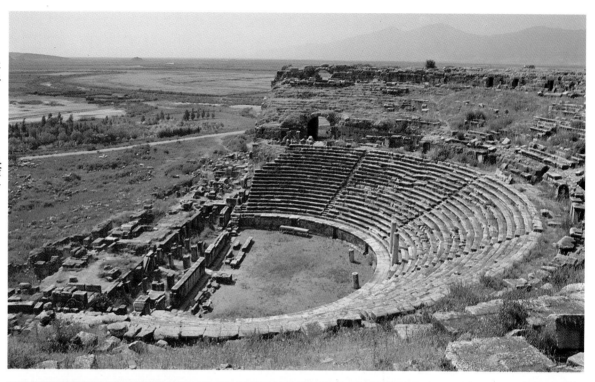

S. 909

12.32,33*
Herod the Great built the Mediterranean port of Caesarea, naming it after the Roman Emperor Augustus, whose statues and temples dominated the town. A Roman garrison was stationed at Caesarea — and Paul was held in safe custody there for two years following his arrest in Jerusalem (described in Acts chapter 21). The governor Felix heard Paul's case. But, hoping for money and to please the Jews, he failed to set Paul free.

After two years in prison in Caesarea and several hearings, Paul exercized his right as a Roman citizen. He appealed to Caesar, and took ship to Rome under armed escort.

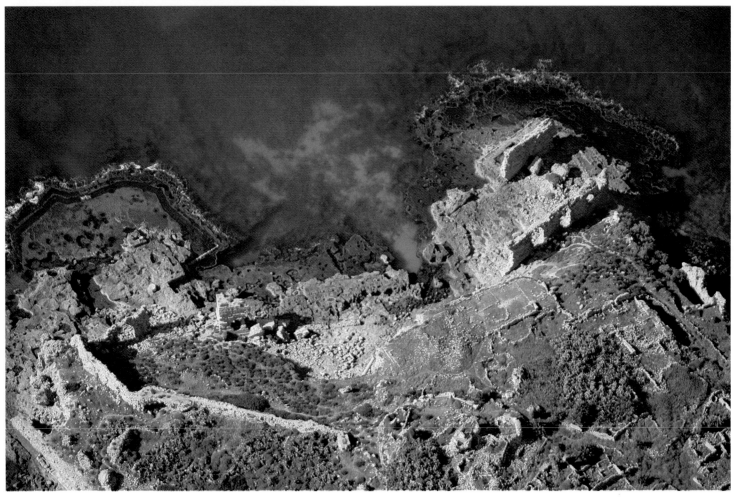

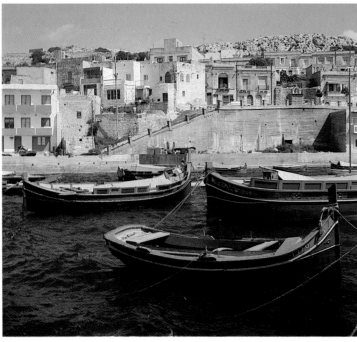

12.34
A north-easter hit Paul's ship as it sailed along the coast of Crete. It was blown, helpless before the gale, to Malta, where the ship was wrecked on a sandbank. But, thanks to Paul's initiative, no lives were lost.

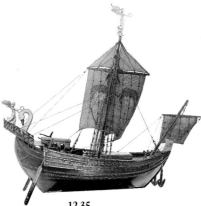

12.35
A Roman grain ship from Alexandria, which had wintered at Malta, took Paul on the final stage of his voyage to Rome.

12.36*
Christians from Rome, hearing of Paul's arrival, came out along the Appian Way to welcome him.

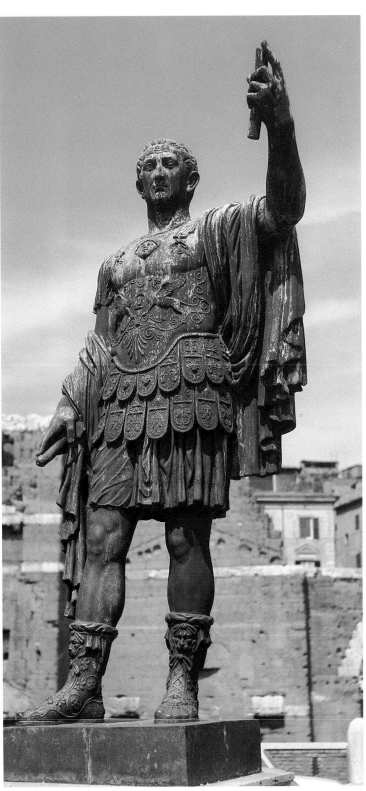

12.37*
When Nero succeeded Claudius as emperor of Rome an era of persecution began for Christians throughout the empire.

12.38
Revelation, the last book of the New Testament, set against a background of persecution, addresses the church at Ephesus and six other churches in the surrounding area.

This inscription from Ephesus refers to the 'divine' Caesar Augustus. By the time Revelation was written Christians suffered persecution for refusing due worship to the emperor.

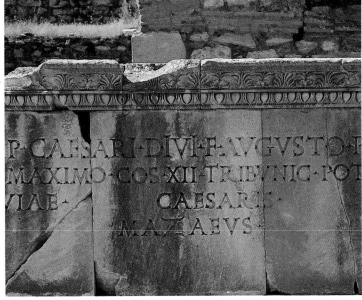

12.39*
Smyrna, modern Izmir, on the
west coast of Turkey, is described
in Revelation as being poor —
but rich in the things that matter.
The forum dates from the Roman
period.

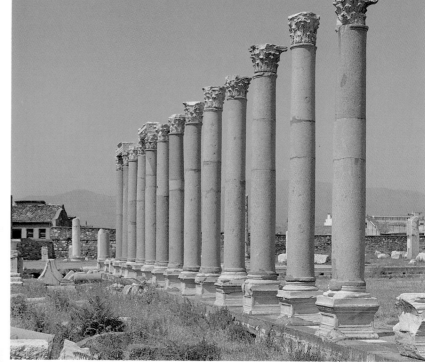

12.40*
Pergamum boasted the first
temple dedicated to Rome and
the Emperor Augustus, built in 29
BC. It was also a centre for the
cults of Zeus, Athena and
Dionysus. 'I know where you
live,' says the letter to the church
at Pergamum, 'where Satan has
his throne.'
　　A spectacular theatre, dating
from the hellenistic period, looks
down on the modern town.

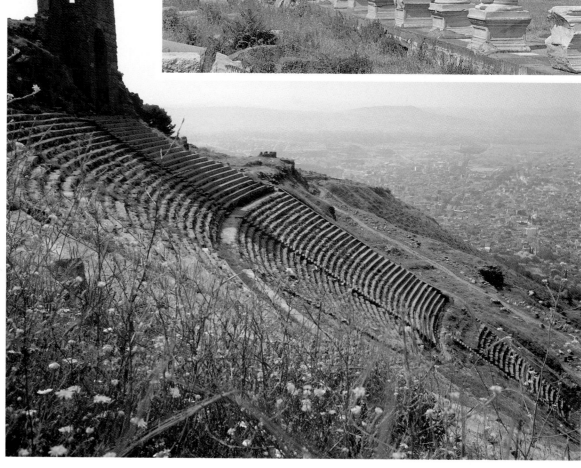

12.41
The healing centre connected
with the Temple of Asclepius
drew many to Pergamum. This
sacred tunnel is thought to have
played its part in a form of shock
treatment for the patients.

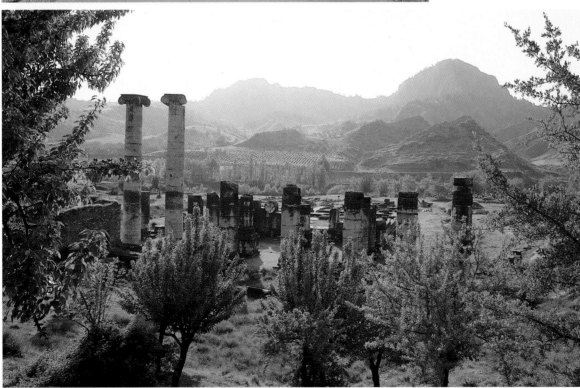

12.42*
The Temple of Artemis, shown
here, still stands at Sardis, in
western Turkey. So too,
interestingly, do the remains of
an early Jewish synagogue. The
church at Sardis, although
apparently alive, was in fact
dead, according to the letter in
Revelation chapter 3. But some
Christians remained true to the
faith.

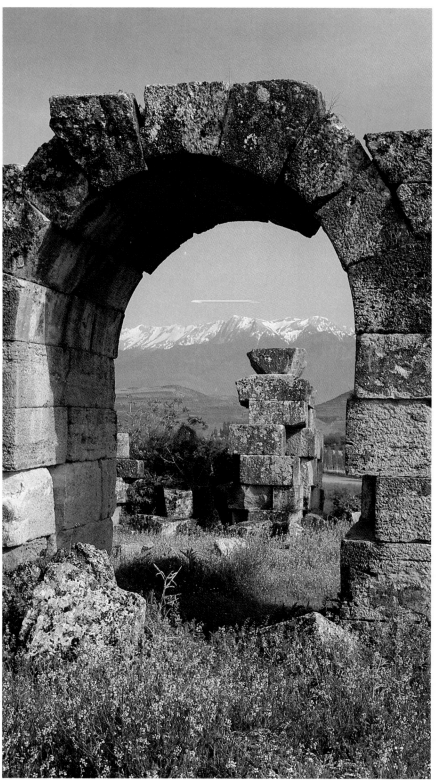

12.43,44,45*
Mineral deposits from the hot springs at Hierapolis (right) in western Turkey have built up into strange terraces and waterfalls. Nearby Laodicea (left) had water channelled from local hot springs which arrived luke-warm. It was a fitting image for the church, according to the letter in Revelation chapter 3 — neither hot nor cold, and fit for nothing. No other church receives such severe condemnation. And yet there is hope. 'Behold, I stand at the door and knock,' says the Lord of the church. 'If anyone hears my voice and opens the door, I will come in . . .'

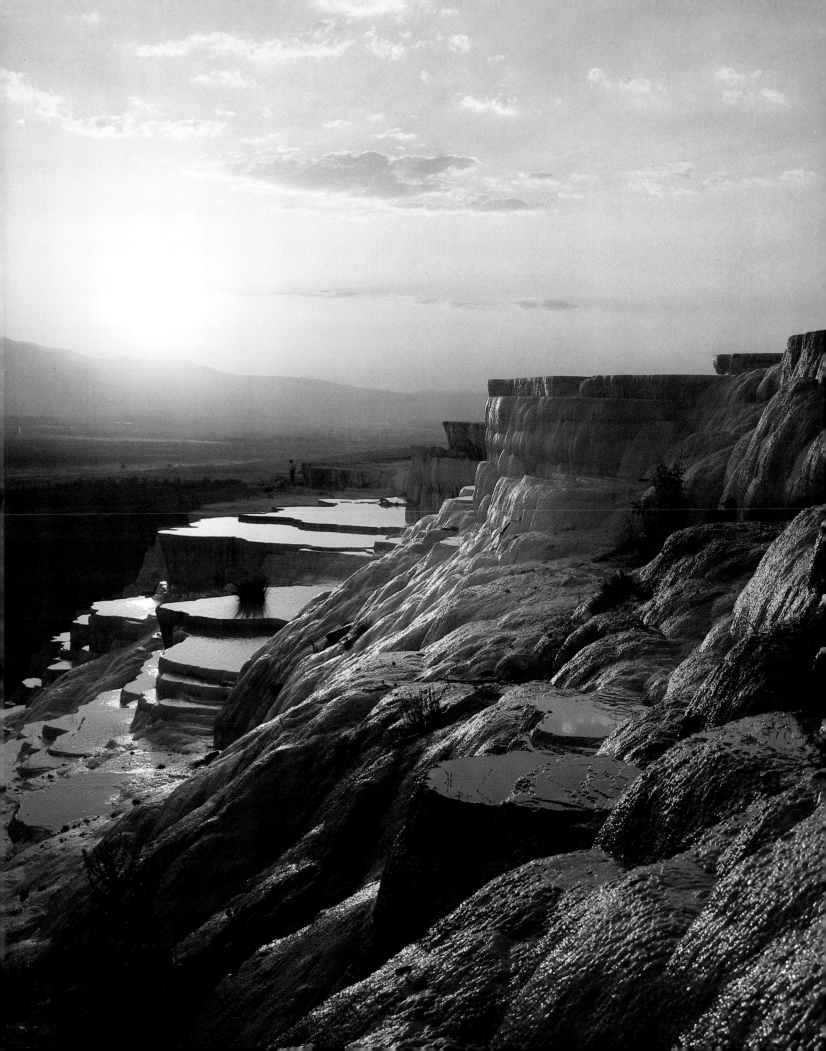

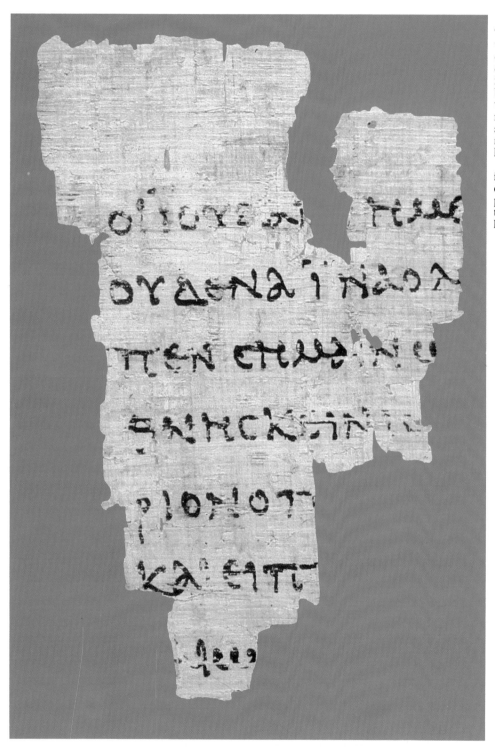

12.46*
The age of the first Christians was passing, but their message did not die with them. It was carefully preserved in written form from the earliest days — both in Paul's letters and in the whole story of Christ's life, recorded in the four Gospel accounts and drawing on the memories of those who had known him best.

This papyrus fragment found in Egypt is written in Greek and dates from about AD 125-150. It is part of a copy of John's Gospel — the earliest surviving copy of any New Testament book.

Gallery One

1.2
The Babylonians had more than one story about creation. This one, copied in the sixth century BC, begins 'when all the lands were sea'. The god Marduk made land, then with a goddess, Aruru, created mankind to serve the gods. He went on to bring animals and plants into being, and the cities of Babylonia. Other stories specify that man was made from the blood of a defeated god, in one case mixed with clay. It is unlikely that these myths and Genesis 1-3 are connected. Ideas they share — man made of a divine element and of earth; man made to serve a higher power — are ones that have arisen independently in other parts of the world.

1.6,7
Babylonians built their temple-towers or ziggurats high to mark them as chief places of their gods. The custom goes back at least as far as the third millennium BC. Most famous of all was the temple of Marduk in Babylon which rose in seven stages, each painted a different colour, to a height of 90 meters/295 feet. On top was the shrine of the god containing his statue. Priests would move in procession up and down the staircases daily to wake and wash the god, to bring food and to offer prayers.

1.8-14
Ur was one of the oldest cities of Babylonia, beginning as a settlement on a hillock in the flood plain of the Euphrates river. By the time of the 'Royal Cemetery' Ur had become a prosperous centre for agriculture and trade. The treasures found show the range of raw materials imported to please the rulers: copper from the Persian Gulf coast, gold from Iran, lapis-lazuli from Afghanistan. Sixteen burials are called 'royal' because attendants were laid to rest with the owners, but it is not certain that the owners were kings and queens. Some of the women, at least, may have been priestesses 'married' to the Moon-god. Nowhere else in Babylonia has the custom of sending courtiers into the next world with their master or mistress been observed. It seems to reflect a very strong feeling that life after death would have many similarities with earthly life.

1.11
Several lyres and harps lay in the tombs. Although it is impossible to reproduce the sounds of their music because the strings and woodwork have rotted and their thickness is unknown, it is obvious there was a wide range of tones. Drums, pipes and other instruments were also played.

1.14
The mosaic 'Standard of Ur' measures 48.3 cms/19 ins in length, 20.3 cms/8 ins in height, British Museum no. 121201. The scenes move from the bottom upwards. First, porters bring booty taken from an enemy and others lead captured donkeys; then oxen and sheep are herded along. At the top, victory is celebrated with a drink by the king (larger than all the other figures) and his officials, while a girl at the far right sings, accompanied by a musician playing a lyre like those found in the tombs (1.11).

1.15,16
Leading the visitors is an Egyptian scribe who holds a scroll describing them as 'Asiatics brought by the prince Khnum-hotep on account of eye-paint, Asiatics of Shutu to the number of 37'. The occasion was obviously an important one in Khnum-hotep's life. Shutu appears to have been part of Transjordan and perhaps Sinai.

1.17
In his excavations at Ur, Sir Leonard Woolley cleared the ruins of houses abandoned about 1740 BC in two areas of the city. His reconstruction assumed an upper storey, but more recent study suggests the houses had only one floor, with stairs leading to the roof. The plan of the houses, with all the rooms opening off a central courtyard, is well-suited to the climate, giving some shade and protection from wind-blown sand.

1.20
Why are there no records of Abraham and his family outside the Bible? Life in tents leaves next to nothing for archaeologists to find. When the Patriarchs stayed at one place for a long time they may have made more permanent homes, but if one was found today only an inscription saying 'Jacob's house' could point to its owner.

1.21
Nomadic herdsmen often wandered over great distances following the pasture, but returned to winter at a more or less permanent base. (In Genesis, chapter 37, Jacob sent Joseph from Hebron to find his brothers at Shechem, but they had moved on to Dothan.) They visited towns to trade in the market-places and would sometimes work for the townsfolk. In times of need they might give up their nomadic life-style completely, or, if they were strong enough, raid and rob the towns.

1.22
Early in the second millennium BC cities in Canaan which had been deserted for three or four centuries were rebuilt. Each was ruled by its own prince and encircled by strong walls to protect it from rival powers and from nomadic raiders. A guarded gateway led through the walls (see Genesis 23:10, 18). Almost every one stood by a spring or a river, or at a place where wells could be dug, as they were at Beersheba (Genesis 26:17-22).

1.23,24
Sodom and its sister cities (Genesis 14, 19) are thought to have stood in the area now covered by the southern end of the Dead Sea, but no recognizable traces of them have been found. Reports that the names of Sodom, Gomorrah, and the other places had been read in documents from Ebla, north Syria, written about 2300 BC are mistaken.

1.25
Tools and weapons became more effective at this time (the Middle Bronze Age) with the spread of the use of bronze, harder than the copper previously common. Weapons like those shown in this painting have been found in Canaanite tombs.

1.26
To sacrifice a human being to a god in death is a horrible idea to modern western people. Examples from biblical times are rare, except among the Phoenicians and, perhaps, their ancestors the Canaanites. They apparently offered children to their gods, making them 'pass through the fire to Moloch', something forbidden to the Israelites (Leviticus 18:21; 20:2-4). Abraham's test may have had the secondary purpose of showing that God did not demand the deaths of his servants or their children.

1.27
In the centre of Hebron stands the traditional site of Abraham's tomb, still surrounded by a wall which Herod the Great had built. Below the floor is a cave. Multiple burial in natural or artificial caves was normal in patriarchal times, so this could be the cave Abraham bought (Genesis 23), but there is no way to prove it.

Gallery Two

2.1
Although roads ran north-east from Egypt to Palestine, and ships could sail from the mouth of the Nile to ports around the Mediterranean, the land was quite isolated and self-contained. From the Delta southward, only the land beside the Nile can be cultivated and inhabited. Outside the river valley the country is rocky desert, with a few oases.

2.4
Amun was the supreme god of Egypt, the creator and controller of nature. This temple was a home for his statue which stood in the innermost dark room. The priests, the only people regularly allowed into the temple, would wake the god with a hymn, wash and dress it each morning, and take food to it three times a day. Every powerful king hoped to build better temples than his forebears to honour the gods who had chosen him to rule and given him success. Originally the carved stonework was brightly painted.

2.5
A constant stream of immigrants from Syria and Palestine eventually led to the overthrow of the native pharaohs and the rule of the Hyksos kings in the north (about 1780-1550 BC). Many scholars believe it was one of these who encouraged Jacob and his family to settle in Goshen in north-east Egypt (Genesis 45:16ff.).

2.6,7
To run a country like Egypt needed an administrative system that brought a regular income to the king. The country was divided into regions, called nomes, each one with a governor responsible for it. Officials in ranks below him included those in charge of measuring the fields to estimate the harvest and the amount of tax due.

2.9
Ramose was prime minister of Egypt under Pharaoh Amenophis IV (about 1356-1340 BC) who, as Akhenaten, introduced a short period of major change in Egyptian art and religion. Emphasis was placed on reality, resulting in more natural painting and sculpture than had been seen before.

2.10
The envoys bring elaborate vases of precious metals. Some gold ones have golden flowers in them; one is modelled as an animal's head. Silver pitchers and jugs are painted black. They were especially valued, as silver is not found in Egypt. One man holds a small girl who was probably brought as a servant to the Egyptian's household. Although paintings like this show foreigners as tributaries to Egypt, the things they brought were often exchanged for Egyptian products in a form of state trade.
British Museum no. 37991. Height 114.3 cms.

2.14
For Egyptians the scarab-beetle pushing a ball of dung before it was a symbol of the sun-god pushing the sun across the sky. This necklace represents the sun beginning its daily journey from the east, resting in a golden boat on a blue sea. It is made of gold, lapis-lazuli, turquoise, and pink felspar. The whole necklace is 50 cms/20 ins long and was made about 1340 BC.

2.24
The treaty or covenant was an agreement between two parties. Using a common pattern helped to ensure that the contract was properly understood. The problem always was how to ensure the parties remained faithful to their promises. Among the means used was the preservation of written copies in temples or other sacred places, and the calling of the gods to be witnesses. They would, it was believed, punish anyone who broke oaths sworn in their names. The blessings were extra benefits for the faithful, the curses were another form of threat to those who were tempted to be disloyal. Deuteronomy preserves much of the covenant form of the second millennium BC most clearly, notably in Deuteronomy 28:1-14 (blessings), 15-68 (curses).

2.25
The standard of Hammurabi's justice was high: he announced his aim 'to root out wicked men from the land and promote the welfare of the people.' There were laws to prevent fraud in business, to deal with theft, with hiring goods and services, with marriage and family relations. Some seem severe. 'If a builder built a house for a citizen but did not make it strong, and so it collapsed and killed the owner, the builder shall be put to death' (Law 229). Others are more humane: 'If a citizen married and his wife has contracted a continuing disease, if he decides to marry again, he may do so, but he may not divorce the sick wife. She shall live in his house and he shall support her as long as she lives.' Hammurabi's Laws have to be studied in the context of Babylonia of the seventeenth century BC. Life was full of dangers, anyone who caused more should be stopped. A sick woman, divorced, would have no means of support. Other laws deal with offences which could not be proved, such as an accusation of sorcery, and the method of dealing with them was to seek a god's verdict through trial by ordeal. Hammurabi's Laws have similarities with the Laws of Moses, 500 years later. Both were prepared for small-town agricultural societies with many comparable situations. Both claimed divine inspiration. Hammurabi's Laws were made to improve on existing situations, Moses', were for a newly formed nation. Hammurabi's are especially concerned with property, and punish crimes of theft with death. Moses' Laws contain absolute moral commands, and value human life above possessions.

Hammurabi's Laws were copied by scribes for a thousand years but, so far as has been discovered, were never put into force.

2.26
The bull has been worshipped in many cultures. Among the Canaanites the god Baal was sometimes called 'the bull'. Metal figures of bulls from Syria and Palestine may represent the god himself, or be the animal on which his image stood.

2.28
The tabernacle can be compared with portable prefabricated pavilions Egyptian craftsmen made for royalty long before. They had wooden parts covered with gold in the same way. Several layers of cloth and skin, stretched across the walls, made the roof of the tabernacle. This, too, is similar to an ancient Egyptian method of roofing a shrine.

2.29
Copies of some ancient treaties or covenants were placed in temples beside the statues of the gods who witnessed them. Israel had no statue of their God, but their covenant, the charter of the nation, was safeguarded in the same way, by being part of the most sacred object they possessed, the ark where God's presence was shown.

Gallery Three

3.2,3
Archaeologists digging at Tell Beersheba have not found inscriptions giving the ancient name of the site, and the references in the Bible are not exact enough to locate Beersheba precisely. Roman Beersheba lay beneath the modern town, and the biblical site may be there, too.

3.4
For most of the year the Jordan is approximately 25 meters/80 feet wide opposite Jericho, and about 1.5 meters/5 feet deep, not difficult to ford at several places. In the spring the rains and melting snows swell these figures to 35 meters/115 feet and 4 meters/13 feet, and the water flows faster.

3.5,6
Jericho has been the scene of excavations by several expeditions, especially in the 1930s and 1950s. They revealed there was already a stout wall around the town in 7500 BC to defend it, a time before the invention of pottery. City succeeded city through the centuries, until it was deserted for a while near the end of the second millennium BC. Current research has been unable to reveal remains of the city which fell before Israel's army (Joshua 6). Walls once claimed to belong to that city were in fact part of a much earlier one. Some suppose the story is a legend, others that erosion has removed the ruins, and yet others that the date of the attack should be changed from the thirteenth to the fifteenth century BC, from which there are extensive ruins. The debate continues.

3.7
Unusual geological factors allowed perishable materials to survive, dessicated, in the underground tomb chambers around Jericho. This unique feature gives a glimpse of the household equipment usually lost by decay. The tombs containing those goods belong to the years 1800-1550 BC (Middle Bronze Age II).

3.9
Mount Gerizim and Mount Ebal were appropriate places for the people to gather, standing in the centre of the land, the town of Shechem at their feet. It was essential that Israel should remember the terms of the covenant, the basis of their existence, as they took possession of their Promised Land.

3.10
Israel's conquest was made a little easier by the rivalry of the Canaanite cities whose princes were often fighting each other. Some were content to be subject to Egypt, others tried to be independent. As well as the threat brought by Israel, the Canaanites were also attacked by the Sea Peoples during the thirteenth and twelfth centuries BC and by Aramean tribes in the north.

3.11
Canaanite craftsmen took ideas and styles from Babylonia, Egypt and their other neighbours, mixing them to produce their own creations. This meant they often took over religious emblems from other cultures, too, to work into their designs. Tombs containing jewellery of this quality are rarely found; most Canaanites would have been too poor to own any.

3.12,13
It was these Canaanite gods whom the Israelites often worshipped instead of, or in addition to, their own God. Perhaps not unnaturally, they thought the gods of the land they had conquered could help them as they lived in it (see 2 Kings 17:24ff.). Those gods also offered a very easy way of life to their devotees; they made practically no moral demands, in contrast to the strict commandments given through Moses. They could not, for they themselves were described by the Canaanites as fighting each other, quarrelling and indulging their lusts without restraint.

3.15
Recent excavations at Lachish have shown that the Canaanite city was finally destroyed in the twelfth century BC. This shrine lay outside the city wall. It had been rebuilt twice in the course of 300 years. In the ruins of the last period lay scores of pottery bowls which had held offerings, many of them the right forelegs of sheep or goats (compare Leviticus 7:32).

3.16
Hazor was a very old city which was greatly extended in the eighteenth century BC with an enormous rampart enclosing an area of some 200 acres. Within it were houses, temples and tombs; at the south end was the original city, the citadel.

3.17
Several Canaanite shrines at Hazor had been violently destroyed during the thirteenth century BC. Altars, vases and other ritual furniture lay smashed in their ruins. The largest of the pillars in this shrine is 65 cms/25.5 ins high, the smallest 22 cms/7 ins. Pillars were a common part of ancient Near Eastern culture.

They might be memorials, like Jacob's pillow at Bethel (Genesis 28:18ff.) or monuments to the dead, like Absalom's (2 Samuel 18:18). Some apparently came to be worshipped as symbols of gods or as their dwelling-places. Israel, therefore, had to destroy any they found in Canaan (Exodus 23:24) and they were not to erect their own (Deuteronomy 16:22).

3.18
This Late Bronze Age pottery includes pieces imported from Cyprus (the tallest one) and Mycenean centres in the Aegean (the vase at the right). They are relics of an active trade which the Israelite invasion interrupted.

3.20
Asher's failure to gain control of its allotted territory allowed Canaanite Tyre and Sidon to continue as independent city-states. They became major centres of pagan, Phoenician culture, which affected Israel (see Gallery Four, 14, 15).

3.21
In studying photographs of Palestine today it is essential to remember that modern drainage and irrigation schemes have radically altered the appearance of the land. Thus in biblical times there was a lake surrounded by marshes between Dan and Galilee, Lake Huleh, which has now been almost entirely drained, providing fertile agricultural land.

3.24
The Valley of Jezreel, running north-west from the Jordan past Beth-shan, is part of an important route across Israel which leads into the Plain of Esdraelon and on to the port of Accho, thus linking the coast to the river-valley. The Jezreel Valley is especially fertile (compare Hosea 2:21-23), but the Plain of Esdraelon was quite marshy in ancient times: the River Kishon's waters flowed through it in winter. (Note: Esdraelon is the Greek form of Jezreel, but the plain lies west of the town, the valley to the east.)

3.27
Dan's territory included segments of hill-country and of the coastal plain, rising to Joppa. Joshua 19:47 records that the tribe was unable to occupy all its land, and most of it moved elsewhere (to Dan in the north, see Judges 18:1ff.). The Amorites were too strong for the Danites and, before long, the Philistines were in control of the town of Ekron. Failure to conquer this region thoroughly weakened Israel both commercially and strategically.

3.32

Some scholars have doubted the truth of Merenptah's claim, although without good grounds. Another inscription names him 'binder of Gezer'. There can be no doubt that this stele records the existence of a group of people called Israel in Canaan in Merenptah's reign.

3.33

In Judges 4:3 the historian makes special mention of the Canaanites' 'chariots of iron', perhaps because they were a new and frightening weapon. Iron gradually came into use after 1200 BC, although it was rare and costly for a long time. The chariots were probably strengthened or armoured with iron.

3.35-39

The Sea Peoples apparently moved from the Aegean through Cyprus to the Levant. Many towns along the coast were violently destroyed soon after 1200 BC, and some were never reoccupied. Archaeologists link this destruction with the attacks the Egyptian inscriptions and carvings record. The 'Philistine' pottery is quite distinctive, always occurring in levels of occupation built on top of the destroyed towns. After the Egyptians had defeated the Sea Peoples they seem to have employed some of them as garrison troops and to have allowed them to settle in south-west Canaan. There they occupied the five cities of Ashdod, Ashkelon, Ekron, Gath and Gaza. Excavations at Ashdod have uncovered a fortress, houses and shrines of this time containing 'Philistine' pottery and other objects imitating styles at home in the Aegean and in Mycenean Greece.

Gallery Four

4.4

Where the wilderness of Judea breaks down towards the Dead Sea the valleys and ravines are riddled with caves, some virtually inaccessible. They have always made ideal hiding-places for outlaws or refugees. Some of them left their belongings behind, and some died in the caves. Pots and pans, basketry, woodwork and leather from many periods have been recovered. So far no trace of David and his men has come to light; there can be no certainty that they left anything identifiable to be found.

4.5

The fact that Mount Gilboa lies in the northern part of Israel, in the Valley of Jezreel, shows how far the Philistines had advanced, how near they were to controlling the whole of the Promised Land.

4.6

The ancient city of Beth-shan stood at the east end of the Valley of Jezreel. Excavations in the ruin-mound revealed a rich Canaanite city with relics of an Egyptian garrison and temples with Egyptian decoration. During the early Iron Age (about 1150-1000 BC) two temples were built, one containing a dedication to the goddess Anat; the other was possibly dedicated to the god Dagon. In the cemetery lay a number of clay coffins with faces modelled in relief. They belong to the same tradition as others found near the Philistine city of Gaza.

4.7,8

The pool at Gibeon is 11.3 meters/37 feet in diameter and 10.8 meters/35 feet deep. From the foot of the stairs a tunnel leads down to an underground spring almost 12.6 meters/43 feet lower still. This great work was not entirely successful, for another tunnel was dug later, running under the city wall to obtain water by a different route. There is no inscription, so it is impossible to be certain when either system was dug, but the pool is the earlier, and may have been the one mentioned in the biblical story.

4.9

Excavation in Jerusalem is complicated because the city was built and rebuilt on the same site for generation after generation. Water supply was always a major concern and several tunnels and conduits were dug, taking advantage of natural crevices and channels in the limestone (see Gallery Five, 28-32). The meaning of the Hebrew

word translated 'water shaft' in 2 Samuel 5:8, in the description of how David's men captured the city, is uncertain. The common idea that it describes the vertical 'Warren's Shaft', which enabled people within the city to draw water from the spring outside the walls, is currently doubted by archaeologists working in Jerusalem.

4.10

The original Jerusalem was built on this little hill because the only good spring, Gihon (now the Virgin's Fountain), lay at the foot of the eastern slope. There was so little space on the hill that many houses were set on stone terraces erected along the slope of the hill. City walls enclosed the buildings, standing about half-way up the slope, but as the population grew other houses were erected outside the walls.

4.11

In the middle of the tenth century BC the great powers Egypt, Assyria and Babylonia were weak, so David was able to establish his extensive kingdom, and Solomon to prosper through his trade. Cedar wood was valued because it provided much bigger beams and planks than the trees in Palestine and other countries of the Near East.

4.13

The statement that Solomon plated the interior of the sanctuary with gold arouses doubt, charges of exaggeration, or dismissal as folklore. Such a thing is unreal! Yet written records and physical evidence from the ancient world clearly show that great kings did lavish large quantities of gold upon the temples of their gods, covering the walls with gold — one boasts — 'like plaster'. All this splendour in Jerusalem was seen only by the priests, for the Israelites worshipped and offered sacrifices outside, in the Temple courtyard.

4.14,15

These ivories were carved to decorate wooden furniture (see Gallery Five, 14,15). Their designs reflected in miniature the ornaments of Egyptian buildings, interpreted by Phoenician craftsmen. Creatures like the winged sphinx had particular meaning in Egyptian religion, but when used by other peoples may have been no more than 'lucky' figures. Solomon's throne (1 Kings 10:18-20) had an overlay of ivory in the same way.

4.16

The stand from Megiddo probably held a basin of water or perhaps a brazier. It is 9.5 cms/3.75 ins high. Those in Solomon's Temple were about 1.3 meters/4.5 feet high and supported large basins. Huram decorated them with lions, bulls and cherubim, which we can imagine were modelled

in the same technique. The Megiddo stand may have had wheels when it was made — other stands of the same type, like Huram's, certainly did — so that they could be moved while they contained heavy or dangerous loads (such as water or fire).

4.17
Although none of the foundations bore the words, 'Solomon built this gate', the pottery found with the ruins, and other indications, show that they belong to the tenth century BC. It is reasonable to associate them with 1 Kings 9:15. Other cities had walls and gates planned in much the same way in the following centuries, with houses incorporating the casemates as rooms. The passage through the gate is 4.2 meters/13.5 feet wide, which would give easy passage for chariots and donkeys in both directions.

4.18
The Gezer Calendar can be translated and explained as follows:
(Two) months of harvest (olives: September-November).
(Two) months of sowing (grain: November-January).
(Two) months of late planting (vegetables: January-March).
Month of cutting flax (March-April).
Month of reaping barley (April-May).
Month of reaping and measuring (wheat; reckoning for tax: May-June).
(Two) months of pruning (vines: June-August).
Month of summer fruit (grapes, figs, etc: August-September).

The tablet is 11 cms/4.25 ins high and 7 cms/2.75 ins wide, held easily in the hand. The writing could be scraped off the soft limestone to leave a clean 'slate'. The original is in the Archaeological Museum, Istanbul.

4.20,21,22
The shrine stood in one corner of the fortress at Arad which the excavators date to Solomon's reign. Josiah's reforms late in the seventh century BC are thought to have brought it to an end. There was a courtyard almost 10 meters/33 feet square with, at one time, a brick-built altar in the centre. At one end was a small holy room with benches along the walls, and at the back of that was a 'holy place'. A stone incense altar stood on each side of the stepped entrance, and a stone slab was set upright against the back wall. Exactly what sort of worship was performed here is unknown.

Gallery Five

5.1
Shishak's campaign in Palestine is recorded by a list of towns carved on the wall of a temple he began to build for the god Amun at Karnak in Egypt. Shishak's son Osorkon made enormous gifts of gold and silver to the gods of Egypt — treasure which, it is suggested, was partly the booty his father had taken from Jerusalem. This armlet was made for another of Shishak's sons. British Museum, no. 14594. Height: 7 cms/2.75 ins.

5.2
Baal was the Canaanite god of rain and storm, vital for the growth of the crops. His name simply means 'Lord'. He was adored in many Canaanite cities, and when King Ahab married the princess Jezebel of Tyre she brought with her the worship of the Baal of Tyre, known as Melkart.

5.3,4
At Megiddo a new, solid city wall replaced the casemate wall, and a new gateway was built above the Solomonic one. Among new buildings were several oblong halls divided by two rows of pillars forming a passage down the centre. Some of the pillars had holes bored through them, and stone troughs standing between pillars led to the first suggestion that the buildings were stables. From similar discoveries at Hazor and elsewhere, it appears that the buildings were storehouses for goods received as tax. Donkeys could be hitched to the pillars and fed whilst being loaded and unloaded.

5.7
The seal stone was about 3.7 cms/1.5 ins long and is one of the oldest Hebrew seals recovered.

5.8
Samaria stands on an isolated hill commanding the main north-south road through the central hills and a route west to the coastal plain. From the summit it is possible to see as far as the Mediterranean. Olives and vines grow well on the steep hills and valleys around.

5.10
Israelite masons perfected the technique of building walls entirely with square-cut blocks of limestone (ashlars), not simply giving a dressed-stone face to a wall of rough stones, as done previously. The best examples are to be seen in the ruined palace at Samaria, where they lie below the walls of a temple founded by Herod in

honour of Augustus and Rome, and later rebuilt.

5.11
Ivory-embellished furniture was an expensive luxury, often taken as booty or tribute by Assyrian kings from the cities they conquered. The creamy-white ivory appeals to modern taste, but the ancients tried to enrich it by covering some areas of the carvings with gold foil and inlaying them with blue and red glass or stones. Some fragments of finely carved ivories were found in the ruined palace at Samaria, including some with this design. Thousands more lay smashed in the Assyrian palaces at Nimrud, south of Nineveh. These pieces are in the British Museum.

5.12
The Moabite Stone is the longest inscription from the period of the Kings found in Palestine and Jordan. Its language is close to biblical Hebrew and the writing is identical with that current among the Israelites. Mesha's expressions are also similar to biblical ones; his god Chemosh, he says, was angry with his land, just as the book of Judges, for example, says Israel's god was angry with them. Mesha's monument honoured Chemosh for the victory he gave him, and was probably set up in his temple.
The Moabite Stone, just over 1 meter/3 feet high, is in the Louvre Museum, Paris.

5.15
Archaeology in the Near East began when French and British explorers unearthed ruins of Assyrian palaces in the 1840s. Exhibitions of the great stone sculptures in Paris and London stirred the public imagination, especially when the cuneiform writing was deciphered, to reveal that some inscriptions mentioned kings known from biblical history.

5.16,17
Shalmaneser III (about 858-824 BC) campaigned extensively in Syria, where a coalition of twelve local kings, including Ahab of Israel, fought him in 853 BC. In 841, after another campaign, Jehu, who had seized the throne in Samaria, paid tribute, perhaps to help strengthen his position. The title 'Son of Omri' marks Jehu as ruler of the state which the Assyrians first met under the rule of Omri's family.
The Black Obelisk is now in the British Museum, no. 118885. It is 2 meters/6.5 feet high.

5.18
The site of Nineveh was never completely forgotten. It lies opposite the modern city of Mosul, which has spread across the Tigris river into the area of the ancient city. Sennacherib

(about 700 BC) rebuilt the city walls, about 12.8 kms/8 miles long, to enclose the city area and planted orchards within it. Two ruin-mounds cover the areas of ancient palaces. One, Quyunjik, which is about 30 meters/100 feet high, has been extensively excavated. The other still has houses on it and the traditional tomb of Jonah — hence its name: Nabi Yunus.

5.19
Sennacherib's Nineveh boasted fifteen gateways, many of them flanked by stone figures. These human-headed winged bulls were believed to have magic powers to keep enemies out of the city.

5.20
The artist had to depict a group of captives walking away from their homeland to exile in another province of the Assyrian empire. His human touch is a reminder that even exile was not necessarily slavery; people were often resettled in other regions and allowed to lead normal lives, unless they tried to return home. Some, however, were made to work for the king.
British Museum.

5.21
Assyrians and Babylonians used small stone cylinders to seal documents. Pictures cut around the circumference left their imprint when rolled across damp clay. Examples such as this one display the great skill of the seal-engravers who had to work on the tiny curving surface.
British Museum.

5.22
The king reclines on a couch and his queen sits on an upright chair. They celebrate a victory over an Elamite enemy. (His head hangs from a tree, off the picture to the left.) In this carving, which is about 50 cms/20 ins high, the sculptor has included details of the royal clothes and jewellery (a necklace hangs from the head of the couch). The decoration on the furniture can be compared with the ivory carvings — 14. As the royal couple eat in a bower where vines grow, servants wave fly-whisks, and others (off this picture) play music.
British Museum.

5.23
Killing a lion seems to have proved the king's rule over beasts as well as people. In Assyrian times the lions were kept in cages (compare the lions' den in Daniel 6) and released into an arena for the king to chase. Ashurbanipal's lion-hunt reliefs are among the finest of the Assyrian sculptures. If they are true to life, they imply that the royal lion

hunter required some strength and courage!
British Museum.

5.25,26
Sennacherib had his palace walls lined with these carved stone slabs to display the power of Assyria and parade his achievements before his court and visitors from other countries. Parts of them were probably painted. The gangs of labourers are made up of men deported from rebellious countries, some of them being men from Judah, to judge from their clothes (compare Gallery Five, 34).

5.27
The 'Taylor Prism', and others like it, was written to be buried in the foundations of a royal building. Such records give accounts of military victories and describe the buildings. Their purpose was to glorify the god of Assyria (Ashur) through the success of his viceroy, the king. For that reason they never report a defeat. Future kings should read them when they repaired the buildings and give honour to their predecessors and praise their god. These foundation inscriptions are a major source of information for writing the history of Assyria.
British Museum, no. 91032.

5.28-32
Hezekiah's tunnel twists and turns underground, as the workmen followed natural channels in the rock wherever they could. The inscription was cut in the rock wall of the tunnel by lamplight, some distance from the Siloam end. It is the finest example known of early Hebrew writing showing the style in use in the days of the prophet Isaiah.

5.34,36
The Assyrians overran Lachish and every other town in Hezekiah's kingdom. Their invasion was a punishment because Hezekiah broke the treaty his father Ahaz had accepted, whereby Judah became a vassal state to Assyria. Taking Lachish seems to have impressed Sennacherib as a major achievement, for the pictures telling the story decorated a small central chamber in his palace.

5.37
A short cuneiform inscription above the king identifies the scene. Strangely, although the reliefs are well preserved, Sennacherib's face has been cut away. This may be accidental, but it may not be too fanciful to suppose a captive from Judah took his revenge after the king was assassinated in 681 BC.

The Lachish relief series is exhibited in the British Museum.

5.40
Tyre presented every attacker with a problem because it was an island. Assyrian kings threatened it and cut off its supplies, but it was Alexander the Great who ultimately ended its independence by building a causeway to join the island to the mainland, and that has lasted to this day.

5.42
The bronze panels were fixed to the double doors of a small temple. Each of the doors was 1.8 meters/6 feet wide and over 6 meters/20 feet high, so the small figures in the panels at the top would have been invisible from the ground. In style these reliefs are just like the stone panels from the palace walls, and they tell the same story of Assyria's military might. Inscriptions identify the different scenes.

British Museum. Height of whole panel is 28 cms/11 ins.

5.43
Wealthy citizens of Jerusalem had large tombs carved in the face of the valley opposite the City of David. Some can still be seen, and several had inscriptions. This is the only well-preserved inscription. It says, 'This is (the tomb of . . .)-iah the royal steward. There is no gold or silver here, only (his bones) and the bones of his slave-girl with him. Cursed be anyone who opens this!' If the owner can be identified with the royal steward whom Isaiah condemned for his extravagant tomb, then his name would be Shebnaiah, shortened to Shebna.

Found in 1870 and brought to the British Museum. Length: 1.32 meters/4 feet 4 ins.

5.44
Tomb-chambers cut in the rock surrounded Old Testament Jerusalem. Usually there were one or two steps down from the doorway into a room with ceiling and walls cut square and rock benches at the sides where the dead would be laid. These were family tombs, sometimes with more than one burial chamber. As more burials were made, the older bones were collected and put in a pit in the floor or a small room at one side (on the right of this picture). With the bodies, pots and pans and jewellery were buried, and often a lamp left alight. This all suggests an idea that the dead needed equipment to go with them into the next world, but that, after a while, their individual remains were not of great significance. In one such tomb on the edge of the Valley of Hinnom there were rich burials, one of them having two tiny silver scrolls worn as amulets. The words of the

'Priestly Blessing' (Numbers 6:24-26) were written on one, about the time of the prophet Jeremiah. This is the oldest piece of any biblical text known to us.

Gallery Six

6.1

After the death of Alexander the Great (323 BC), Babylon's importance declined. In later centuries its ruins were used as a quarry for bricks to build village houses. The temple-tower, Etemenanki 'the house of the foundation of heaven and earth', was entirely dug away, leaving only its outline in the ground.

6.2

The Babylonian chronicle is not an official comprehensive record but a series of extracts from larger chronicles which Babylonian scribes made for their own purposes. Where the information they give can be checked against other sources, it appears to be very reliable. This tablet concerns Nebuchadnezzar's military activities to secure his empire in the early years of his reign. (He became king in 605 BC and ruled until 562 BC.) After the fall of Assyria, the Egyptians tried to extend their power into Syria. The defeat at Carchemish ended their attempt, bringing the Babylonian forces through Palestine to the Egyptian frontier. They turned into the hills to ensure that Judah remained loyal to Babylon. Repeated rebellion brought Nebuchadnezzar back in 598-97 and 587-86 BC.
British Museum no. 21946. Height: 8.25 cms/3.25 ins.

6.3

Weapons were made in both bronze and iron at this period. Some arrows had simple, two-edged heads; others had three heads. Those with a barb on the socket are associated with the Scythians, a group of nomad tribes who moved into the Near East from Asia during the seventh century BC. (In the Old Testament their name is Ashkenaz.)

6.5

The Ishtar Gate guarded the Processional Road leading to the great temples in the centre of Babylon. Statues of the gods were carried in state along this road at major religious festivals, some being brought from other towns. Stone blocks paving the street were marked with Nebuchadnezzar's name and titles. The bricks for the gate and walls were baked in kilns outside the city. One of these could have been the furnace heated up to destroy Daniel's friends (Daniel 3).

6.7

The Greek writer Herodotus, 100 years after Nebuchadnezzar, tells of the 'Hanging Gardens'; there are no Babylonian records of them.

However, Assyrian, Babylonian, and Persian kings did have elaborate gardens created for their enjoyment, so it is quite possible that a part of the palace area in Babylon was designed as a series of terraces, planted to imitate a hillside. Herodotus says the king made them to please a foreign princess who pined for her native mountains.

6.8

Hebrew letters and other documents were usually written on papyrus, the paper made from reeds growing in the River Nile. When papyrus was expensive or unobtainable, or when messages were short or only of passing interest, people wrote on the scraps of broken pottery that lay strewn about the towns. In Palestine's damp soil the papyrus does not survive, but the potsherds do. These from Lachish, and dozens more from other places, show what Hebrew writing was like in Jeremiah's time. The 'Lachish Letters' are usually thought to be reports sent from a military outpost to Lachish. Several are pieces of the same jar, and so an argument has been put forward recently that they are drafts for a letter or letters finally written on papyrus to be sent from Lachish to Jerusalem.
British Museum.

6.9

Nabonidus had been an important courtier of Nebuchadnezzar and his successors. In 556 BC he siezed the throne for himself. For reasons which the inscriptions do not reveal, he left Babylon to live at Teima in Arabia for ten years. During that time he entrusted the kingship to his son, Belshazzar, whose character the book of Daniel reveals (Daniel 5). With Nabonidus the last phase of independent Babylonian power came to an end. From 626 BC it had grown to importance under the Chaldean rulers who came from the south of the country. Under the Persians it became one of several principal cities.
British Museum no. 90837. Height: 58 cms/23 ins.

6.10

The Babylonians, in alliance with the Medes of western Persia, had conquered Nineveh (612 BC) and caused the downfall of Assyria. Cyrus the Persian overthrew the Median domination of his people in 549 BC and extended his power across Anatolia. Then he turned against Babylon. In 539 BC, using the system of canals and sluices arranged to protect the city from flooding, he diverted the waters of the River Euphrates, which flowed through the city, and marched in along its course. 'That very night Belshazzar, king of the Chaldeans, was slain' (Daniel 5:30). Tradition reports that Nabonidus was given a post in a distant province.

Gallery Seven

7.1

The 'Cyrus Cylinder' was written to celebrate the king's action in returning gods of Babylonian cities to their proper homes and the restoration of the normal cult of Marduk in Babylon. Nabonidus had rearranged the rituals and collected various divine statues in the capital in the course of his unorthodox religious reforms. While Cyrus' action followed a pattern of earlier kings in trying to please and so to pacify his new subjects in Babylonia, this cylinder and other pieces of evidence agree with the biblical record in showing the Persian rulers' care that loyal subjects should be able to worship their own gods in their own ways.
British Museum no. 90920.

7.3

This 3.7 cms/1.5 ins high agate cylinder was engraved around the outside so that it would leave an impression when rolled across a piece of clay. The design shows the king shooting a lion, an old and widely used symbol of royal power. Behind him is a date-palm tree, an emblem of fruitfulness, and above is the figure of the supreme god, Ahura-mazda, protecting the king. This seal was apparently made for an official to use on the king's behalf in Egypt, where it was found. Three kinds of writing give the name and title of Darius in the Old Persian, Elamite and Babylonian languages and cuneiform scripts. About 500 BC. British Museum no. 89132.

7.4

Darius I had the carving done to proclaim how he brought peace to the empire after Cyrus' son Cambyses died in the middle of a revolt (522 BC). Darius, who belonged to another branch of the royal family, claimed that he alone was able to put matters right. He defeated and killed the leader who pretended to be Cambyses' brother and then crushed his supporters in Persia, Mesopotamia and Armenia. To make sure everyone could learn of his power, he had the story engraved on the rock in Babylonian, Elamite and Old Persian, and copies of it circulated through the empire. (An Aramaic copy was found near Aswan in Egypt.) His victory, he said, was due to the power of his god, Ahura-mazda, whose winged figure hovers over the rebels.

7.5

Susa, which Darius made his capital, was nearer to the Persian homeland than Babylon but, like Babylon, most of its buildings were of brick. In the palace there were friezes showing magical animals, similar to those on the Ishtar Gate (see Gallery Six, 5,6), and the guards. The royal bodyguards, 1,000 strong, were called 'The Immortals' because it was said that whenever one fell, there was always another to take his place.

7.6,7

Why Darius built the splendid palace at Persepolis is not known. There may have been special ceremonies held there for the New Year, or it may have been a clan or family centre. Tombs of Darius, Xerxes and later kings lie not far away. Whatever its theoretical purpose, the building also served to glorify the king. Built of stone, with elaborately carved capitals to the many pillars, and rows of figures of subjects bringing gifts, of guards, and of the king himself, it focussed attention on the king, emphasizing his position at the heart of the empire.

7.8

Darius holds a sceptre which he might extend as a mark of favour to those who came into his presence (compare Esther 5:2). The man behind is often identified as the king's heir, Xerxes, the king who married Esther.

7.9

The destruction of Persepolis was very thorough. The Persian kings had amassed an enormous treasure, but nothing of gold or silver was left for archaeologists to find, except a handful of coins. Greek historians report that over 9,000 tons of gold fell into Alexander's hands after the capture of the Persian palaces (see nos. 14, 15, 16).

7.10,11,12,13

Persia's wealth came partly from the annual tribute depicted here. As well as products, the provinces also provided skilled men, at the king's demand, to help build the palaces. Ionian Greeks from the west coast of Turkey worked in stone, Egyptians in wood, Babylonians in brick. In style the decoration derived from Assyria, but the designs had changed subtly, and the sculptures were more rounded and given a finer finish.

7.14,15,16

The Oxus Treasure illustrates the wealth of the Persian Empire. Most of the gold was in the hands of the king, his governors and great landowners. Some was stored as coin or bullion, but much was put to use as ornaments and tableware. What can be seen in museums today is only a small fraction of what was in a palace such as that at Susa. The palace hoards and the large amounts accumulated in the chief temples provided a national reserve for use in times of need, and a tempting booty for robbers and invaders. As fashions changed, the majority of the golden objects made by ancient craftsmen were melted down and refashioned. The armlet is 11.5 cms/4.5 ins across; the goose is 10.7 cms/4.25 ins long; the bowl is 12.1 cms/4.75 ins in diameter.

7.17

Several examples of vases like this one have been found, scattered over the Near East. The Persian king may have sent them to favoured friends, containing some precious perfume, or they may be relics from the looting of the Persian palaces.

7.19

Only in Egypt and very dry parts of the Jordan Valley have documents on papyrus or leather lasted from Persian times. A large collection from Elephantine island in the Nile at Aswan records the affairs of a Jewish community living there in the fifth century BC. Their pagan neighbours persecuted them, so they wrote to the Persian king and obtained his permission to celebrate the Passover. The papyri include marriage agreements, deeds of sale, and wills. In Persia, where papyrus was not available, leather was apparently the common writing material. This letter on leather was sent from Babylon or Susa by the Persian governor of Egypt to one of his officials there, ordering the release of some foreign soldiers wrongly held.
About 400 BC. Bodleian Library, Oxford.

Gallery Eight

8.1

Guided by Pericles, Athens reached its 'Golden Age' between 443 and 429 BC, heading a league of Greek cities. With its wealth, the Athenian leaders decorated the city with fine buildings and sculpture which have become a major point in the history of human achievement. The Parthenon held the statue of the goddess Athena the Maiden (Parthenos). The sculptor Pheidias erected the statue; its surface was carved in ivory and overlaid with gold plates, and it stood 12 meters/40 feet high. The Parthenon belongs to the simple Doric order of Greek architecture. Yet the simplicity is the product of deep insight which has given both strength and lightness to the whole structure. Apparently straight lines are very slightly curved. Each pillar, for example, tapers from bottom to top, but swells slightly in the middle, while the floor rises very slightly towards the centre. Both devices avoid the impression of concavity which straight lines might give.

8.2

High up on the outside of the Parthenon wall a carved frieze ran around the building. It was visible only to those who came close and craned their necks. Beautifully sculpted figures represent a great procession held once every four years, when the people took a new robe to dress the old statue of Athena. In the procession are city officials, stewards, people bringing animals for sacrifice, and a crowd of horse-riders accompanying them. Originally the stone slabs, which are about 1 meter/3.25 feet high, were brightly painted.
British Museum.

8.3

The Nereid Monument was, in fact, a tomb built like a small temple set on a high platform. Two rows of relief carving decorated the sides of the platform, and this slab comes from one of them.
British Museum.

8.6-11

The Greek potters took their craft to artistic heights which have never been copied. Their finest pieces were painted as prizes in sport and other competitive events (the origin of the cups still often presented as prizes) — 8.8 is one of those. Different styles of painting belong to different towns or periods. Thus 8.10 is painted in red and black in a manner at home in Corinth, while 8.8, 9, 11 are in the famous black figure fashion of Athens.

8.13

Baalbek (the Semitic name means 'Lord of the valley') was an ancient centre for worship of the sun, called by the Greeks Heliopolis, 'City of the Sun'. The great temples were erected by Roman emperors in the second century AD. For those kings the sun-god was the same as Jupiter. Here Greek culture, Roman religion and the ancient traditions of the place were fused together. The six standing columns of the temple of Jupiter are 20 meters/65 feet high.

8.14,15

Jerash was founded by Alexander or his general Perdiccas, and a colony of Macedonians settled there. The photograph reveals part of the typical Greek chequer-board street plan. Under Roman rule, in the first and second centuries, Jerash prospered, the colonnaded streets, the temples and the city wall were built. Gadara was a similar, but smaller, Greco-Roman town, now known as Umm Qeis. Ruins of a theatre are visible within the modern town.

8.17

The theatre at Beth-shan was built about AD 200. When complete, with the upper tiers of seats, it would hold an audience of about 5,000. Recently, well-preserved remains of a Roman amphitheatre have been uncovered, where animal and human fights and other spectacles were staged.

8.18

The fact that the sculptures made in fifth and fourth century BC Greece were constantly copied afterwards, and that collectors in Roman times paid very high prices for them, shows how soon they were recognized as outstanding works of art. This figure demonstrates a problem which led some Greek philosophers to atheism: they thought of their gods in human terms, portrayed them as human beings, and found they could have no reverence for them.

8.19

Wooden tablets, coated on one side with wax, were commonly used as notebooks. Writing scratched on the wax with the point of a stylus could be smoothed away with the flat end. Examples have been found in many parts of the Roman Empire, from northern Britain to Egypt. These two tablets were not waxed, however, and perhaps carried texts the pupil wanted to study for some time.
Found in Egypt.

Gallery Nine

9.2

Tying the phylacteries to the head and to the upper left arm, near to the heart, is the literal fulfilment of those words. The practice dates from the second century BC at least, and may be older. Even so, it is not certain that the command was intended to be interpreted so literally. Modern phylacteries are relatively large. Examples found with the Dead Sea Scrolls, from the first century AD, are very much smaller — little more than 0.2 cms/.75 ins long and 0.13 cms/.5 ins wide. When worn they would have been barely visible. This gives point to Jesus' condemnation of people who 'make their phylacteries wide' and so show off their piety (Matthew 23:5).

9.4

This view looks across the Temple area from the south. In the foreground are excavations which have uncovered buildings of medieval times and some remains of Herod's Temple. His work replaced the older Temple, and no trace of Solomon's, the first Temple, has been found. It is impossible to excavate within the walled area because it is a Muslim sacred place. The whole area was levelled for Herod's work. At the north end, part of the hill was cut away; at the south end, the level was raised with an artificial platform. Part of that work remains, rebuilt and repaired since the first century and traditionally called 'Solomon's stables'. Just west of the Temple a deep valley divided it from the city. Herod built vaulted bridges to carry roads to some of the gates on the western side, and at the southern corner made a staircase down to the street which ran along the foot of the wall. Two gates gave entry to the Temple at the south end. A flight of steps led up to them, then there were ramps rising through the platform to the level of the courtyard inside. Some of these steps have recently been uncovered.

9.6

The stone blocks were cut square before being put in position, with a narrow margin around the edges of the exposed face. Some of the stones are as much as 7 meters/23 feet long, and weigh up to 100 tons. The lower courses of the platform at the southern end of the Temple enclosure and along the east and west sides are the original Herodian building, including the Western or Wailing Wall.

9.7

When Titus returned victorious to Rome, his father Vespasian, who had left the campaign

against the Jews in his hands in order to seize the throne, gave him a lavish triumphal welcome. The spoils and captives were paraded through the city for all to see. One panel in Titus' Arch illustrates the procession, giving us the only pictures we have of furniture from the Temple in Jerusalem. In the course of the celebration, 2,500 Jewish prisoners were killed in fights with wild animals or with gladiators in shows to mark the birthday of Titus' brother Domitian. Titus ruled as emperor AD 79-81.

9.8

The inscription says: 'No gentile may enter beyond the dividing wall into the court around the holy place; whoever is caught will be to blame for his subsequent death.' Traces of red paint remain in the letters of the fragment found in 1936, showing that the notices were very obvious in their original state. The complete block is 86 cms/34 ins wide. Acts 21 tells the story of the riot about Paul and his friend. In Ephesians 2:14, Paul explains that the notice is no longer effective, for Christ 'has broken down the dividing wall'.

9.9

Few synagogues of the first century have been found. One at Masada (Gallery Ten, 20) and another at Herodium (Gallery Ten, 18) were built by the rebels in AD 66 within Herod's fortresses. Another, at Gamla, north-east of Galilee, was a normal town synagogue. All share a similar plan: a simple hall with stepped seats around the sides, so that the congregation faced inwards to the centre, where a reader might stand for the Scripture lessons.

9.10,11,12,13

The imposing ruins of the synagogue at Capernaum seem to belong to the fourth century AD, although some scholars argue for a date as early as 200. Finely built of white limestone (imported into an area where the natural stone is black basalt) and elaborately decorated, it was obviously the work of a wealthy patron or community. Just beside it lies the traditional site of Peter's house, a rival, Christian, centre. Beneath the white synagogue are traces of an earlier, basalt one, possibly that built by the Roman centurion. The carvings of grapes and a date-palm tree symbolize the fruitfulness of the land; the candlestick, incense shovel, and ram's horn are religious emblems, the design of the candlestick echoing that on the Arch of Titus (no. 7).

9.14

When a copy of a book of the Bible was damaged or worn out, pious Jews would not keep it; neither would they destroy it, because by doing so they would profane the name of God written in it. Therefore they hid old scrolls in cupboards or buried them to decay naturally in the ground. No copies of the Hebrew Bible older than the Dead Sea Scrolls have been preserved, partly for that reason. The oldest copies known before 1948 were made in the tenth century AD. The fact that those are almost identical with the Scrolls made so long before is a tribute to the care and accuracy of the scribes who copied the sacred books for century after century. Every book of the Old Testament is represented among the Scrolls, except Esther.

9.15

The people of Qumran used some of the caves as living quarters. Eleven caves had scrolls in them, and some were probably the books the occupants of the caves left behind when the Romans came. One cave at least, cave 4, in the centre of the photograph, was used as a hiding-place for about 400 scrolls. Unfortunately, the effects of the weather and the activities of rodents reduced them to thousands of fragments, which are difficult to read and piece together. As well as books of the Old Testament, there are copies of apocryphal books like Ecclesiasticus, and of the rules of the community and of their own compositions, previously lost.

9.16,17

The Essenes were a deeply religious party whose founder, the Teacher of Righteousness, had broken away from the majority parties in Judaism in the second century BC. He followed a different calendar, so could not share in the communal services at the Temple. His community had rules of conduct and purity even more strict than the Pharisees. These were some reasons why his followers set up their headquarters at a remote place on the edge of the Dead Sea. There they had an almost self-sufficient 'monastery', with a farm further down the shore. Their peculiar life came to an end during the Roman advance in AD 68, and the place became a military watch-post.

9.18

The 'Thanksgiving Hymns' were written by the Teacher of Righteousness or his disciples. They are based on the biblical Psalms, but are all prayers or songs of thanks uttered by an individual. One main theme is praise to God for electing the speaker to the community of the righteous and so showing him some of the mysteries of knowledge about God's plans for the future.

9.19

Having dried out in the heat of the region, the leather scrolls have become very brittle. Scrolls that had suffered exposure to the air, like this one, had to be humidified to make the leather slightly flexible before unrolling. Some fragments were separated after a period in a refrigerator because the leather had become gluey at the edges. Once treated, the scrolls and fragments are mounted between glass sheets.

Gallery Ten

10.1

Although Rome took over the government of many of the states the Romans conquered, appointing consuls or other officials to take charge of them, if there was a reliable native ruler he was often allowed to govern the country, subject to a treaty or agreement and an annual tribute payment. That was the position of Herod in Palestine, and his sons in the regions they ruled. Where there were Roman governors they were sometimes fair and efficient, sometimes intolerant or intent on improving their own fortunes. Pontius Pilate, who was not in the first rank of governors, was finally recalled for mishandling Jewish and Samaritan affairs (AD 37).

10.4

The Dacian tribes living north of the Danube in what is now Romania threatened areas south of the Danube which were under Roman care. Augustus set the Danube as the frontier, but there was trouble throughout the first century and Trajan campaigned twice in AD 101-102 and 105-106, to make Dacia into a Roman province. Trajan recorded his wars in the form of an illustrated scroll unwinding around the column erected in his forum in Rome. It depicts vividly the activities and equipment of the Roman army. A statue of the emperor stood on top, his arm stretched over Rome to protect the city.

10.6

After securing his throne, Augustus turned to improving the administration and communications of the empire. To assure the necessary regular revenues, he ordered a census of each province before the annual poll-tax could be collected. During the first century a census was taken, in theory, every fourteen years, although the process took a long time, not necessarily starting at once. The tax was one denarius per head. The denarius was the coin Jesus used to avoid an attempt to trick him into an anti-Roman statement (Luke 20:20-26).

10.7

Claudius became emperor in AD 41 simply because he was the only member of the imperial family available. He reformed the administration and took great pains to act justly in an atmosphere of corruption. He expelled Jews from Rome (Acts 18:2) because of riots caused by someone called Christus. This name is often thought to be a form of Christ, but that is by no means certain. Claudius also had to deal with Jewish unrest at Alexandria

in Egypt, but, again, there is no clear evidence of Christian involvement.

10.11

Lamps of the shape seen here were made in Italy in the first century AD and exported and imitated widely. The lamps were made in moulds which had the design cut into them. Lamps like this, of a size to fit in the hand, could give adequate light for a couple of hours. The oil was poured into the bowl through the central hole; the wick of cloth or fibre rested in the spout. From time to time the wick had to be pulled forward to keep it burning. In Judea lamps of similar shape were made, usually plain, certainly without human figures decorating them because Jewish interpretation of the second commandment prevented it.

10.13

Mithraism was an offshoot of Persian religion which seems to have had a special appeal to soldiers in the Roman army. Its converts were initiated in a pit where the blood of a freshly slaughtered bull flowed over them. Somehow this re-enacted the god's slaughter of a bull which released new life. In this way Mithras had brought salvation to the world. Mithraism was a mystery religion; that is to say it was a semi-secret society whose members were bound to each other by a special loyalty and their shared secret knowledge. There was a progression through seven grades to the innermost circle. With its links of fellowship, ideas of salvation and promise of a blissful life after death, Mithraism became a notable rival to Christianity. Apart from major theological differences, Mithraism was distinguished from Christianity as a religion restricted to men.

10.14

The model shows a soldier wearing body armour of iron strips sewn onto a leather jerkin and a kilt of leather also strengthened with iron plates. An iron helmet protects his head and iron greaves his legs. His leather sandals may have had iron studs in their soles. When armed, he would have carried a spear and have had a short sword slung at his waist.
British Museum. Second century AD.

10.15

The Antonia fortress has completely disappeared, so any reconstruction is hypothetical. The 'Ecce Homo' arch in the Via Dolorosa in Jerusalem, long thought to be part of it, seems to belong to Hadrian's rebuilding of the city after AD 135. As a sign of subjection, the Romans kept the High Priest's ceremonial vestments in the fortress for many years, allowing them to be removed only a week before each major festival. Special

passageways led from the Antonia to the Temple, so that any nationalistic religious movement or other trouble there could be quelled quickly, as the riot over Paul was (see Gallery Nine, 8).

10.17,18

These aerial views emphasize the well-chosen defensive positions of Herod's fortresses (also Masada, no. 20). Herodium was also designed to be the king's burial place, although no sign of a tomb has been found. All these fortresses were built with the most lavish refinements of Roman culture. Walls were plastered and painted to look like marble; bathrooms were fitted with fine mosaic floors, and we can be sure the furniture was the most luxurious. At each fortress an army of servants and slaves swept and polished, drew water and tended the plants.

10.19

Herod's palace in Jerusalem occupied the position of the present citadel. Virtually nothing of it remains. The finds at the fortresses and at the extensive Jericho palace indicate how sumptuous it was. Private houses uncovered in Jerusalem demonstrate that there were able craftsmen at work in the city, aware of the latest Roman designs.

10.20,21,22

At the north end of Masada, Herod had an extraordinary palace built on three levels, almost hanging from the cliff (no. 21). Like the others, it was finely decorated, and it commanded a magnificent view along the shore of the Dead Sea and across to Transjordan. Herod's fortifications, and the extensive water storage system his architects had incorporated, enabled the Jewish rebels to face the long Roman siege. After that, the place was deserted except for a small Roman garrison, and a monastery of the fifth and sixth centuries AD. The dry heat allowed the preservation of the shawl, sandals and hair, which would usually decay, and also of some wooden combs and containers, basketry and leatherwork. Some fragments of biblical and other scrolls were found in several places.

10.23

The Nabataeans were an Arab tribe that occupied former Edomite territory in the fourth century BC, after the Edomites had moved into southern Judea. Petra commanded the main route from southern Arabia, along which incense was carried to the port at Gaza, for distribution throughout the Roman world. Incense was used in large amounts in Roman cults, so Petra prospered. The Nabataean kings maintained a mainly peaceful relationship with Rome after Augustus failed to

conquer Arabia, until Trajan overwhelmed them in AD 106. Thereafter the prosperity of the region declined.

10.24
Petra stood in a valley with high cliffs on either side. The city was destroyed by a series of earthquakes, and much of it lies as heaps of stone awaiting excavation. The dead were buried in tombs cut in the cliffs. Wealthy families demanded more and more elaborate tombs, with facades carved to look like fine buildings. The most magnificent is 'The Treasury' which has a portico, seen here, with doorways beautifully decorated, all chiselled from the living rock, in a mixture of Egyptian, Phoenician, and hellenistic styles.

Gallery Eleven

11.6
Tradition locates Cana at Kefr Kenna on the road from Nazareth to Tiberias, where the church stands. Some scholars suggest another site, Khirbet Kana, north of Nazareth. There is no way to resolve the problem unless an inscription is found. The jars in the miracle story were kept for ritually pure water. Stone jars for the same purpose have been found in the ruins of first-century houses in Jerusalem.

11.7
See Gallery Nine, 10-13 for the synagogue at Capernaum. Matthew's business in Capernaum was probably to collect taxes on goods brought from the separate state ruled by Herod Philip, east of the Jordan.

11.13
The Pool of Bethesda, beside the Crusaders' church of St Anne today, was first made about 200 BC to supply water for the Temple. There seem to have been two pools side by side, with one colonnade in between, thus making five colonnades in all. Although Herod made a new pool closer to the Temple, these remained open. In the second century there was a shrine for the god of healing, Aesculapius, there. Later, a church was built, part of it supported on the stone arches, visible in the photograph, which are founded on the rock at the bottom of the pool 13 meters/42 feet below the present surface. Only part of the pool has been cleared; various buildings stand on the rubble and earth filling the rest.

11.16
Although these great paving stones are certainly Roman, the theory that they covered the courtyard of Pilate's palace, probably the Antonia Fortress (Gallery Ten, 15), is now discarded. In the light of new discoveries and further studies, it appears that this pavement should be related to the rebuilding of Jerusalem as the Roman city of Aelia Capitolina, after Hadrian suppressed the Second Revolt, led by Bar Kochba, in AD 135. That soldiers in Pilate's guard scratched similar games on another pavement is quite likely.

11.17
Pilate's inscription was reused as a paving stone when alterations were made to the theatre in Caesarea, probably in the fourth century. At that time part of the lettering was hammered away. The stone seems to have recorded the building of a shrine or other structure in honour of the

Emperor Tiberius by Pilate. In the second line can be seen part of his name (PON)TIVS PILATVS. The inscription is in Latin, the official language of the Roman government, although Greek was used for most purposes. The stone is 82 cms/32.75 ins high and 68 cms/27 ins wide.
Israel Museum.

11.18
The present walls of the Old City of Jerusalem were built by the Turkish sultan Suleiman in the sixteenth century. They follow the lines of older walls for most of their course. Visitors find it strange that Calvary is located inside the walled area, in the Church of the Holy Sepulchre, and prefer to look for a place outside. However, the present north wall stands upon a wall built by Herod Agrippa after the crucifixion. The wall at the beginning of the first century ran much further to the south and, as far as current evidence tells, turned in such a way that the traditional sites of Calvary and of the Holy Sepulchre lay outside the city. Although their authenticity cannot be proved, they have a stronger case than this site, known as 'Gordon's Calvary'.

11.19
First-century Jewish tombs around Jerusalem were artificial caves. The entrance was normally small, so that it could be easily sealed with a boulder or rolling stone. With dogs and other scavengers roaming the outskirts of towns and cities, it was essential to protect the corpses from disturbance. Inside, the tomb chamber was large enough for someone to stand upright. At the sides were benches cut in the rock on which the bodies were laid for final attention. Short tunnels were dug in the rock walls as the graves. In the Jerusalem area the bones of the dead were often collected into stone or wooden boxes (ossuaries), which occupied less space.

Gallery Twelve

12.1
During Old Testament times Joppa was an important port; timber for Solomon's Temple was landed there from Lebanon, and Jonah sailed from there to avoid going to Nineveh. Herod's new port-city at Caesarea a little way up the coast (see 32, 33) took much of Joppa's trade. In the Middle Ages it again became the major port, continuing so until modern Tel Aviv, which began as a suburb on the north side, eclipsed it.

12.2
A great road-building programme in the second century has left its traces all over the Roman Empire. This stretch of road west of Aleppo illustrates the effort expended to make travel easier and enable armies to move fast. The stone blocks, some over 2 meters/6 feet long, originally had grooved surfaces to prevent the horses slipping. In other places roads were not always paved but were levelled and drained.

12.3
'Straight Street' was a main road across Roman Damascus, part of the typical hellenistic grid-iron city plan. It still runs straight across the old city. At one end stands one of the Roman gateways through the city wall, two of its three arches still intact, although much repaired. The central arch spanned a road 6 meters/20 feet wide. One of the two side arches is shown here.

12.4
Tarsus was an important port on the River Cydnus 16 kms/10 miles from the coast. A provincial capital under the Persians, Tarsus gained some sort of independence from the Greek kings of Syria early in the second century BC. The city attracted settlers from many areas, and developed as an intellectual centre. The Emperor Augustus' tutor was a native of Tarsus. Other scholars taught there, notably Stoic philosophers. A large group of Jews lived there, influencing the move to independence, probably aiding the Roman general Pompey to pacify the region when it fell under Roman rule in 65 BC. At that time, it is suggested, Paul's family was awarded the Roman citizenship to which he proudly claimed he was born (Acts 22:25-29). Tarsus, too, was a place of which one could be proud (Acts 22:3). Paul's wide knowledge of Greek culture, beside his thorough training in Jewish tradition, was no doubt due to the tolerant cosmopolitan atmosphere of his home town.

12.5
Antioch on the Orontes was built as the capital of the Greek kingdom of Syria after the break-up of Alexander's empire. It grew into a very large city, with fine buildings, a centre of trade and culture. It was also a centre of gross immorality connected with the cult of Apollo and Daphne, which even the Romans thought extreme. Many Jews inhabited Antioch, encouraged to settle in the city as full citizens from the start. They provided the nucleus for the church there. Although the third greatest city of the Roman Empire, Antioch declined as its harbour, Seleucia, silted, and an earthquake in 526 destroyed the major buildings. Today few remains of the Greco-Roman city can be seen, except for some first mosaic pavements removed to the museum.

12.6,7
Cyprus became a Roman province, first as part of Cilicia (southern Turkey), then under its own governor who, from 27 BC, was a proconsul. All the cities were given temples and market-places in Roman style. Salamis, at the east end of the island, was always important because it gave an easy route to the Syrian coast. However, Paphos, at the western end, was made the capital of the province in Roman times (Acts 13:6). Later, Salamis became the seat of government.

12.8,10
Perga was a major port on the south coast of Turkey opposite Cyprus, a few miles up the River Cestrus. The city stood at the start of the route up through the hills of Pisidia and on to the central plateau of Anatolia. It was a prosperous place with aqueducts, one of the largest Greek theatres (shown here and seating about 12,000 people), and a famous temple of the goddess Artemis. Perga was gradually replaced by its port, Attalia, modern Antalya (no. 10). This city was founded by Attalus II, king of Pergamum, and bequeathed to Rome by Attalus III in 133 BC. City walls, a gateway built by Hadrian which opens towards Perga, and towers protecting the harbour still stand.

12.9
From Attalia to Antioch was about 255 kms/160 miles, involving a climb of 1,000 meters/3,300 feet through mountains where robbers lurked. Pisidian Antioch fell within the Roman province of Galatia. Greek and Jewish settlers lived among the local Phrygian populace. Traces of the first-century city have been revealed by excavations near modern Yalvaç. There were ornamental gateways, squares, and temples, porticos and shops. The aqueduct to the north of the city brought water from nearby hills. Antioch stood at a junction on the road from Ephesus to Syria, and drew much of its importance from its position.

12.12,13
Philippi, near the eastern end of the Egnatian Way (no. 11) was rebuilt by Philip II of Macedon, father of Alexander the Great, and named in his honour. Later, Augustus, the Roman emperor-to-be, defeated Brutus, one of Julius Caesar's assassins, there (42 BC) and shortly after gave the town valuable civic privileges. Philippians were proud of the status they enjoyed, and so would feel even more keenly the wrong they did to Paul and Silas (see Acts 16:20-39). The ruined forum is a second-century replacement of the one where Paul stood.

12.14
Thessalonica stood 160 kms/100 miles from Philippi. The city was founded in 315 BC and named after Alexander's sister. It was the main port of Macedonia and a major meeting point for overland routes, and it retains its importance today as Saloniki. Galerius' triumphal arch was erected in AD 303, the year in which he induced the Emperor Diocletian, under whom he ruled in the eastern part of the empire, to decree the persecution of Christians. Constantine, the ruler in the west, refused to co-operate.

12.15
After the battle of Philippi, Augustus was in Thessalonica and declared it a 'free city'. That meant it had no Roman governor, administering its own affairs. Control was through the citizens' assembly and a panel of magistrates. In Acts 17:6,8, these men are given an unusual title — 'politarchs' (city-rulers). This inscription, and others including one from AD 44, show that the authorities in Thessalonica did bear that title, a pointer to the accuracy of the report in Acts. British Museum, Inscriptions, 171. Length 2 meters/6.75 feet. AD 143.

12.16
The Areopagus' official meeting-place was on Mars' Hill where traces of benches cut out of the rock still survive. By Roman times the meetings were usually in one of the colonnaded buildings in the *agora*. The Areopagus began as the senior council of state, but lost much of its power to other bodies, keeping responsibility for weights and measures, building works, education and religion. It was before the Areopagus that Socrates was tried, 450 years before Paul's hearing.

12.17
Julius Caesar rebuilt Corinth in 46 BC, making it a Roman colony and adding many Roman freemen to its population. The great market-place, to the

centre in the photograph, was lined with shops. One had its owner's name carved on the doorstep, 'Lucius the Butcher'. Leading to the market-place from the north was the paved Lechaeum road, seen here, with shops on either side. At the opposite side of the *agora* was the judgement-seat (the *bema*, Acts 18:12), remaining as a stone platform decorated with marble carvings.

12.19
Ephesus is the most extensive ruined hellenistic city in western Turkey. The main street ran from the harbour to the theatre, with colonnades along each side. Archaeologists have cleared many buildings from the prosperous years of the second century, among them the market-place, temples, the great theatre and the smaller (the Odeion), and a library. The Goths attacked in AD 263 and destroyed Diana's temple (see no. 20), the harbour silted, and the city declined.

12.20
Artemis was the patron goddess of Ephesus. Her temple was rebuilt after a fire in 356 BC to reach the summit of lavish decoration. It was four times the size of the Parthenon in Athens, 128 meters/ 420 feet long and 73 meters/240 feet wide. Over 100 columns supported the roof, some of the column drums being carved in high relief. The temple was a centre of pilgrimage, drawing people from all parts of the world, and was served by a large number of priests, eunuchs, acrobats and musicians. One month each year was devoted to festivals and processions in honour of the goddess. Not surprisingly, the Ephesians gloried in the title of their city as 'temple warden' (*neōkoros*). The site of the temple was lost until 1870, when, after years of exploration and research, it was located in an area which had become a marsh. Eight green marble pillars were taken from the ruins of the great church of Santa Sophia, built by Justinian in Constantinople (Istanbul) in 548, and are still in position there.

12.21
Artemis or Diana was the goddess of wild animals, hunting and the moon. In addition, she had characteristics of the ancient mother-goddess and fertility symbol. Her statue at Ephesus was said to have fallen from heaven (Acts 19:35), which may refer to a meteorite. Statues like the one shown seem to represent her fertility and fruitfulness. Possibly the meteoric stone, if such it was, also appeared to represent several breasts. Followers of Diana titled her 'great' according to the inscriptions. The silversmiths who were afraid Paul's Christian gospel would ruin their trade apparently made small models of the goddess in her shrine for the pilgrims to take home.

12.22
The ruined theatre may be in part the one of Paul's confrontation. It was begun in the reign of Claudius (about AD 50) and finished about fifty years later. Three were sixty-six tiers of stone seats, yet the acoustics were so good that everyone could hear.

12.24
Colossae is now a ruin-mound in the Turkish countryside, awaiting excavation. The hollow shape of a theatre can be traced on the side of a low hill nearby. In the fifth and fourth centuries BC it was a strategic city on the road across Anatolia eastwards. The foundation of Laodicea, about 260 BC, ten miles to the west took away its importance (see nos. 43, 44). Dyeing cloth was a major industry, one which Jews in Asia Minor often practised. In AD 60 a major earthquake devastated the area.

12.25
This medallion, 57.15 cms/2.25 ins in diameter, may have been hung around a slave's neck on a locked metal collar. It may also have been used as a dog tag. Fourth century AD.
British Museum no. GR1975.9-26.

12.28
This letter, written during the first century, is a typical example of hundreds of letters and other documents from the Roman period recovered from Egypt. Most of the towns and villages were close to the Nile and their records have perished in the damp soil. Some settlements, however, were in an area where the water drawn from a branch of the Nile eventually dried up. In their ruins and in their rubbish dumps thousands of pieces of papyrus survived, dehydrated.
British Museum Papyrus 356.

12.30,31
Miletus was an ancient Greek city standing on a small promontory, with four harbours. Excavations conducted since the beginning of this century have revealed many buildings which were in use at the time of Paul's visit. There were three market-places, the south agora being the largest of all at 164 meters/525 feet × 196 meters/645 feet, a council chamber, public baths, a gymnasium and a stadium. The theatre was begun in the fourth century BC and remodelled at various times. Temples honoured Apollo, Athena, and the Egyptian god Serapis. Miletus was the home-town of Hippodamus. He originated the grid-iron street plan, rebuilding his own city after the Persians destroyed it in the fifth century BC. Jewish inhabitants had liberty to observe the sabbath and follow their own religious customs. The

inscription from the theatre indicates that, as in other places, there were local people who attached themselves to the Jews without becoming wholly Jewish. By the fourth century AD the silt of the River Meander had blocked the harbours of Miletus, and today its ruins lie some 8 kms/5 miles inland.

12.32,33
Extensive ruins at Caesarea include the theatre (Gallery Ten, 16), warehouses, amphitheatre, aqueduct, and — the reason for the city's existence — the great harbour: all works initiated by Herod. Excavations on the coast and underwater have begun to reveal parts of the artificial breakwaters that formed the harbour. The southern one, curving, was 600 meters/655 yards long, the northern 250 meters/270 yards. These great structures suffered in an earthquake in 130, and part of the harbour silted up. Recent work has uncovered fine mosaic pavements in a building which may be the palace of Herod and, after him, of the Roman governors, including Felix.

The name Felix was quite a common one (it means 'happy'). The tombstone shown was not erected for the governor of Palestine but for a Roman soldier, about AD 200. Felix was a particularly bad governor (AD 52-59), greedy for gain and careless of justice. His conduct resulted in his recall to Rome where he faced charges brought by the Jews, but was aquitted through the influence of his brother Pallas with the emperor.

12.36
The Appian Way ran from Rome to Capua. It was laid by Appius Claudius Caecus in 312 BC. He probably founded the staging-post for travellers. At the forty-third Roman milestone from the capital, it was one day's fast journey (about 63 kms/40 miles from Rome). The place had a reputation for bad water, insects, and extortionate inn-keepers. Doubtless Paul was glad to meet friends there (Acts 28:15). Another group met him at the Three Taverns, 33 Roman miles out (about 48 kms/30 miles).

12.37
Nero was born in 37, the son of a Roman noble and of the great-grand-daughter of Augustus. He became emperor because his mother, Agrippina, married the Emperor Claudius and had him adopt Nero. She murdered Claudius in 54 and Nero was proclaimed emperor. For five years he ruled under the influence of his tutor Seneca and the captain of the guard, Burrus. They governed well, while allowing Nero every indulgence. In 58 he fell under the influence of Poppaea and, desperate for money, confiscated Roman estates and devalued the coinage. In July 64 a great fire broke out which

destroyed over half of Rome. Many thought Nero had started it. He found a scapegoat in the Christians whose beliefs were thought offensive to the gods. Thus began the persecutions and scenes in the arena which scarred the first three centuries of Christian history. Nero had to contend with more conspiracies, lost the support of the Praetorian Guard, and killed himself in June 68.

12.39

'The ornament of Asia' both in fine buildings and prosperity was Smyrna, a port now buried beneath modern Izmir. These columns are the only visible remains, part of the market-place rebuilt after an earthquake devastated the city in about 178. Smyrna was the first city in Asia Minor to build a shrine for the cult of the city of Rome, and later became a centre of emperor worship, something directly opposed to Christianity.

12.40,41

Pergamum was the seat of a line of kings following the break-up of Alexander's empire. The last of them, Attalus III, bequeathed his kingdom to Rome when he died in 133 BC. Excavations made since 1878 have exposed many of the major buildings, the greater part of them from the first and second centuries AD. Three deserve mention. Most famous is the great Altar of Zeus, which had a sculptured frieze running round the base for 136 meters/446 feet. Among the greatest hellenistic works of art, this is now one of the treasures of the Staatliche Museen in Berlin. Some scholars identify the altar with 'Satan's throne' in Revelation 2:13. The second building is the library. Ancient reports affirm that it contained 200,000 scrolls in the first century BC. A large hall has been cleared, once a reading-room. Holes in the walls show where the book-shelves were fitted. When papyrus supplies were denied to King Eumenes II (197-159 BC), he had sheep and goatskins treated to make a writing material. It was named *pergamentum,* after the city, and has come into English as parchment. Pergamum was the second centre for healing in the Greek world. The sanctuary of Aesculapius was located by springs and mud-pools where the sick bathed. In the shrine the sufferers might sleep, hoping that the god would appear to them in a dream to heal them. The tunnel ran from one of the healing centres to the pools in the second century.

12.42

Sardis, city of the wealthy Croesus, was ruined by an earthquake in AD 17, and rebuilt with funds from the Roman imperial treasury. One of the main buildings was the temple of Artemis (see also no. 21). Croesus had it built in the sixth century BC. It was destroyed in the revolt of Greek cities in Asia Minor against Persia in 498 BC, was rebuilt on the orders of Alexander the Great, and rescued from landslides after the earthquake. Remains of a magnificent synagogue were uncovered in the city, and it has been partly restored. It dates from the third and fourth centuries AD. Although it stands on the site of different buildings, an inscription shows there was a synagogue in the city in the first century BC and Obadiah 20 indicates that Jews were living there in the sixth century (Sepharad is the native form of Sardis).

12.43,44

Laodicea, which eclipsed Colossae (see no. 24), produced glossy black wool, commanded a major crossroads, and was a flourishing centre of banking in the first century BC. Like Sardis, it suffered in the earthquake of 17 and had help for reconstruction from Rome. Ruins of public baths (no.43), two theatres, a gymnasium, a stadium and great gateways exhibit the wealth of Laodicea. The god of healing, Aesculapius, was worshipped in Laodicea, and doctors there may have developed an ointment for the eyes (compare Revelation 3:18).

12.46

Only 9 cms/3.5 ins × 6.2 cms/2.3 ins, this piece of a page contains words from John 18 verses 31 to 33 on the front (shown here) and verses 37 and 38 on the back. Its age is deduced by comparing the style of writing with the script of other manuscripts which bear dates. With about half a dozen other copies of Christian books made later in the second century, this scrap is witness to the spread of Christianity and the reading of Christian literature along the Nile. It is also interesting to see that early Christians were using the book form with pages (the codex), rather than the normal scroll, long before it came into general use for other Greek literature. It is, of course, much easier to use, simpler to find a reference in, and more compact. Christian scribes were eager to make the good news of the Gospel easily available.

INDEX